DRAWING ATELIER

the figure

how to draw in a classical style

Jon deMartin

NORTH LIGHT BOOKS
CINCINNATI, OHIO
www.artistsnetwork.com

CONTENTS

TERMINOLOGY

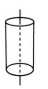

AXIS

An imaginary line that runs through the center of a form.

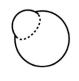

BASE BOUNDARY

An imaginary enclosed line (shape) that describes where a form originates.

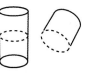

CROSS-SECTION

The intersection of a three-dimensional body with a plane; the end view of a cut made across a form.

DOUBLE CURVATURE

A form turning in two directions.

OPTICAL BOUNDARY

The outside boundary or outside shape (contour) of a form.

OVERLAPPING LINES

Indicate one form in front of another.

PEAK POINT

The highest point of a form.

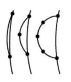

RELIEF FORMS

High, middle or low forms that rise up from a larger surface underneath.

PLANE

A flat or slightly curved single-planed surface; a conception used by artists to simplify a multi-planed surface or a curved surface.

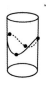

SPACE CURVE

A line that travels three-dimensionally in space.

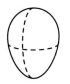

SURFACE CENTER

A line that runs down or across the center of a surface of a form (as opposed to an axis, which runs deep through the middle of a form).

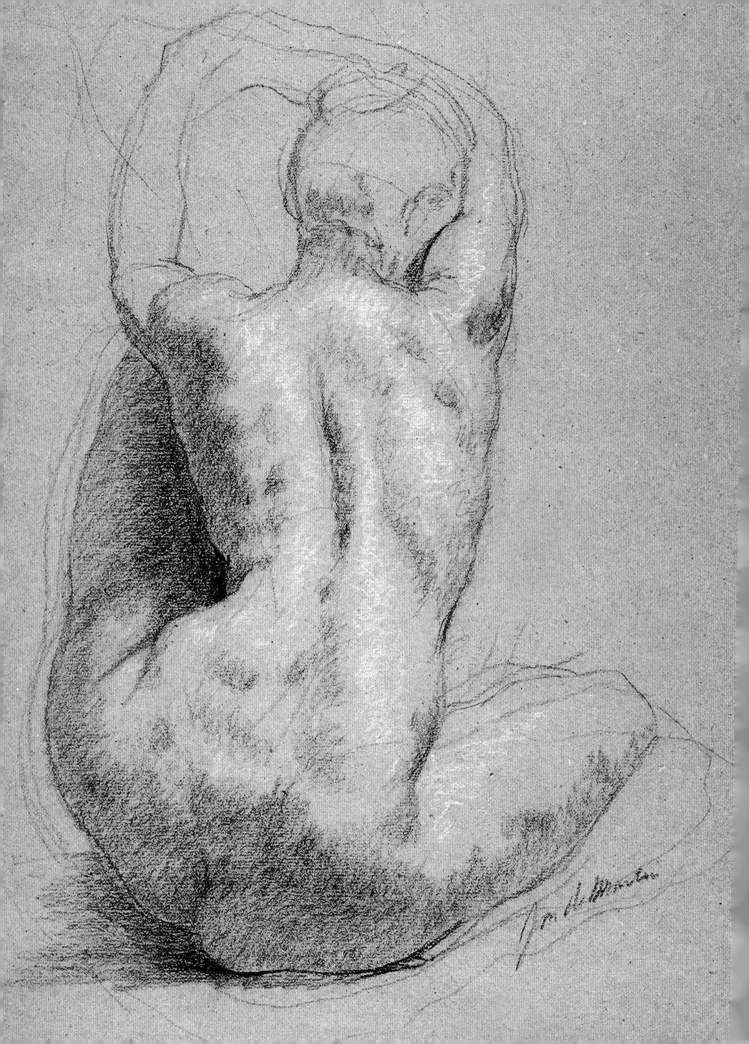

INTRODUCTION

This book seeks to shed light on the principles exemplified in the drawings of the Old Masters. Much of the information it contains is the result of a long, meaningful collaboration with my teacher, Michael Aviano. We share a deep passion for classical drawings, particularly those created during the Renaissance, the Baroque period and the eighteenth century. Drawings from these periods seem larger than life, as though nature were pushed to a higher degree. The artists who drew them were adept at creating three-dimensional form with both line and value.

In this book, we'll focus on the power of line and how it can be used to create the third dimension. Learning how to deconstruct and then reconstruct the figure from life (or from the imagination) can empower you to travel in whichever direction your creativity takes you. To achieve this facility requires practice, but you must practice in the right way. You must have a process you believe in. If your process is good, your results will be good.

Since 2008, I've written a series of articles about the fundamentals of figure drawing for American Artist's *Drawing* magazine. This book is based, in large part, on those articles. I've added step-by-step demonstrations and additional drawings to fortify the written text because I want to *show* as well as tell. In many cases, I added diagrams to illustrations that reveal my thought process during a work in progress.

We'll begin with a chapter on the materials and methods of classical drawing, which was inspired by a drawing treatise, *Méthode Pour Apprendre le Dessein*, written by Charles-Antoine Jombert in 1740. Next, we'll progress to contour, proportions and how to measure, before tackling the challenge of foreshortening. We'll also cover the head and its features, as well as the hands and feet.

Finally, we'll explore short-pose figure drawing. In my view, it is important to learn the principles of figure drawing and to develop drawing skills in longer studies before challenging yourself with short poses. As Leonardo da Vinci said, "Learn diligence before speedy execution."

Whether emphasizing line, value or both, the more techniques you have in your arsenal, the more you can exercise your imagination—your most valuable asset of all.

HELEN SEATED
Jon deMartin, 2007
Sepia and white chalk on toned paper
23" × 16" (58cm × 41cm)

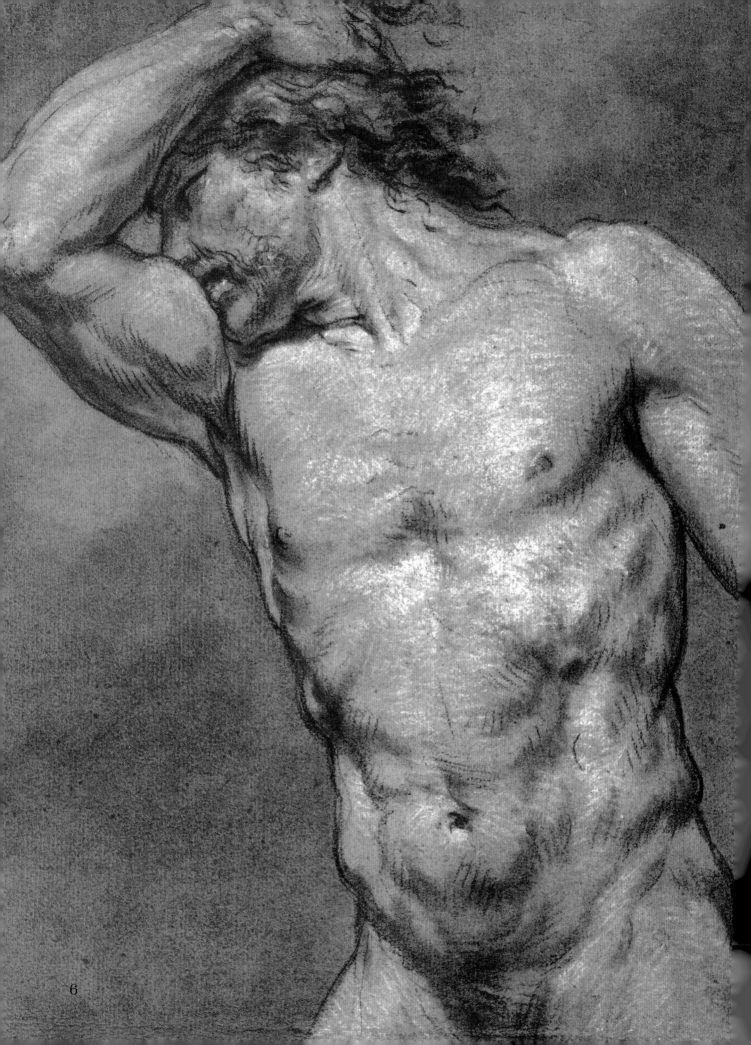

6

1

TOOLS, BASIC TECHNIQUES & COPYING DRAWINGS

Copying engravings, etchings, lithographs and drawings has been a widespread method of artistic training for centuries. The information in this chapter is primarily based on the classical methods of the eighteenth century, specifically Charles-Antoine Jombert's 1740 treatise, *Méthode Pour Apprende le Dessein*.

All of the methods and techniques covered here can help expand your artistic vocabulary and enrich you with a variety of tools and problem-solving skills that are useful for copying master works, as well as for developing original artwork. The more concepts you bring to your art, the more engaged you can be in the creative process.

In this chapter you will learn:
- various techniques for copying a drawing
- different methods of shading
- how to choose the materials that will work best for a given drawing
- how to self-correct your drawing without a teacher.

ACADÉMIE D'HOMME
Jacques-Louis David
Black and white chalk on toned paper
24" × 18" (61cm × 46cm)

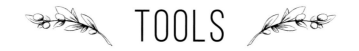

TOOLS

To get the most out of copying exercises, make sure you select your materials and choose your method of shading strategically. Different drawing implements, as well as different papers, are more or less suited for various copying tasks. The image below shows some of the tools you might choose to use. Throughout this chapter, I'll explain which materials I prefer for particular exercises and why.

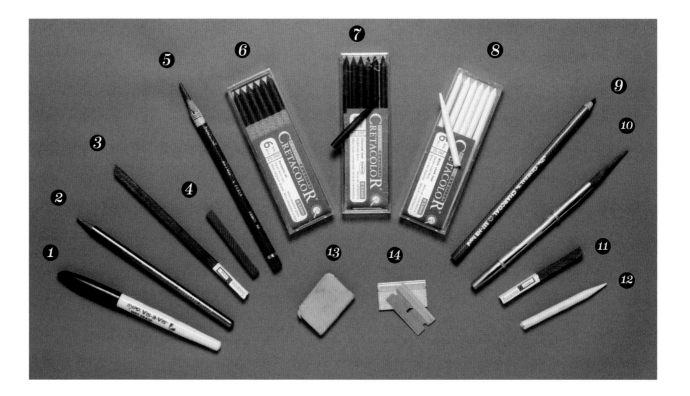

DRAWING MATERIALS

1. *Black Expo Vis-à-Vis wet-erase marker*
2. *Progresso HB graphite pencil*
3. *Nitram Académie Fusain HB vine charcoal*
4. *Conté à Paris crayon stick 2451, Sanguine Light*
5. *Conté à Paris crayon pencil*
6. *Cretacolor sanguine oil 262-02*
7. *Cretacolor black charcoal leads (medium)*
8. *Cretacolor white chalk leads*
9. *Charcoal HB pencil*
10. *Crayon or chalk holder (porte-crayon)*
11. *Nitram Académie Fusain HB charcoal stick*
12. *Blending stump (tortillon)*
13. *Kneaded eraser*
14. *Single-edge razor blades*

FUNDAMENTAL DRAWING STRATEGIES

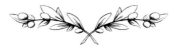

Choosing Your Format

Before you begin drawing, the first thing you will need to decide is whether the height of the subject is greater than its width. If the height exceeds the width, then typically, you orient the composition vertically. If the width of the subject is greater than the height, orient the composition horizontally.

Holding Your Drawing Tool

When you hold your drawing tool, grip it farther back from the point that you would if you were writing a letter. This will help you draw with freer, bolder strokes. If you use chalk, I recommend a chalk holder to act as an extension. If you're holding a small piece of chalk, you may work too much with your wrist; it's better to work mainly from your shoulder and elbow.

Positioning Yourself

Stand or sit straight, far enough away from your subject so that you don't have to raise or lower your head when looking back and forth between the subject and your drawing. You want to be able to see your subject and your drawing in one glance. This will allow you to make comparisons more effectively and accurately.

Drawing Big

Once you've established your format, get in the habit of setting guidelines on your drawing so that you can fit the drawing within your marks. Get used to drawing larger because it encourages you to draw all parts of your subject. Mistakes are much easier to see at a larger scale, and drawing large has the benefit of allowing you to include the small, beautiful structures of a form. Learning to draw on a large scale makes it easier to draw on a smaller one. The opposite is not true—if you get comfortable drawing small, then drawing large becomes difficult. When copying in particular, make sure that your copy is at least the same size as the original.

Getting Started

Make your first sketch with the fewest, lightest lines possible in order to capture the general idea; it's simply an approximation of what the finished drawing will look like. The universal rule of all drawing is not to finish any single part right away, but to faintly sketch the whole. In other words, you should give a certain visibility to all of the principal parts before finishing any single part. This will enable you to make intelligent and informed corrections. Whatever the stage of a drawing, it should have the same degree of resolution throughout.

Keep It Sharp!

Always keep the point of your drawing tool as long and as sharp as possible. You'll be in a good position to make precise and elegant strokes rather than blunt, crude ones. I prefer a single-edge razor blade for effective sharpening. Take care to always sharpen away from yourself, using long, straight strokes while turning the pencil or chalk with your fingertips. You want a long, tapered, conical point.

CHECK FOR ACCURACY
BY GAUGING

In order to ensure accuracy, your eye must be trained to function as a plumb line so that you can gauge the horizontal and vertical relationships of your subject. A plumb line is an absolute vertical line used to compare vertical alignments and to gauge angles in both the model and your drawing. It's usually made out of a string attached to a small weight that hangs vertically, but this swings around too much. A straight and narrow object, such as a knitting needle or a bicycle spoke, can be held vertically to enable you to compare both vertical and horizontal alignments.

The illustration on the next page is a plate from Charles-Antoine Jombert's *Méthode Pour Apprendre le Dessein*. It shows vertical and horizontal lines that cut through the engraving of the eye. When I copied this plate, I drew the same lines so that I could copy the original accurately. I don't recommend using diagonal lines for this purpose. They're difficult to duplicate and are therefore unreliable. However, you can sleep well at night knowing that your floors and walls are (hopefully) horizontal and vertical. Horizontals and verticals are reliable gauges for estimating the tilts and angles of lines.

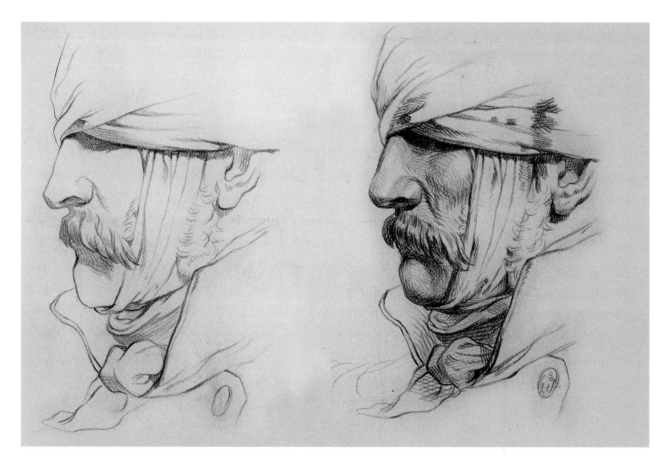

**COPY AFTER *HEAD OF WOUNDED SOLDIER*
BY BERNARD-ROMAIN JULIEN**
Jon deMartin, 1985
Graphite on Strathmore 400 paper
24" × 18" (61cm × 46cm)

I used a Progresso graphite HB pencil for both the preliminary and the finished drawing of this copy after Julien. It's good discipline to try to use the same medium throughout the course of a drawing. This requires a light touch initially so that you can gradually build up to your darker darks as you finish. For this exercise, I used the technique of graining and then hatching.

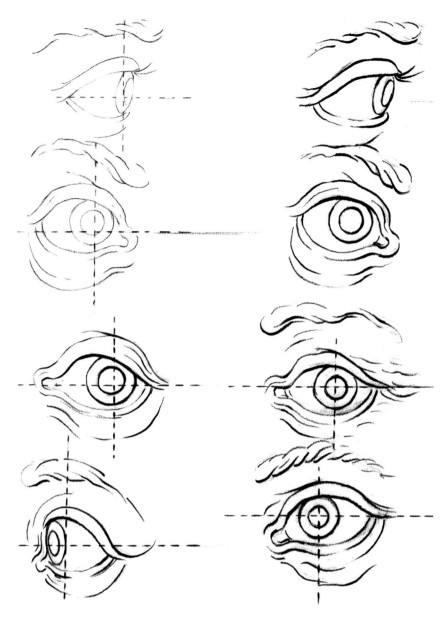

In the upper left area of Jombert's
drawing, the lines are light and have very
little variation. At the right, the lines vary
in weight to suggest the illusion of light
on form.

Tools for Accuracy:
Self-Check Using a Picture Plane

*A very effective way to self-check for accuracy
involves using Plexiglas to make critical judgments
about your picture plane. Before you begin your
copy, lay a sheet of Plexiglas over the source image
you'll be working from. Trace the most important
lines on the Plexiglas. Avoid elaborate detail. Then
set it aside and begin your copy. (You can use an
Expo Vis-à-Vis wet-erase marker for this.)*

*As you proceed, you can place the Plexiglas
over your drawing to compare how far off you
are from the original. I recommend first checking
your drawing against the Plexiglas tracing after you
make your initial drawing in vine charcoal. Hold the
Plexiglas between your eye and the original drawing.
Look through one eye only. To minimize distortion, it's
crucial that you hold the Plexiglas parallel to your
drawing. If the tracing on the Plexiglas registers cor-
rectly, proceed to the final phase of the drawing. If not,
make corrections before advancing.*

*This is an excellent way to self-check when there
isn't a teacher around. It's also important to note: No
matter what you are drawing, always draw by eye first.
Mistakes cannot be corrected unless there is some-
thing to correct from.*

SHADING TECHNIQUE 1: HATCHING

In the great classical drawing schools, students were taught how to shade, or model, a drawing in three primary ways. The first of these methods was hatching, which means to shade an area with closely drawn parallel lines. Historically, the medium recommended for its study was pen and ink. Drawing with pen and ink requires a great amount of practice, however, because every stroke counts and it cannot be erased.

There is no better way to learn this technique than to copy good prints. It's best to find examples that show simple, clear, beautiful hatchings with minimal confusion or detail. Copying drawings using hatching is extremely helpful in learning to appreciate how artists can use line to caress a form's three-dimensional nature. This technique can help animate your lines and give a living force to drawings of form.

To improve my own hatching technique, I chose to copy the rudimentary engravings from Abraham Bloemaert's copybook, *The Tekenboek*.

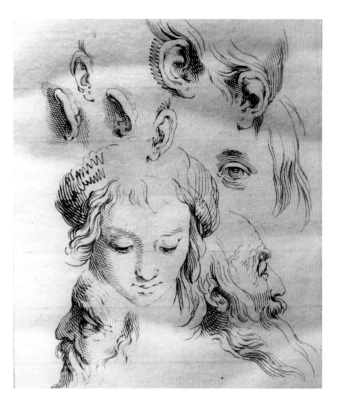

STUDY OF FEATURES, HEAD AND PROFILES—PLATE 24
Frederick Bloemaert, after Abraham Bloemaert
Engraving, 13" × 11" (33cm × 28cm)

HATCHING
The general rule for hatching is to never cross the hatchings at a right angle. It's also important to avoid making your lines too skinny and parallel.

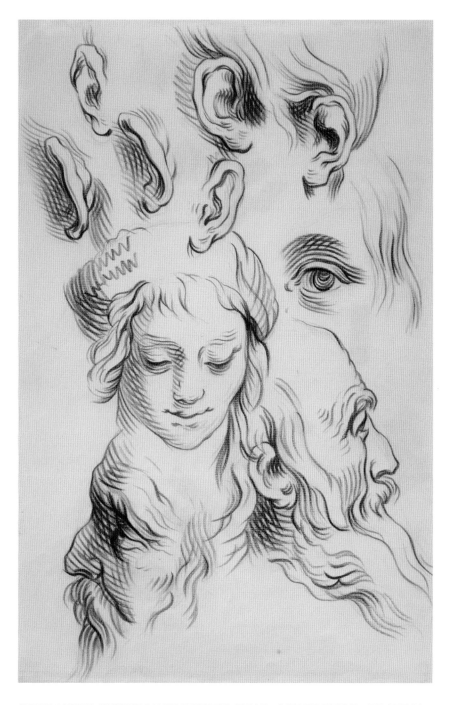

COPY AFTER *STUDY OF FEATURES, HEAD, AND PROFILE—PLATE 24*
Jon deMartin, 1983
Sanguine Cretacolor on Strathmore 500 paper
18" × 12" (40cm × 30cm)

Since my goal was to learn to draw with chalk, not pen and ink, I used a sanguine
Cretacolor with a crayon holder. This hard, waxy crayon lets you make lines with varying
amounts of pressure without breaking the point. A Conté crayon, on the other hand, is
more brittle and can break easily.

SHADING TECHNIQUE 2: GRAINING

A second way to shade a drawing is by graining—rubbing chalk or crayon on the paper to make a large mass of tone. This is the recommended technique for copying engravings with complicated hatchings.

The method of beginning a drawing in vine charcoal and finishing it with chalk was espoused in the eighteenth century, especially for académies—the term used to describe drawings done from the live model. Jombert explained it this way: "After first drawing with charcoal, you then wipe away the charcoal until it's virtually clean, then re-draw with crayon over those traces of your first marks, then grain in the darkest areas. One prepares the drawing by this method over the entire drawing all at once, but before shading entirely and finishing, it is necessary to make sure your marks and the original are exactly alike and accurately made."

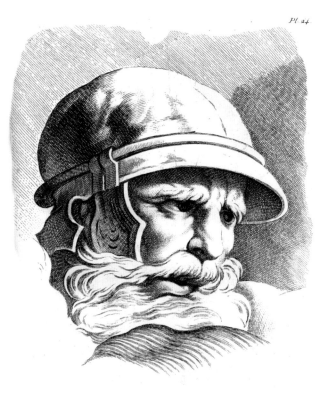

HEAD AFTER RAPHAEL—PLATE 24
Charles-Antoine Jombert, 1740
Engraving from *Méthode Pour Apprendre le Dessein*
11" × 9" (28cm × 23cm)

GRAINING
The medium catches on the high points of the paper's texture, and as a result, the grain of the paper shows through.

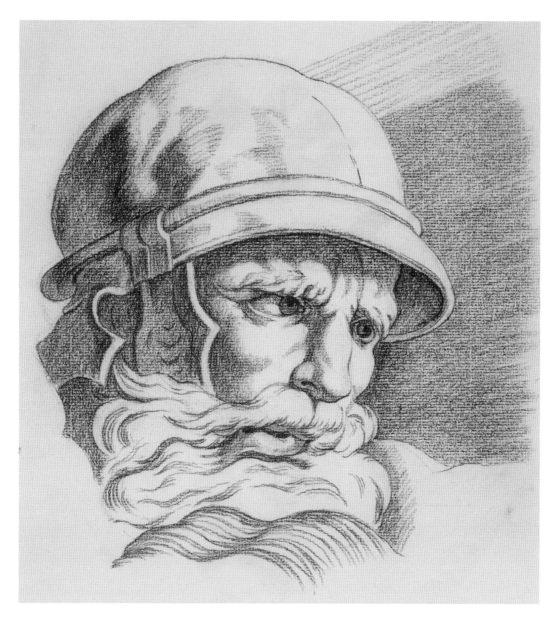

COPY OF *HEAD AFTER RAPHAEL*— *PLATE 24*

Jon deMartin, 1983
Nitram Académie Fusain HB charcoal and sanguine
Conté crayon on Strathmore 500 paper
18" × 12" (46cm × 30cm)

In my copy of Jombert's engraving, the ribs of the paper give the shadows a pleasing texture. The paper that is best suited for this technique is a white charcoal paper with a laid finish. I used vine charcoal for the initial drawing. I have found Nitram Académie Fusain HB vine charcoal to be the most effective because it is long-lasting and produces sharp lines that are easy to correct due to the relative softness of the medium.

To finish the drawing, I used a sanguine Conté crayon because it was conducive for the graining technique. It's a softer chalk than the waxier Cretacolor and it rubs on easily. However, because of its softness, it takes some practice to control the varying densities of tone, which are created by the use of pressure. It's important to note that my initial shadow values were made light so that I could gradually make them darker.

Graining With Hatching

Before moving on to the third major shading technique, it's useful to look at how the techniques of hatching and graining can be combined. Too much hatching can give your drawing a dry and narrow manner. However, when hatching is combined with other shading techniques such as graining, it can create beautiful effects.

Jombert wrote, "When one would like to draw in good taste, it is not necessary to copy exactly every single mark and beautiful hatching, but one must grain a lot and use some hatchings, because a drawing that is only grained will seem drawn too softly. One is obliged to hatch in certain areas to make halftones and reinforce shadows more assuredly, but it is necessary that this be done tastefully."

The engraving below by Gilles Demarteau (after an original académie by Francois Boucher) shows further examples of these two shading techniques combined.

GRAINING WITH HATCHING

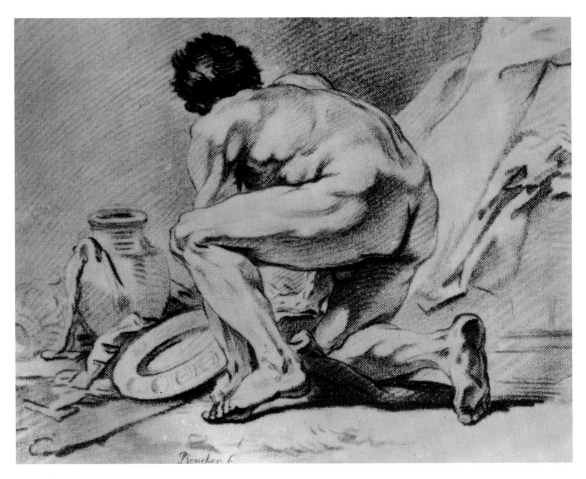

ACADÉMIE D'HOMME
Gilles Demarteau, 1742
Engraving, 19" × 20" (48cm × 51cm)

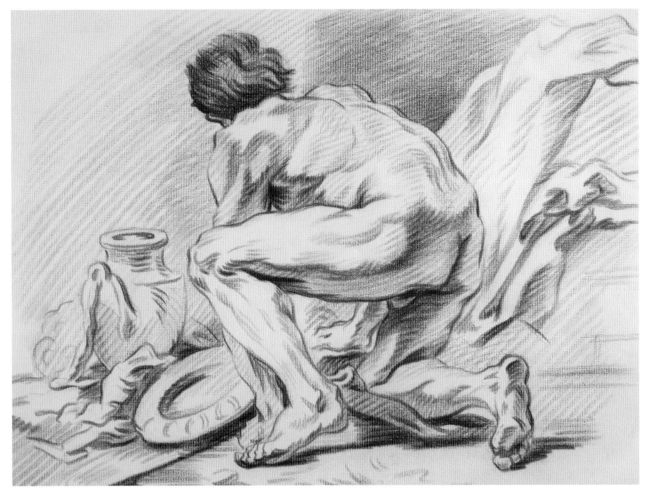

COPY AFTER *ACADÉMIE D'HOMME*
Jon deMartin, 1983
Nitram Académie Fusain HB charcoal and
sanguine Cretacolor on Strathmore 500 paper
12" × 18" (30cm × 46cm)

I combined the techniques of graining and hatching in my copy of Demarteau's engraving. I found the sanguine Cretacolor versatile enough to give me both vigorous, bold outlines and subtle shades and halftones. Initially I grained in my larger shadow masses lightly, then gradually modulated them depending on their strength of darkness. I let the lighter reflections in the shadows show through from the initial stage and then reinforced the shadow edges and halftones with hatchings.

SHADING TECHNIQUE 3: STUMPING

The third way of shading is called stumping—simply rubbing your work with a stump to soften what you've drawn with graining or hatching. The charcoal stump, also known as a tortillon, is a cylindrical drawing tool usually made of rolled paper that is tapered at one end.

Black chalk, which is technically a compressed charcoal, is less greasy than red crayon and is a better medium to use with stumping. You can create delicate and beautiful halftones if you have the right amount of chalk on the stump and draw directly with it. Shadows can later be reinforced with hatchings by drawing over what has already been stumped. The effect is similar to when you hatch over what you have grained.

Instructors in the traditional académies generally recommended stumping only in the shadows, not in white chalk or highlights. This gives drawings a nice balance between the more vigorous hatchings with white chalk and the softer, melted appearance of stumped shadows. The lights come forward and the shadows recede. It is advised not to mix your lights with the white chalk into the charcoal shadows, as this can make a mess that can't be undone.

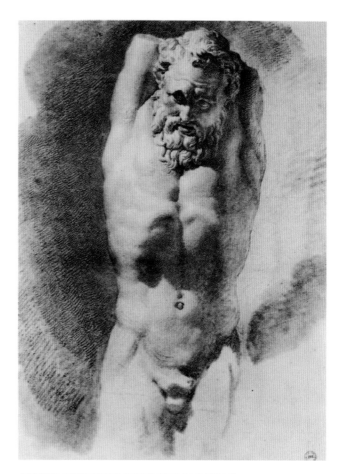

AFTER *THE TORMENT OF MARSYAS*
Tommaso Minardi
Black chalk, 20" × 15" (51cm × 18cm)

STUMPING
The medium catches on the high points of the paper's texture, and as a result, the grain of the paper shows through.

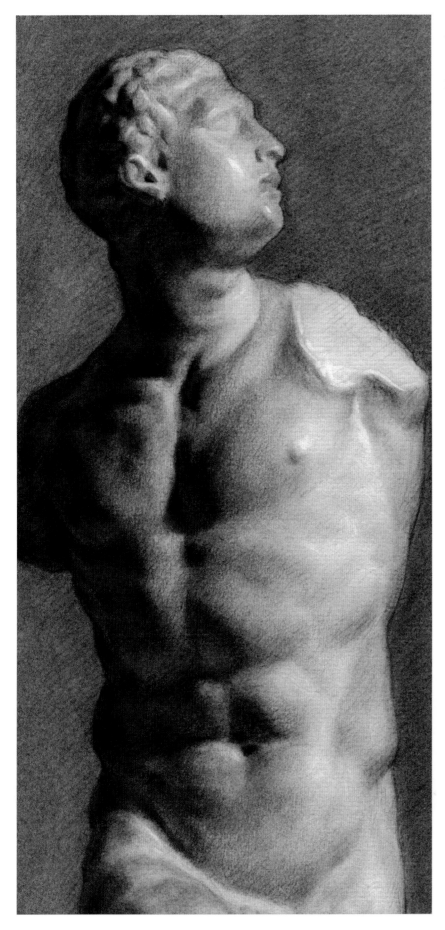

DRAWING AFTER *THE BORGHESE WARRIOR* BY AGASIAS OF EPHESUS
Jon deMartin, 1987
Black and white chalk on cream
laid finish charcoal paper
12" × 8" (30cm × 20cm)

Develop the values through graining so that you can see the subject's value range and its light effect before you begin stumping. Be particularly careful in developing the halftones between the light and shadow. The more refined and accurate your graining is, the better the stumped passages of the drawing will appear.

Use as much care in gently stumping the shadows as you did when you grained. Remember that using the proper amount of pressure is paramount. For instance, use a little more pressure to darken the form shadows and a little less pressure for the reflected light shadows so they're proportionally lighter. I recommend using the graining and hatching techniques (with no stumping) for the halftones so you can control their subtle gradations.

By combining all of these techniques, you can achieve textural richness and variety. The shadows will melt together quietly and mysteriously, creating a nice contrast to the more vigorous grainings and hatchings that show the immediacy of the artist's hand.

SELECTING PAPER & USING IT TO YOUR ADVANTAGE

Historically, when students began copying drawings, they were required to start with white paper. This trained them to manage all the values from the darkest dark to the white of the paper. Once students mastered working on white paper, they would progress to colored or toned papers.

Working on toned paper allows you to use the value of the paper as part of your modeling and enables you to increase the value range in the drawing through the use of black and white chalk. To achieve the best possible results, let the paper show through wherever possible. (We will explore more in-depth techniques for working on toned paper in chapter 3.)

In the meantime, for practice, I chose to copy a drawing by Giovanni Battista Piazzetta, who was known for his exquisite drawings on toned paper.

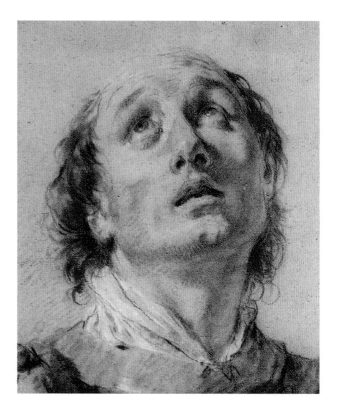

SAINT STEPHEN
Giovanni Battista Piazzetta
Black and white chalk on toned paper
17" × 14" (43cm × 36cm)

COPY AFTER *SAINT STEPHEN*
Jon deMartin, 2011
Nitram Académie Fusain HB charcoal and Cretacolor charcoal
lead on toned paper, 17" × 14" (43cm × 36cm)

The paper that worked best for this exercise was a toned middle-
to light-gray Strathmore 500. The paper's tooth is designed to
hold the charcoal when stumping. As in previous examples, I
began the drawing with the Nitram Académie Fusain HB, but I
finished with a harder charcoal. I used Cretacolor charcoal lead
(medium) and Cretacolor white chalk. General charcoal pencils
are also effective, since they are made with compressed charcoal,
which is handy if you don't have a chalk holder.

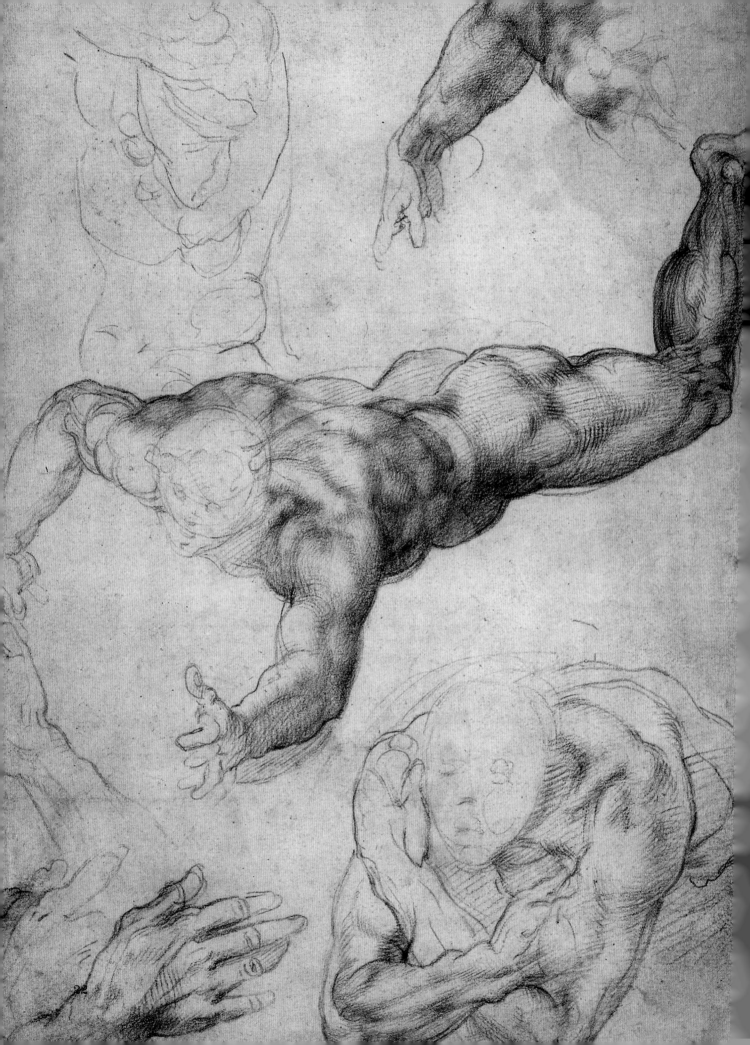

2
PERSPECTIVE, MODELING THE FORM & CONTOUR

A colleague of mine once asked his students, "What's the point of drawing the model if you can't draw the model stand in perspective?" One of the goals in figure drawing is to convincingly depict the figure as a three-dimensional object on a flat piece of paper. The best way to build up to this is to practice drawing basic geometric volumes in perspective and then shade them to create the illusion of three-dimensional forms.

Start simple and straightforward. As you build your skills, you can apply those same concepts to drawing the figure in three dimensions. With a solid understanding of freehand perspective, you'll be able to penetrate beyond the picture plane and draw a three-dimensional subject convincingly. It's no small chore, but it's definitely possible if you take it one step at a time.

In this chapter you will learn:
- how light affects both simple and complex forms
- how to use light and dark values to create the effect of three dimensions
- the way that outside shapes (optical boundaries) and inside shapes (base boundaries) are crucial in depicting complex forms
- the causes of surface form and how to relate the parts to the whole
- how to model a form with line as well as value.

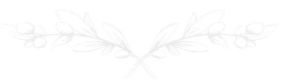

A FLYING ANGEL AND OTHER STUDIES
Michelangelo, ca. 1534–1536
Black chalk, 15" × 16" (41cm × 38cm)
Collection: The British Museum,
London, England

THE CUBE

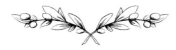

The quickest way to perceive perspective is to reduce forms to a cube or box. Drawing the cube will give you a good introduction to basic perspective and to one of the geometric building blocks of all objects—including the human figure.

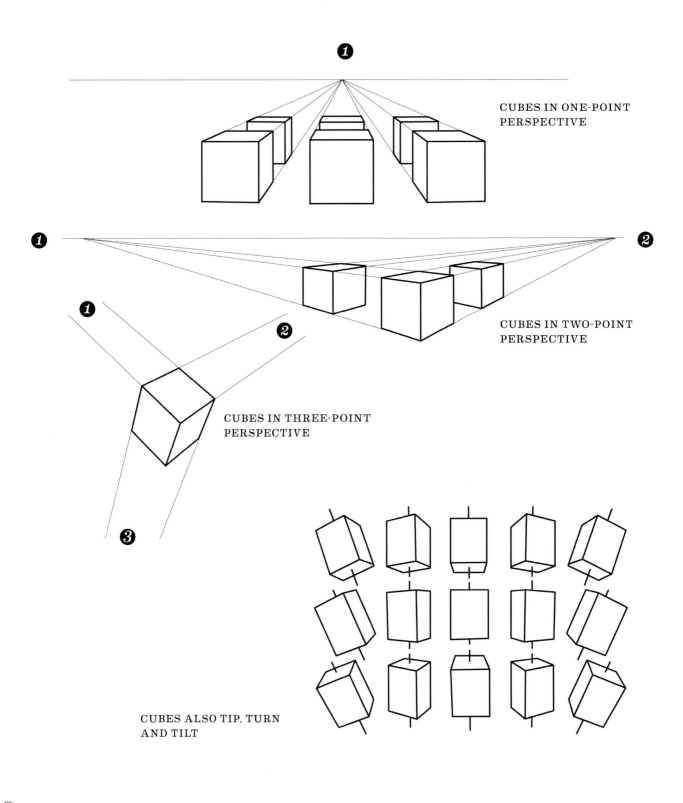

CUBES IN ONE-POINT PERSPECTIVE

CUBES IN TWO-POINT PERSPECTIVE

CUBES IN THREE-POINT PERSPECTIVE

CUBES ALSO TIP, TURN AND TILT

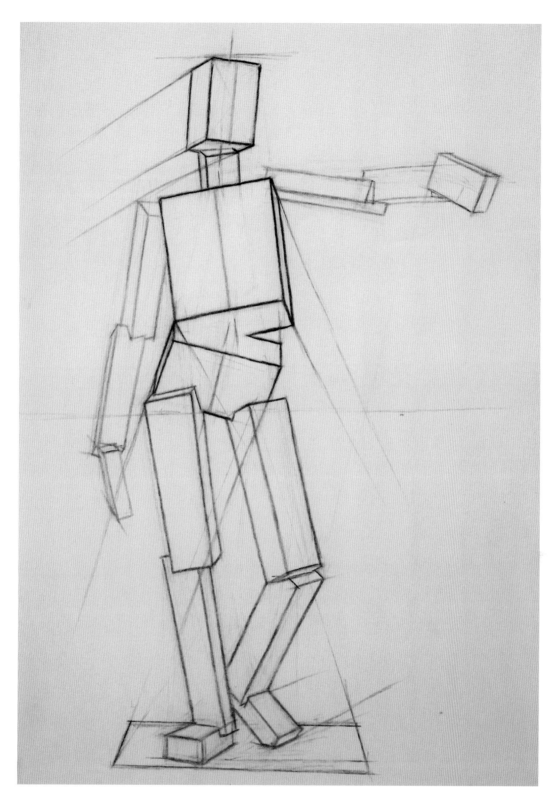

DRAWING AFTER SCULPTURE BY ELIOT GOLDFINGER
Jon deMartin, 2008
Black chalk on newsprint
24" × 18" (61cm × 46cm)

Visualizing the masses of the head, rib cage, pelvis and all parts of the
body as cubes will help you to understand their spatial orientations.
Notice how each box has its own vanishing point.

THE CYLINDER

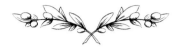

Halfway between the geometric forms of the cube and the sphere lies the cylinder. It is a common shape in the human body, and understanding how to depict it correctly will greatly ease and enhance the rendering of most natural objects.

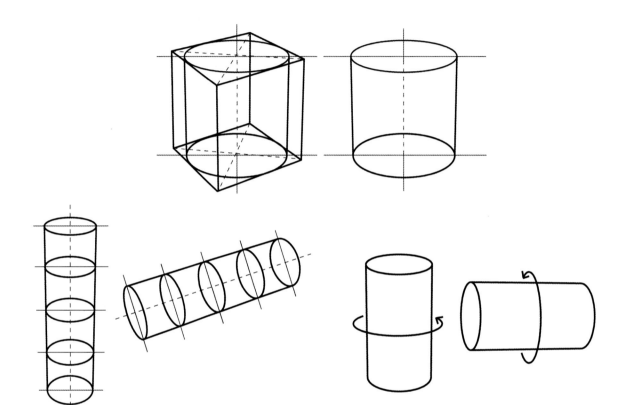

ORIENTATION MAY CHANGE, BUT CURVATURE REMAINS THE SAME

The top illustration shows a cylinder built out of a cube with its axis running through the middle. The illustration at the bottom left shows the geometric cylinder in a vertical and diagonal position. The cross-sections become narrower as they get closer to the eye. The illustration at the bottom right shows that no matter what orientation the cylinder takes, it remains a single curvature form.

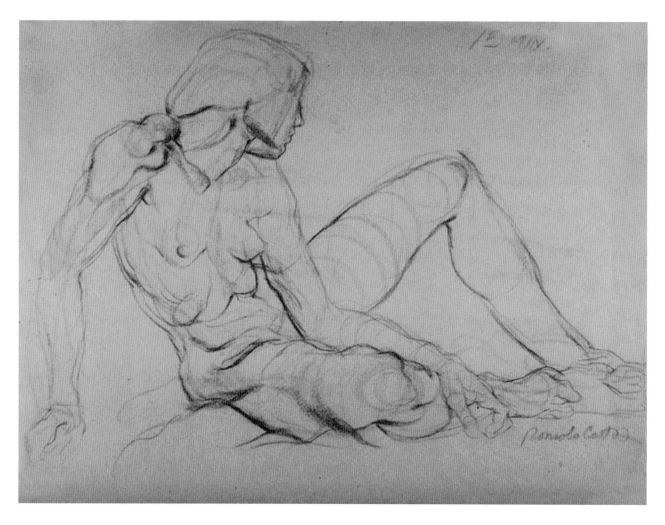

CONTOUR ILLUSTRATION
Romolo Costa, late 1970s
Burnt Sienna Nupastel on newsprint
18" × 24" (46cm × 61cm)

Conceptualizing the limbs as geometric cylinders is a helpful way
to understand the form's direction. When you apply the same
cross-sections as shown on the cylinders to the human figure,
you can immediately perceive the form's direction in three-
dimensional space.

THE SPHERE &
THE OVOID

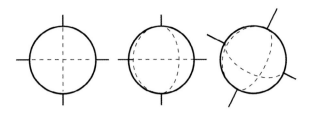

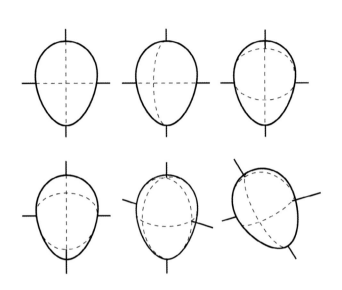

The surfaces of most objects found in nature are complex, irregular and so unpredictable that they can easily overwhelm you. However, once you understand the inherent characteristics of these geometric solids, you will be in a better position to perceive and draw natural forms effectively.

The sphere and ovoid are two geometric forms that represent curvature going in two different directions: up and down, and side to side. Spheres and ovoids underlie many natural forms, including subjects crucial for a figurative draftsperson, such as the human head.

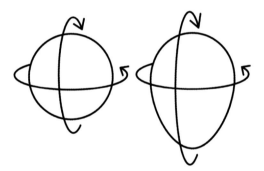

CENTERLINES HELP CREATE THE ILLUSION OF THREE DIMENSIONS

As with the sphere, vertical and horizontal centerlines on ovoids create the illusion of three-dimensionality when the ovoid is turned in different positions. Depicting the centerline on an ovoid is a device artists have used for centuries to create a three-dimensional illusion.

STUDIES OF HEADS AND HANDS
Hans Holbein the Younger
Pen and ink, 5" × 7" (13cm × 18cm)

Baseball players hit for hours in the batting cages, refining
their skills so that by game time, they're so finely tuned that
their reactions become almost automatic. Holbein drew these
studies in pen and ink from his imagination, and probably without
an underdrawing, which gives testimony to his remarkable
confidence and skill. Notice the way he used perspective
and geometric construction to capture the essence of three-
dimensional human form. This is the result of continued practice
throughout a lifetime, both from life and the imagination.
Your weaknesses will be exposed when you draw from your
imagination, and this will require you to go "back to the batting
cage" and work on your skills. But don't be discouraged! Like any
other skill, drawing is a lifetime process of practice and hard work,
but very rewarding if you practice good principles.

Geometric Solids in Line

In order to successfully depict light and shadow, you must first gain an understanding of curved surfaces and how to model them.

While the cylinder curves in one direction regardless of its orientation, the sphere is the breakout geometric solid that curves in two directions (double curvature). It is perfectly round, and no matter where you hold it in space, its shape never changes. Every part of a sphere is equally curved, and all points of its surface are equidistant from its center.

The ovoid is an irregular double-curved surface that comes closest to the organic form of the human head. You must develop the facility to draw these geometric solids in line from any view point as a preparation to modeling form with values.

Light and Shade Affect Value on a Sphere

Depicting light and shadow is essential to creating the illusion of three-dimensional space. Only a flat plane, such as the side of a cube, can be shaded an even value. Curving and rounding forms always produce the effect of graduated values.

It's useful to know why gradations appear the way they do. When looking at a curved form, the most visible gradations will be the shadow and the highlight. They are the most important to identify. Depending on the form's surface, the highlight may be more or less pronounced. For instance, the highlight on the glossy surface of a billiard ball will reflect more light than the highlight on the matte surface of a tennis ball.

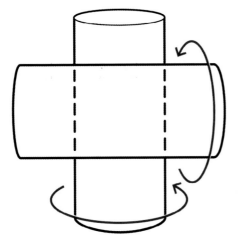

DOUBLE CURVATURE

Combining two cylinders—one on a horizontal axis and one on a vertical axis—creates double curvature.

CURVING, ROUNDED FORMS PRODUCE A GRADUATED-VALUE EFFECT

The two basic geometric solids that curve in two directions are the sphere and the ovoid. Curving, rounded forms always produce the effect of graduated values. The sphere is the most powerful example of this, so we'll use it throughout the book as a foundational example of modeling values on the surface of double-curved forms.

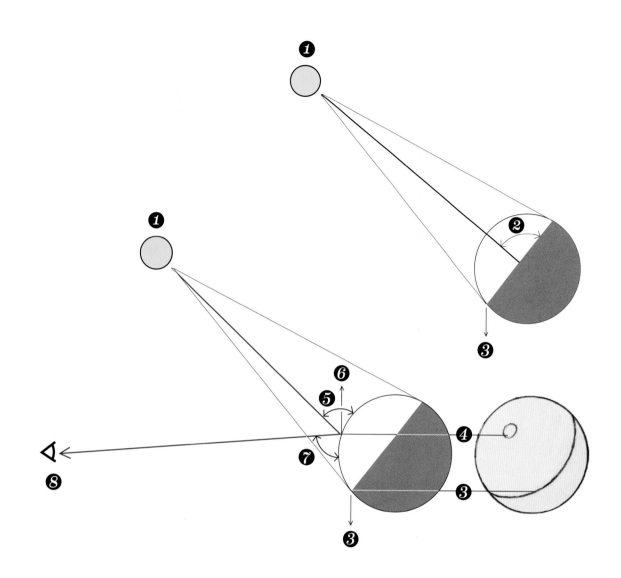

SHADOWS VS. HIGHLIGHTS

The top illustration shows that the dividing line between light and shade on a sphere is perpendicular to the direction of the light. The edge of the shadow indicates the exact point where the light ends (or where the light can no longer reach). All shadows are the result of something blocking the light.

In the bottom illustration, a highlight occurs at a spot on the object where the angle of the light (the incident light) is equal to the angle of reflectance. The highlight is the most direct path from the light source to the object, and from the object to the viewer's eye. It's the brightest of all the lights.

1. Light source
2. 90°
3. Edge of shadow (theoretical side view)
4. Highlight
5. Angle of incidence
6. Highlight
7. Angle of reflection
8. Viewer

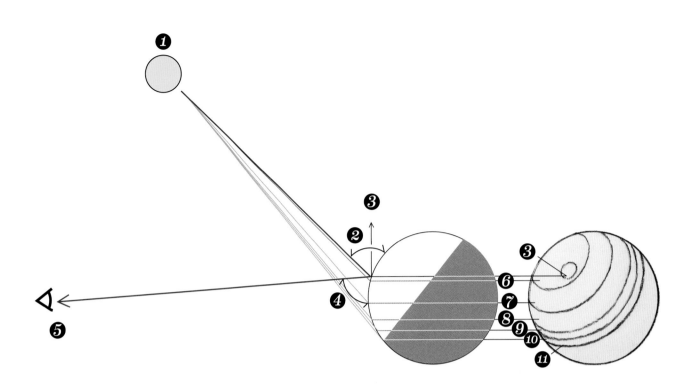

MODELING FACTORS

This illustration shows all the gradations necessary to give a
form its three-dimensional illusion. These gradations are called
modeling factors. Modeling factors are the planes that represent
themselves to the illumination at different angles. As a result,
they produce different values. Each of these facets is a plane
that has a name. If you shade each plane with the correct value
and in the correct sequence, the resulting shape will have a
three-dimensional form. If the gradations jump or skip, the
illusion of form is lost. This takes lots of practice, which is why it's
best to start with a simple sphere before you try tackling more
complicated objects.

In order from lightest to darkest, the modeling factors are the
highlight, the light light, the middle light, the dark light, the light
halftone, the dark halftone and the shadow. The side view of the
sphere shows the relationship between the sphere's surfaces, the
light source and the modeling factors. The right sphere shows the
same modeling factors but from the point of view of the viewer.

1. *Light source*
2. *Angle of incidence*
3. *Highlight*
4. *Angle of reflection*
5. *Viewer*
6. *Light light*
7. *Middle light*
8. *Dark light*
9. *Light halftone*
10. *Dark halftone*
11. *Edge of shadow*
 (theoretical side view)

Modeling Values on a Sphere

The surfaces that face the light (highlight, light light and middle light) reflect the light. The surfaces that turn away from the light (dark light, light halftone and dark halftone) deflect light. As a result, they darken. In order to model a form effectively, you must begin by placing the shadows first and then the halftones that surround them.

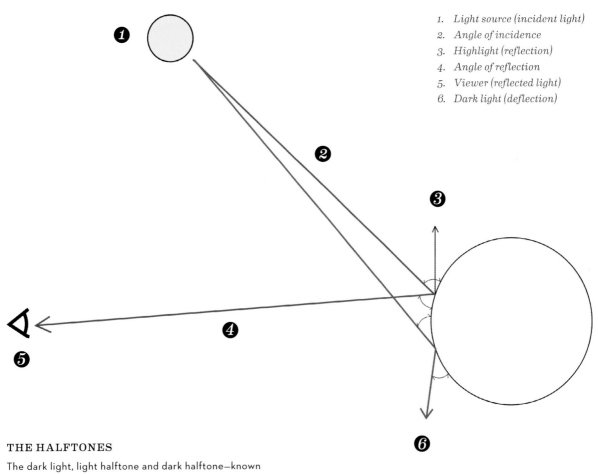

1. *Light source (incident light)*
2. *Angle of incidence*
3. *Highlight (reflection)*
4. *Angle of reflection*
5. *Viewer (reflected light)*
6. *Dark light (deflection)*

THE HALFTONES

The dark light, light halftone and dark halftone—known collectively as the halftones—are the most significant modeling factors for creating the illusion of round form in a drawing.

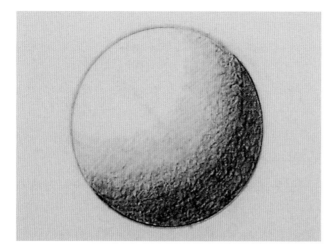

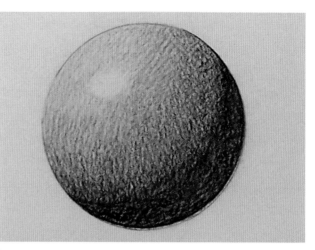

SPHERE MODELED WITH SHADOW AND HALFTONES

This sphere was modeled with just the shadow and halftones. As you can see, the illusion of form is quite apparent, even without the middle light, light light and highlight factors.

SPHERE MODELED WITH ALL MODELING FACTORS

Here the sphere has been modeled with all the modeling factors. The inclusion of all the gradations results in a fully realized illusion of form. The highlight is now apparent. (In this example, the highlight is the white of the paper.) When modeling any form, the shadow is the first value to indicate.

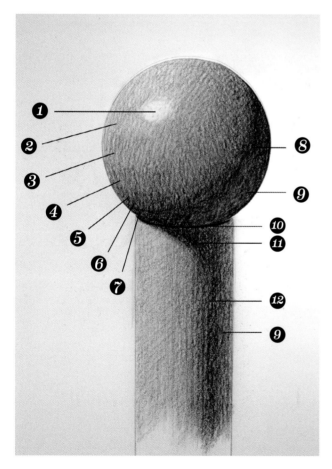

FORM AND CAST SHADOWS ARE AMONG THE MOST IMPORTANT TYPES OF SHADOWS

This sphere resting on top of a cylinder allows us to explore the full range of modeling factors found in the shadows.

- **Form shadows** are found on the form itself and begin at the exact point where the light ends.
- **Cast shadows** appear when a form blocks out light and projects a shadow onto another surface. (In this case, a cast shadow appears near the top of the cylinder where the sphere has blocked the light.) Cast shadows either show the shape of the form casting the shadow or reveal the shape of the surface the shadow is cast upon. Cast shadows are normally darker than form shadows.
- **Reflected-light shadows** are the result of light reflecting from surrounding surfaces into both form and cast shadows. (It's generally more apparent in form shadows than in cast shadows.)
- **Accents** are the absence of light. (Here the accent is seen on the rim of the cylinder touching the sphere.) These are the darkest of all the darks. They give richness to a drawing.

1. Highlight	7. Edge of shadow
2. Light light	8. Form shadow
3. Middle light	9. Reflected-light shadow
4. Dark light	10. Accent
5. Light halftone	11. Cast shadow
6. Dark halftone	12. Form shadow

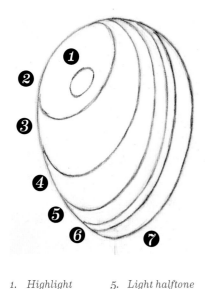

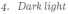

1. Highlight
2. Light light
3. Middle light
4. Dark light
5. Light halftone
6. Dark halftone
7. Shadow

Modeling Values on an Ovoid

The ovoid is a geometric solid that resembles an egg. It's similar to the sphere in that every part of the surface is curved, but unlike the sphere, its curves are not equal everywhere. The angle at which you hold an ovoid changes the shape that you see. It is longer in one direction than the other. The larger end is rounder than the smaller end.

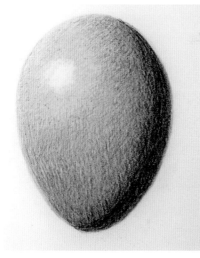

OVOID MODELING FACTORS

The ovoid is an irregular form, so shadows and modeling factors behave differently than on the sphere. However, if you know how light reacts on the sphere, you can take the same principles and apply them to the ovoid (or to any other form). Drawing the ovoid is the first step in drawing a naturalistic object. It's a useful shape because of its relationship to the human form, being similar to the head, rib cage and other parts of the body.

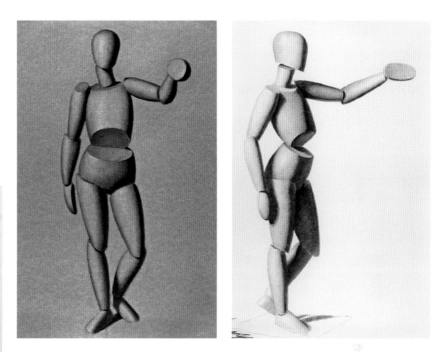

DRAWINGS AFTER SCULPTURE BY ELIOT GOLDFINGER
Jon deMartin, 2008, black chalk on white paper, and black and white chalk on toned paper, 24" × 18" (61cm × 46cm)

Here we have the front and side views of an ovoid figure. Every form has its brightest part. Whether wide, flat, deep, narrow, long or short, each surface still turns in two different directions.

The brightest parts of an ovoid (or a sphere) show a more concentrated amount of light than the brightest parts of a cylinder because a cylinder's surface runs straight along its axis, whereas the forms of spheres and ovoids are convex and gradate continually.

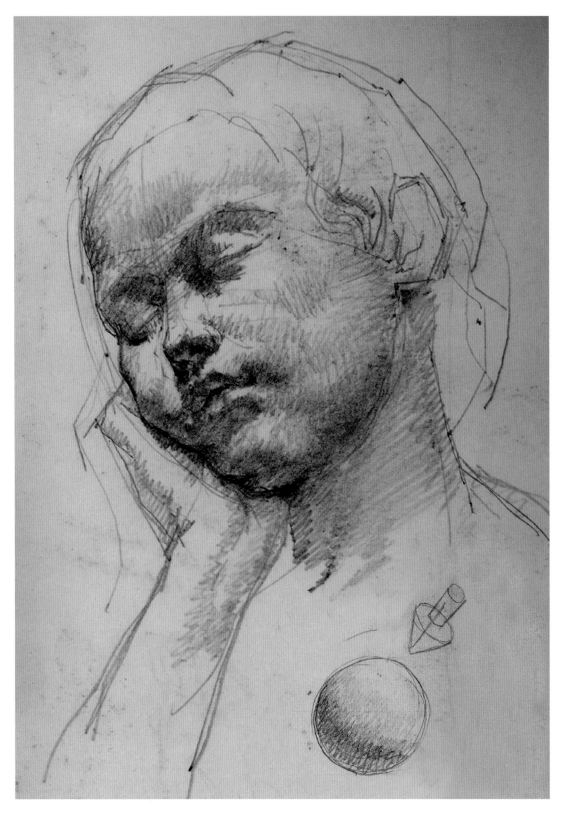

**DRAWING AFTER *SLEEPING BOY* BY
PHILIPPE LAURENT ROLAND**
Jon deMartin, 2012
Graphite, 9" × 7" (23cm × 18cm)

The head is a complex naturalistic subject with a shape that closely resembles
an ovoid. By reducing it to its most basic shape, the task of drawing it becomes
more manageable.

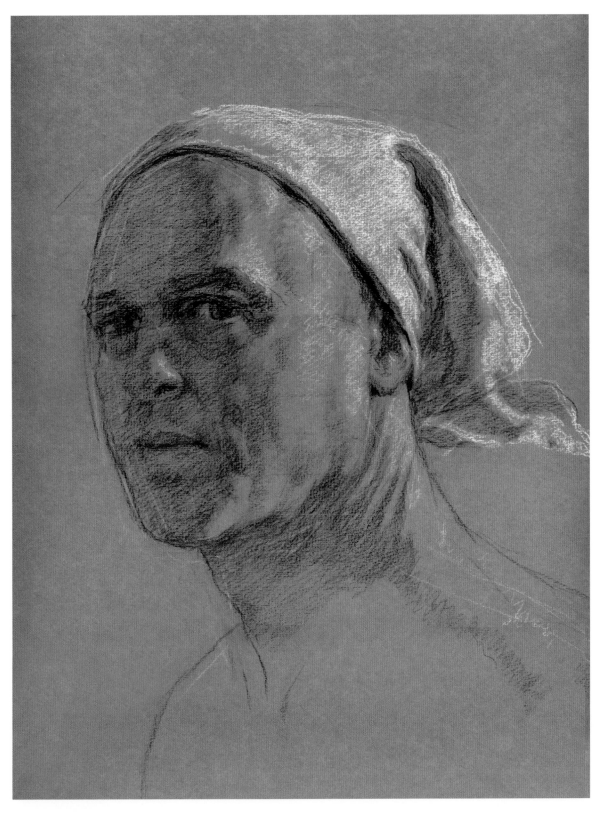

SELF-PORTRAIT
Jon deMartin, 2010
Black and white chalk on toned paper, 17" × 14" (43cm × 36cm)
Collection: The John Pence Gallery

Light falls on the head the same way as on the ovoid—it has a shadow, a highlight
and all the modeling factors in between.

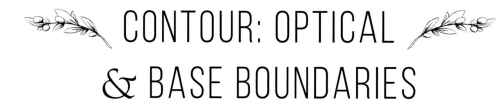

CONTOUR: OPTICAL & BASE BOUNDARIES

Contour is one of the most important elements of any drawing. When drawn well, contour adds striking three-dimensionality and verisimilitude to all manner of forms and figures. A contour is, in essence, a figure's outside edge—its silhouette, or optical boundary. It is the last part of the form the eye can see. Contours often include overlapping lines that indicate one form in front of another, suggesting three-dimensional depth.

Let's break down how to draw contours, analyze what makes them flow rhythmically and gracefully, and explore why it's important to know as much about the inside shapes of a subject as its outside shape in order to draw it with beauty and accuracy.

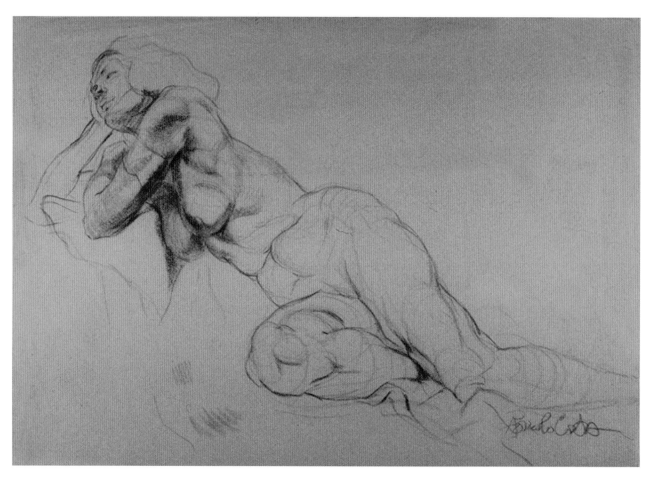

CONTOUR ILLUSTRATION
Romolo Costa, late 1970s
Nupastel on newsprint, 18" × 24" (46cm × 61cm)

The contour, also called the outer shape, is key to drawing any figure realistically. It is created by the numerous curves that exist within natural forms.

Describing Form Through Overlapping Lines

Some contours imply the existence of realistic, three-dimensional forms, whereas others only seem to indicate flat shapes. It's important to understand why this is, so you can use the proper tools to make your drawings feel fully three-dimensional.

OUTSIDE SHAPE

Here we see the outside shape of a geometric form that resembles a snowman. But this illustration does not tell us everything we need to know about the shape of the subject.

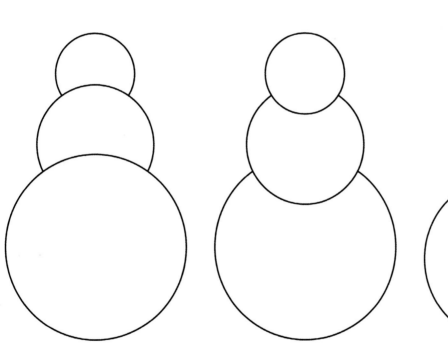

VIEWS FROM BELOW, ABOVE AND THE SIDE

These examples reveal a three-dimensional shape as seen from below, from above and from the side. These views are not just contours—they also include lines within the form. Notice how overlapping lines help explain the spatial relationship of the different parts with the additional lines creating a powerful three-dimensional illusion.

However, does this form necessarily have the shape of a snowman? It may simply be different-sized balls stacked on top of one another, or a string of different-sized beads that touch tangentially at only one point, as in the side-view illustration. In other words, it may not be a snowman at all. The information communicated through the overlapping lines in the first example is not enough for us to fully understand this form.

Base Boundaries

A snowman is usually the result of three mounds of snow packed on top of each other, like three scoops of ice cream that have begun to melt together. It's crucial to understand and identify where and why such "melting" occurs. Critical to this concept is an understanding of the base boundary—an imaginary enclosed line (shape) that describes where a form originates.

TOP LEFT

1. *Intersections*
2. *Overlapping forms*
3. *Base boundary*

BOTTOM LEFT

1. *Base point*
2. *Base boundary*
3. *Equal curve*
4. *Point of amplitude*
5. *Center*
6. *Plane curve*

BASE BOUNDARIES

This illustration shows the same shape as on the previous page, but it also includes the important intersections of the snowman's main forms (indicated with a dashed line). These intersections are the form's base boundaries. When looking at the snowman from above, as shown in the second example, you see a slight overlapping of forms. This is the result of one form partially blocking our view of the other. Notice that the overlaps stop where they hit the base boundary.

BASE POINTS AND PLANE CURVES

When you train your eyes to detect base boundaries, you become able to appreciate and draw the true character of a form's shape. The top illustration shows a straight-on view of the cut edge of a sphere resting on a flat plane. As with the snowman, the base boundary exists where the edge of the sphere touches the flat surface beneath. The base points, which make up the base boundary, are where one form intersects another.

The bottom illustration shows a view from above, which gives a better appreciation of the sphere's shape. In this case, the base boundary—shown as a dashed line that runs around the sphere—is perfectly flat. All of the base points of the sphere are on the same plane. This is called a plane curve.

Irregular Curves and Curved Surfaces

To learn how to draw a strong contour, you must first look at the several types of lines and curves that make up the overall contour of a figure. For example, the illustration on the previous page shows a perfectly symmetrical curve. Its peak point, called the point of amplitude, is in the exact center; it has equal rates of curvature on both sides. Such a perfect curve rarely exists in nature, especially on the human figure.

Indeed, much of the human figure's beauty lies in the variety of curved forms that flow over every part of the body.

The illustration below shows examples of an asymmetrical curve. This curve has a slow rate of curvature on the left and a fast rate of curvature on the right. The point of amplitude is to the right of the center. On a larger form, such as the human figure, varying rates of curvature make the figure's contour more visually appealing.

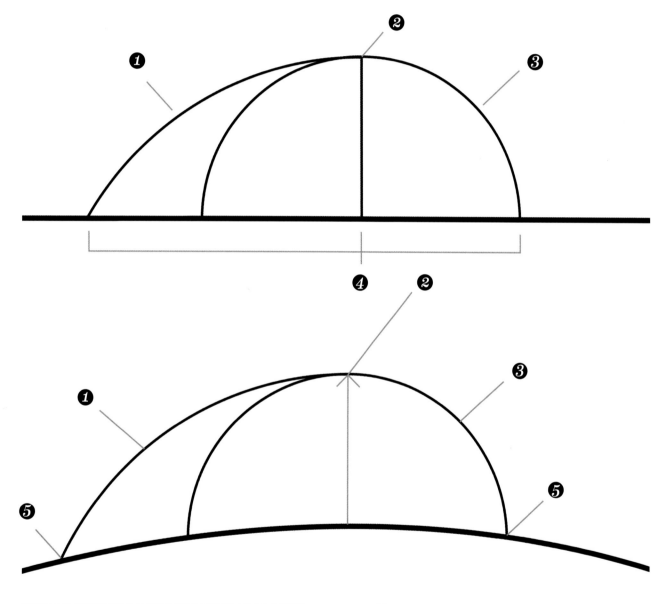

HUMAN CURVES DO NOT SIT ON FLAT PLANES

Forms on the human figure do not sit on flat planes, as the curve in the top illustration does. Instead, the human figure consists of irregular curves that sit on larger, irregular curved surfaces, as shown in the bottom illustration.

1. *Slow curve*
2. *Point of amplitude*
3. *Fast curve*
4. *Right of center*
5. *Base point*

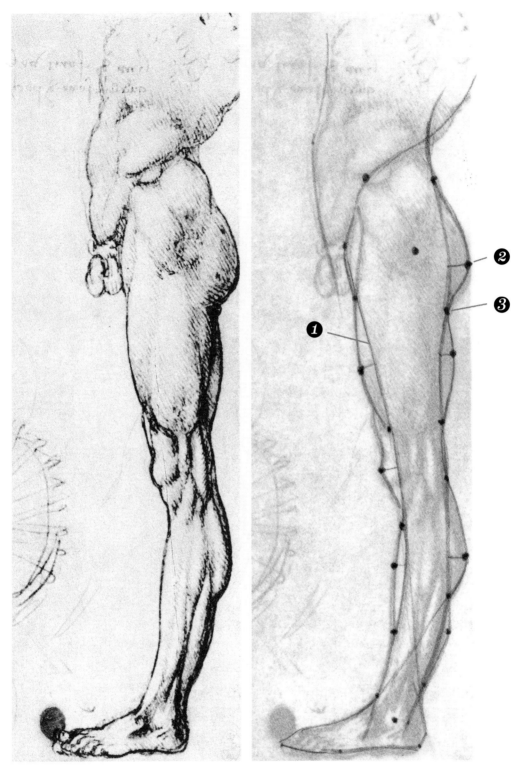

IRREGULAR CURVES AND THE HUMAN FORM

Leonardo da Vinci's drawing of a human leg shows an example of the irregular curves of the human figure. It wonderfully demonstrates the variety of all the leg's curves, with their various points of amplitude and rates of curvature. Notice how the curved lines of the forms glide along the larger graceful curve underneath, which in essence is the leg's outside line of action.

1. *Action*
2. *Point of amplitude*
3. *Base point*

S-curves: The Key to Flowing, Rhythmic Contours

Now that you know the forms on the human figure are irregular and always relate to a larger curvilinear structure underneath, how do you knit all these forms together? To help with this complex task, an important place to focus is the spot where a curve along a figure's contour meets its larger underlying curve (or action). This is known as an S-curve.

S-curves give the contours of the human body and many other forms a graceful, rhythmic flow. Without them, a figure's contour would look hard, angular and unnatural. In *The Analysis of Beauty,* eighteenth-century artist William Hogarth describes "how imperceptibly the different curvatures run into each other, and how easily the eye glides along the varied wavings of its sweep." Old Masters were keenly aware of this principle and even gave their contours a little more variety and flow than the forms actually had.

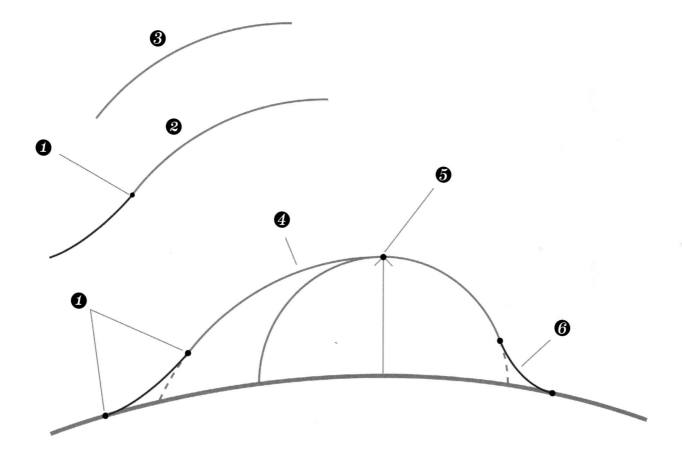

C-CURVES AND S-CURVES

Smaller concave curves will intersect with larger convex curves. A single section of one of these curves is called a C-curve. When you combine a larger convex curve with a smaller concave curve, the result is an S-curve.

The bottom illustration shows how S-curves function in the context of one curve landing on another larger curve. The two smaller curves that gracefully land on the bigger curve are shown in red. Together, with the convex curve rising above the surface, they form graceful S-curves on both sides to unite the forms.

1. *Point of inflection*
2. *S-curve*
3. *C-curve*
4. *Convex curve*
5. *Point of amplitude*
6. *Concave curve*

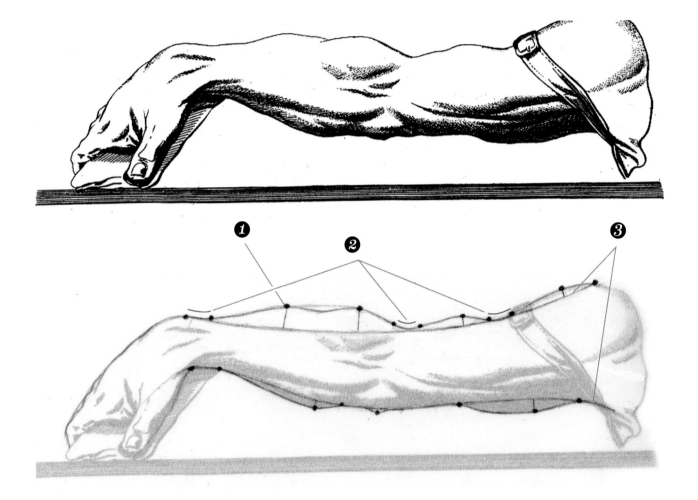

ENGRAVING OF A PLASTER CAST OF AN ARM FROM PUGET'S SCULPTURE *MILO OF CROTON*

From the *Diderot Encyclopédie*, ca. 1762–1777

1. *Point of amplitude*
2. *Concave curves*
3. *Lines of action*

The Encyclopédie of the 18th Century, edited by Denis Diderot, contains an engraving of a plaster cast of an arm from Pierre Puget's sculpture *Milo of Croton*. Notice how the graceful, undulating forms adhere to the arm's main sweeping action and how the subtle concavities (marked with lines) gracefully flow into the larger convexities.

Also, note the variety of the irregular curves; no two convexities and no two concavities are the same. This variety gives beauty and "spice" to the arm's form.

Underlying Forms: The Basis of a Contour

In order to draw confident contours, it is necessary to understand how the origins of the forms—the base boundaries—profoundly impact the appearance of the outside shape. To help with this, we can analyze what happens to base boundaries when double-curved forms intersect single-curved surfaces.

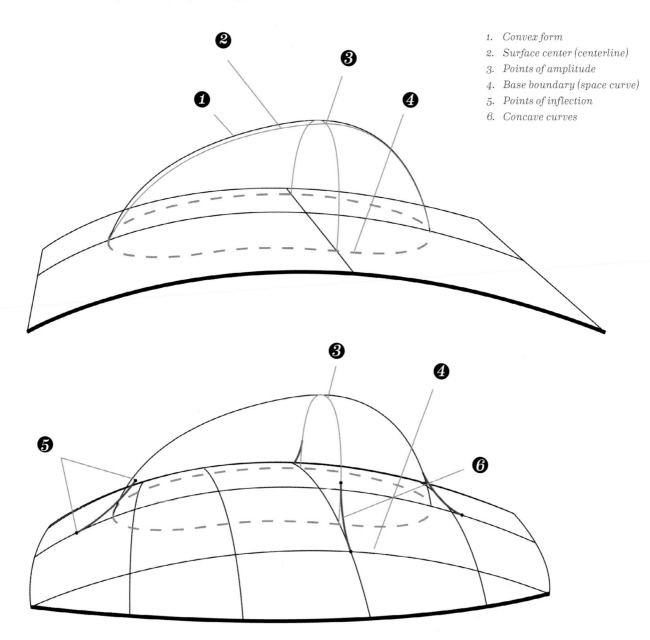

1. Convex form
2. Surface center (centerline)
3. Points of amplitude
4. Base boundary (space curve)
5. Points of inflection
6. Concave curves

FORMS ON SINGLE- AND DOUBLE-CURVED SURFACES

In both views, the form rests on a curved surface. One is single-curved, the other is double-curved. The dashed line running around the forms indicates that the base boundaries no longer lay flat, but bend in space. All the base points no longer rest on the same plane. Instead, they continually move through space. This type of curve is called a space curve.

In nature, and especially on the human figure, forms never sit on a single-curved surface. They are oriented three-dimensionally on double-curved surfaces, as in the bottom illustration. Think about how the form of the female breast sits on top of the larger mass of the rib cage, or how the deltoid lies on the upper cylindrical mass of the arm. In all cases, small concavities (marked with red lines) exist to make the form flow gracefully.

Evolution of a Contour

The contour should never be a flat concept. It is a curve in space that undulates three-dimensionally as the muscles of the body wind and spiral, forward and backward, creating the rhythms of living form. I generally regard the contour as the final product of a series of underlying line developments.

Think of the contour as having three phases. The first phase is the most important—it is the line of action which captures the overall gesture and movement of the figure. The second phase is the addition of the forms, which undulate along the action. The third phase is the final contour, which expresses the spatial relationships of contiguous forms through the overlapping of lines.

You can also use the contour line to indicate the direction of the light by varying the line's density and thickness. It should be lighter and thinner as it rolls toward the light, and darker and thicker as it moves away from the light. In effect, the contour can give the illusion of volume without adding a single tone of value. (In Carlo Cignani's drawing on the next page, the contour outlining the figure is an excellent example of this.)

When you become more confident in your line drawing, these stages will become intuitive and automatic. You don't always have to show your process, and if you're confident, you can go directly for the contour. Skill is the accumulation of practice, as long as you practice in the right way.

STANDING FEMALE NUDE
Jon deMartin, 1990
Pastel on newsprint, 24" × 18" (61cm × 46cm)

I used very light lines to estimate the figure's larger rhythms and actions. Whether the action is on the inside or outside, it must be found before the addition of smaller forms. When I felt the action was correct, I began to look for the variations of the undulating curves, placing them in relation to the main action. I then articulated the form further with the final line, or contour. It's important to note here that your curve will never degenerate into flimsy, weak contours if you relate it to the larger action underneath. As you'll see in the chapters ahead, the action lines originate from key skeletal landmarks.

Base Boundaries and Anatomy

In his 1740 treatise titled *Méthode Pour Apprendre Le Dessein*, Charles-Antoine Jombert wrote, "Anatomy is used not to show every muscle one doesn't see but only to help the artist place the parts more correctly." This succinctly sums up the role anatomy should play when drawing from life. The purpose of anatomy is to assist the artist in getting the base boundaries the right size, shape and proportion for the modeling of surface forms. Anatomist Robert Beverly Hale noted, "In order to draw a specific form, you must be aware that the form exists." In other words, if you aren't aware of the shapes of the forms inside the figure, then the contour will be nothing more than a silhouette against a background.

Every figurative artist should develop a good working knowledge of the figure's main base boundaries and try to commit them to memory. The same base boundaries are found on every human being, but their shapes are unique to each individual. The more you can put a line around a form, either mentally or physically, the more sensitive you'll be to the uniqueness of each individual's shape.

Base boundaries should be drawn with almost imperceptible lightness to help you locate the interior forms' shapes. In Michelangelo's *A Flying Angel and Other Studies* (shown at the introduction of this chapter), you can see how he lightly grasped the interior form's shapes. The fascinating study shows what was underneath his more finished studies that were modeled with values. Each base boundary fits together like a beautiful mosaic, illustrating the importance of knowing the parts in relationship to the whole.

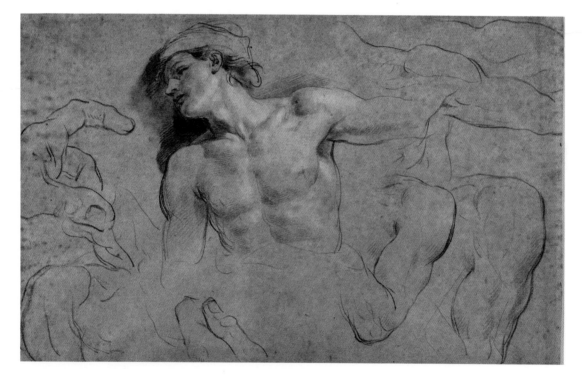

STUDIES OF A MALE TORSO WITH ADDITIONAL HAND, LEG AND SHOULDERS
Carlo Cignani
Black chalk with white heightening on
antique laid paper, 10" × 16" (25cm × 41cm)
Collection: Detroit Institute of Arts, Detroit, Michigan

In this drawing by Italian artist Carlo Cignani, pay attention to the peripheral linear studies that surround the modeled torso in the center of the sheet. These lines powerfully define form independent of light and shade. As a result, the eventual modeling of the drawing in the center is stronger than if he had merely copied values tonally. You can also see the artist's clear conception of the space curve on the deltoid's base boundary in the upper right corner.

STRIVING

Jon deMartin, 1990
Black and white chalk on toned paper
20" × 17" (51cm × 43cm)

3
DRAWING ON WHITE & TONED PAPER

Drawing on white paper is something everyone has done at one time or another. A child who makes his or her first drawings will likely use a piece of white paper. White paper presents a pure and pleasing contrast to whatever medium you choose to use. Ingres, for one, was famous for his sensitive line drawings on white paper, many of which are considered masterworks in their own right—even those that were created as preparatory sketches.

Yet for every artist who has mastered the art of contrasting white paper with dark line and tone, another has been transfixed by the challenge of drawing on toned paper—a practice that offers opportunities for incredible beauty and complexity. Drawings on toned paper make up much of the canon of Western art, from the Renaissance to today.

In this chapter, you will learn:
- the process of drawing on white and toned papers
- basic principles about how to match your drawing and shading methods to the tone of your paper
- how to navigate the challenges presented by different surface tones when modeling (shading).

WHITE PAPER

A Full Value Scale

For beginners, it's advisable to learn to draw on white paper and to practice using a full range of values from dark darks to the white of the paper. This educational practice goes back centuries, and most classical drawing ateliers require artists to start our this way. If you can ably draw with a full value scale, then modeling on toned paper—which requires a more limited value scale—will be that much easier. Once you have mastered drawing with a full value scale, you'll be well positioned to use toned paper for specific artistic purposes.

Let's begin by analyzing a full value range on white paper.

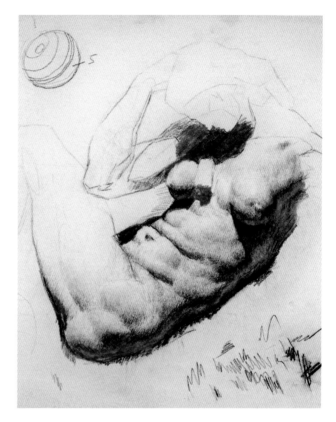

STUDY AFTER MICHELANGELO'S *NIGHT*
Jon deMartin, 2006
Black chalk on white paper, 24" × 18" (61cm × 46cm)

In my study of Michelangelo's drawing, I used the entire value range from the shadows up to the white of the paper.

Below we have a value scale chopped up into nine units, ranging from black (value 1) to the white of the paper (value 9). The black represents the darkest a given medium (in this case, compressed charcoal) can go. The value gradations then lead up to the white of the paper through various shades of gray.

The sphere demonstrates how these values can be applied to a three-dimensional form. As the planes of a form turn away from a light source, they receive decreasing amounts of light and appear darker. Notice that the highlight on the sphere is the white of the paper, and that this is the smallest area of all the modeling factors.

1. *Highlight*
2. *Light light*
3. *Middle light*
4. *Dark light*
5. *Halftone*
6. *Edge of shadow*

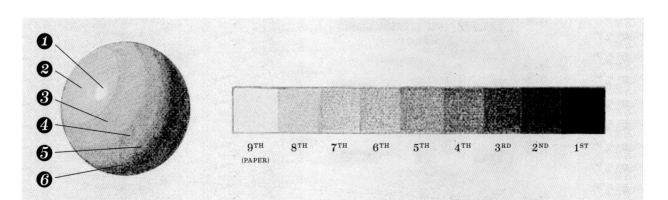

An Abbreviated Value Scale

There are many ways you can choose to represent form if you understand the implications of how planes respond to a light source. You can achieve an illusion of three-dimensional form using only a couple of modeling factors—the dark lights and the halftones. The practiced artist knows this principle well and, as a result, consciously omits the values that aren't crucial to the illusion of three-dimensional form. You might say artists take a shortcut in their modeling of form. This type of abbreviated modeling is called "stopped modeling," because the artist stops modeling values lighter than the dark light.

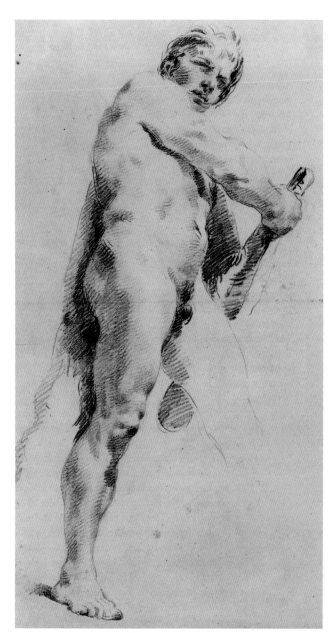

HERCULES STANDING
Giovanni Battista Tiepolo
Black chalk on white paper, 24" × 18" (61cm × 46cm)
Collection: The Morgan Library & Museum, New York, New York

Tiepolo's drawing shows that a drawing can look effectively modeled in the round using only halftones and shadows. He knew precisely which values to include and which to leave out. The dark light, halftone and shadow carry the illusion of form and invite the viewer's imagination to fill in the rest. Because of their economy of effort, drawings such as these can have enormous graphic impact.

In the value scale below, the middle light, light light, and highlight from the full value scale (values 7, 8 and 9) are not differentiated. They are burned out and have been replaced by the value of the paper. The lightest values are also burned out in the sphere. However, the dark lights, the halftones and the shadows are still present (values 1–6). This is enough for the sphere to look three-dimensional.

1. *Dark light*
2. *Halftone*
3. *Shadow*

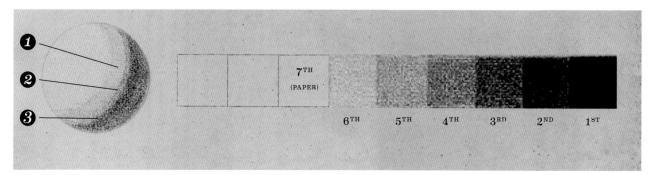

RED CHALK ON WHITE & TONED PAPER

The medium that most naturally lends itself to stopped modeling is red chalk, or sanguine, especially when it is used on white paper. Sanguine doesn't have the capacity to go as dark as black chalk, but it always maintains a pleasant contrast against white paper, as in the red chalk drawing by Michelangelo on the next page.

If you choose to use toned paper with red chalk, the paper's tone should be on the lighter side of the value scale. If the paper is too dark, the contrast will suffer.

MALE NUDE FIGURE STUDY
Corrado Giaquinto
Red and white chalk on light beige paper, 22" × 16" (56cm × 41cm)
Collection: Real Academia de Bellas Artes de San Carlos,
Valencia, Spain

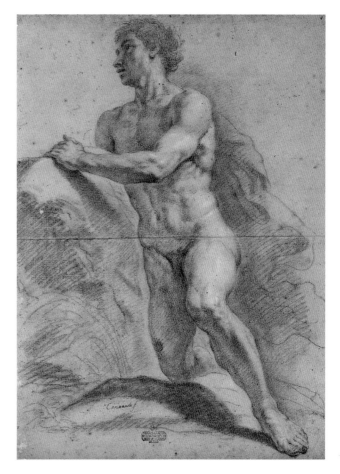

Luminous shadows are common in Old Master drawings, especially sanguine drawings. The limited value range of sanguine means that you must draw shadows lighter than in nature to achieve a pleasing contrast to darker values. This creates richness and variety and has the effect of adding color to the piece.

When working on toned paper, you can add white chalk and still maintain the contrast of sanguine against the paper, as shown in this value scale below.

1. *Highlight*
2. *Light light*
3. *Middle light (paper)*
4. *Dark light*
5. *Halftone*
6. *Edge of shadow*

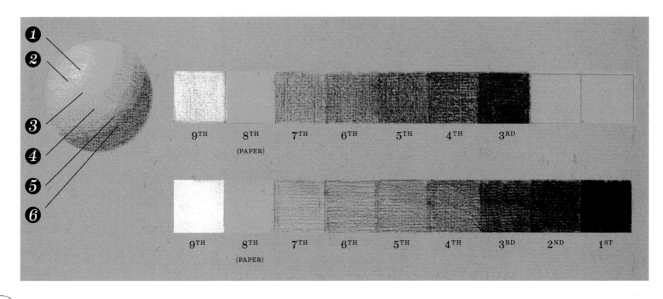

HEAD IN PROFILE

Michelangelo, ca. 1533–1534
Red chalk on white paper, 8" × 7" (20cm × 18cm)
Collection: Ashmolean Museum, Oxford, England

Generally, a cream or buff-colored paper serves as a nice complement to sanguine and white chalk.

MODELING ON TONED PAPER

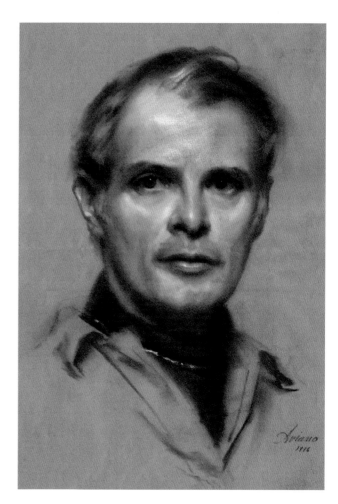

At the 7th Value

The value scale below shows the same nine units, but the tone of the paper comes through at value 7—the middle light. Here with the addition of white chalk, you can expand your value range. Rather than being stop modeled, this scale contains all values, including the middle light (the paper) and values 8 and 9—the light light and the highlight. These latter two values are achieved with white chalk applied at different intensities.

The effect of using a system of values on toned paper is beautiful; it also requires less labor than working on white paper. The Italian Baroque artist Carlo Maratta, for instance, could accelerate his modeling by working on toned paper, allowing the paper to show through as the middle light. (See his drawing on the next page.) If he were working on white paper, this value would have had to be shaded.

1. *Highlight*
2. *Light light*
3. *Middle light (paper)*

4. *Dark light*
5. *Halftone*
6. *Edge of shadow*

SELF-PORTRAIT
Michael Aviano, 1976
Sepia and white chalk on light beige paper
22" × 16" (56cm × 41cm)

This self-portrait by Michael Aviano reveals a very similar value range, with the paper serving as the middle light. Aviano employed white chalk for his light lights and highlights, which occur on the top planes where the light source most directly hits the figure. He used a denser application of sepia chalk for his dark shirt. Such local changes can give a beautiful enrichment to a drawing. The sphere in the illustration below shows this principle in its three-dimensional form.

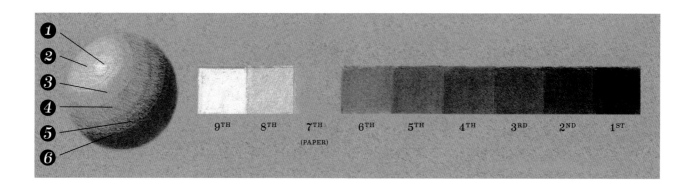

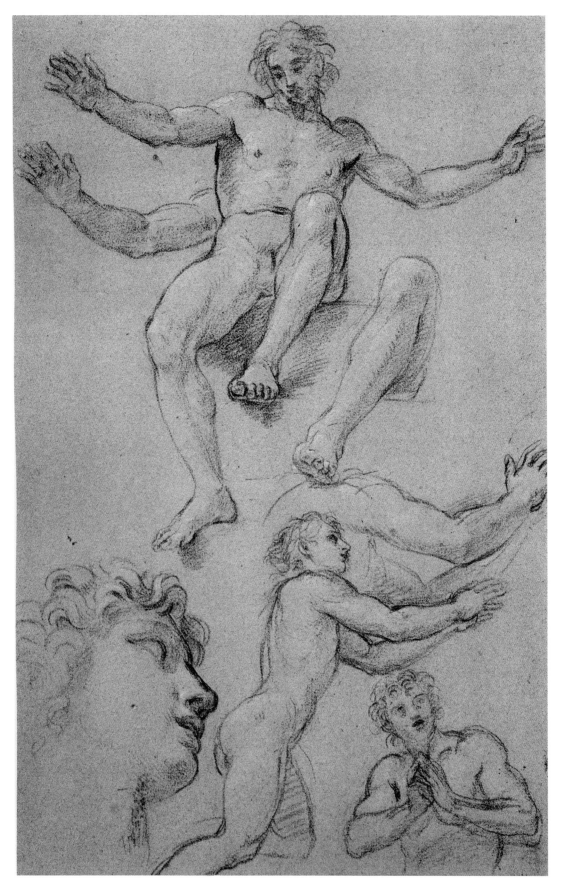

STUDIES OF NUDE FIGURES

Carlo Maratta
Red and white chalk on blue paper
16" × 10" (41cm × 25cm)

At the 5th Value

Artists today have a wide assortment of color papers
at their disposal. If you want to create an atmosphere
or setting, the paper can be an important ally.
The darker the tone of the paper, the more it can
influence the background of a drawing.

COMPETITION FOR THE PRIZE FOR THE STUDY OF HEADS AND EXPRESSION

Charles-Nicolas Cochin, 1761
Black and white chalk on toned paper, 9" × 16" (23cm × 41cm)
Collection: The Louvre, Paris, France

Many darker papers come through at the 5th value. As a result,
more white chalk is needed to expand the value scale to include
the 6th, 7th, 8th and 9th values. If the setting of a scene is dark,
then the paper can serve as the general background value.

In his drawing, Charles-Nicolas Cochin skillfully uses the paper
to establish a low-lit interior with figures and to balance his use of
black and white chalk.

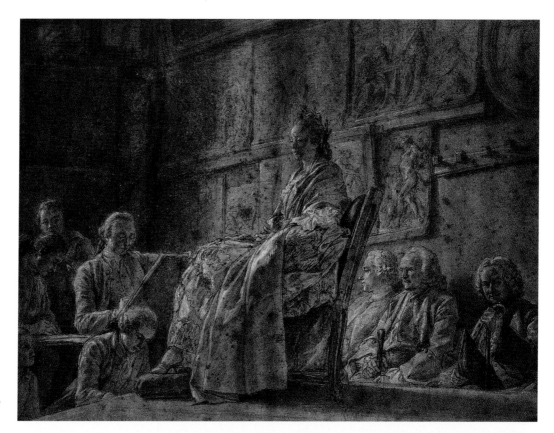

1. *Highlight*
2. *Light light*
3. *Middle light*
4. *Dark light*
5. *Light halftone
 (paper)*
6. *Edge of shadow*

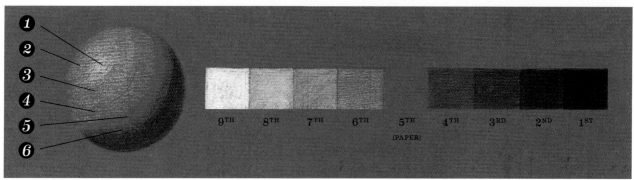

1 2 3 4 5 6

9TH 8TH 7TH 6TH 5TH 4TH 3RD 2ND 1ST
 (PAPER)

At the 3rd Value

Drawing on dark paper can be just as laborious as working on white paper with black chalk, but the effects it makes possible can be worth the effort.

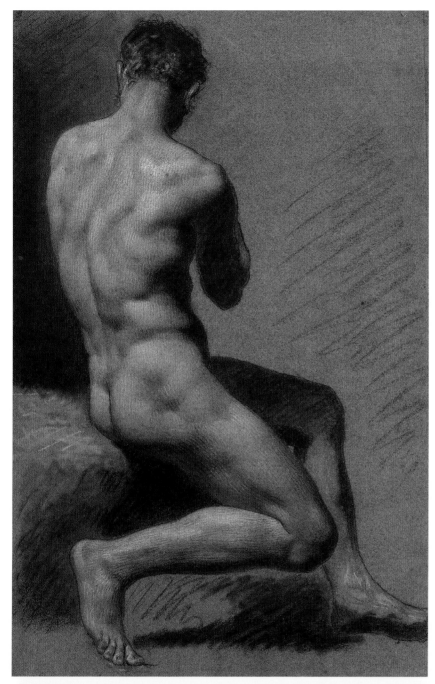

ACADÉMIE OF A SEATED MAN, SEEN FROM BEHIND

Pierre-Paul Prud'hon
Black chalk heightened with white
on blue paper, 17" × 11" (43cm × 28cm)
Collection: Musée Bonnat, Bayonne, France

In this drawing, Pierre-Paul Prud'hon expanded his use of white chalk far down the value scale. His objective was to create a presentation piece rather than a study. The consideration of time was less important, allowing for a more refined modeling with white chalk.

In some cases, the tone of paper can be even darker. The value scale below shows a paper whose tone falls at value 3. On such paper, white chalk is needed to produce values 4 through 9.

1. Highlight
2. Light light
3. Middle light
4. Dark light
5. Dark halftone (paper)
6. Edge of shadow

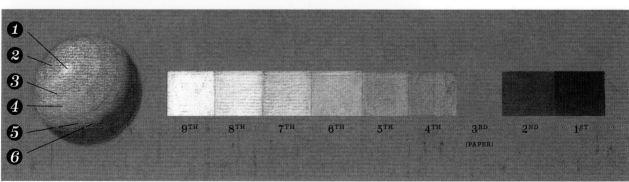

 # SELECTING YOUR MEDIUM

Historically, chalks and charcoal have been the preferred media for use on toned paper because they are more brittle than graphite pencils. The toned paper best suited for these mediums is laid paper—a material made on a screen of wires, which leave the impression of closely spaced grid lines on the surface of the paper. These lines pick up the drawing medium and produce a subtle texture.

Enjoy your experiments with toned papers—you will be walking an artistic path taken by many masters. Your drawing will improve. The more you learn about what your materials can do, the more creative freedom you will enjoy.

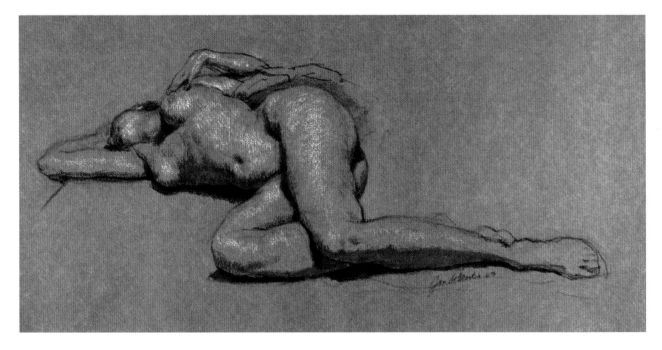

HELEN RECLINING
Jon deMartin, 2009
Black and white chalk on
toned paper, 9" × 18" (23cm × 46cm)

 ### *The Benefits of Working on Toned Paper*

Working on toned paper allows some artists to be more productive and gives models less time to tire. Many artists in the past preferred to work on toned paper, usually of a gray or bluish color. This was not only an aesthetic decision—it was also a practical one brought about by the heavy workloads that most artists faced.

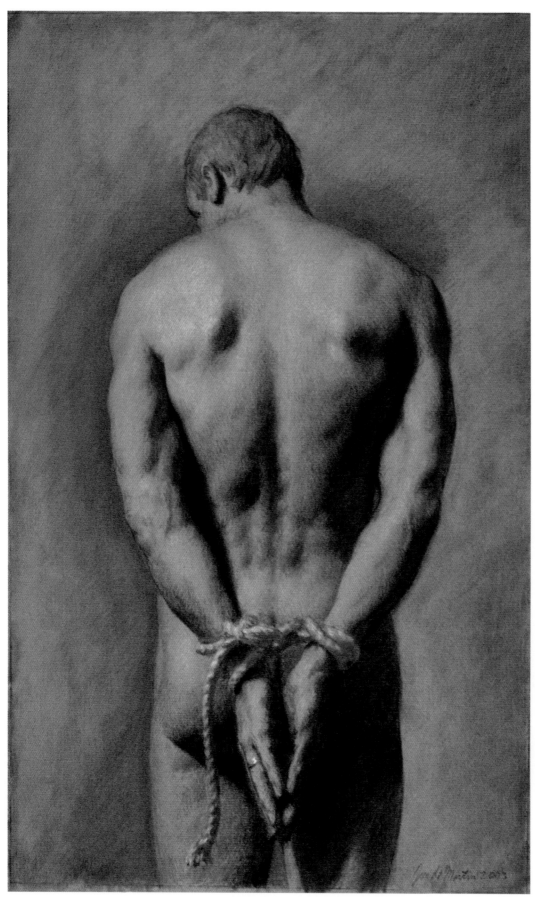

STUDY FOR
BOUND

Jon deMartin, 2004,
Black and white chalk
on toned paper
18" × 12" (46cm × 30cm)

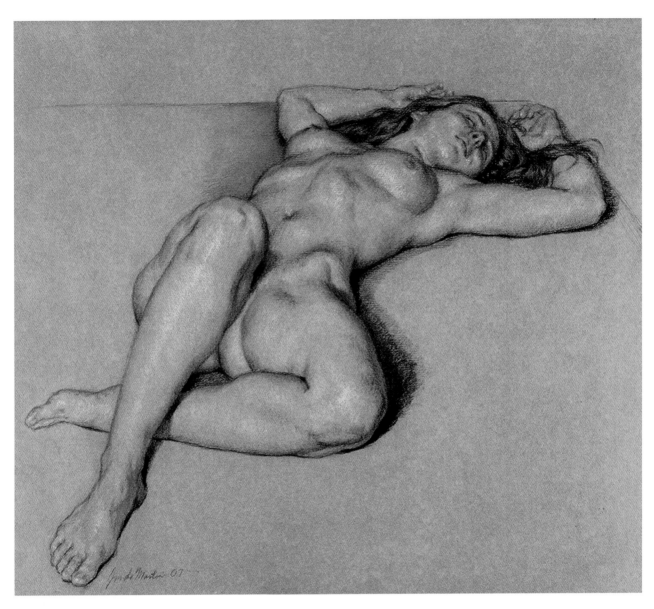

JULIE RECLINING
Jon deMartin, 2007
Black and white chalk on toned paper
16" × 20" (41cm × 51cm)

4

MODELING THE FIGURE

It is customary to begin drawing the figure in simple poses before attempting more difficult, foreshortened ones. By starting with simple poses, you will learn the key structural landmarks of the body that are needed to draw accurate figures. Studying anatomy books is a good way to become familiar with these important body landmarks.

Foreshortened poses can be challenging because they hide important skeletal landmarks. (This is why anatomy books present the figure in clear, standing views that show all sides.) Applying some rules of perspective and geometry will help you negotiate the tipping, turning and tilting of the masses of the figure, such as the head, rib cage and pelvis.

You'll discover how exciting your drawing can become once you understand these dynamics and the way they affect the model's pose. By using these principles you'll also learn how to deconstruct an Old Master drawing, rather than merely copy one. As one of my early teachers, Gustav Rehberger, said, "We must earn the privilege to shade—first draw a good figure in line."

In this chapter you will learn:

- the most reliable and effective landmarks to secure the figure's correct proportions, no matter what the pose
- methods to place the figure on the page while maintaining its correct proportions
- how to model form with values of light and dark
- the step-by-step process for drawing a convincing three-dimensional figure in both simple and foreshortened poses.

MEASURING
THE FIGURE

In order to appear lifelike, a figure drawing needs to accurately represent the proportions of the model. And in order to represent the figure in correct proportion, you need sound measurement strategies that will allow you to check what you've drawn for accuracy. Such basic measurements are not difficult to make.

Now let's look at a simple technique that allows you to verify that the most important proportions of your figure are correct. You can use it to measure key proportions in the early stages of drawing and be sure you have an accurate foundation from which to work.

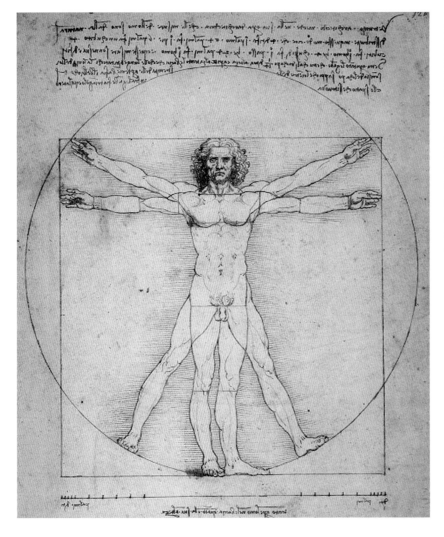

THE PROPORTIONS OF THE HUMAN BODY ACCORDING TO VITRUVIUS (THE VITRUVIAN MAN)
Leonardo da Vinci
Pen and ink and metal-point
14" × 10" (36cm × 25cm)
Collection: Gallerie dell'Accademia, Venice, Italy

In addition to applying basic proportional measurements, it is important to have some knowledge of classical proportions—a topic da Vinci investigated in his famous drawing. Knowledge of classical proportions helps you avoid serious distortions, and because nobody exactly matches the classical ideal, it also allows you to appreciate the differences that make each body unique.

Setting the Extremities of the Figure

One of the first things you must consider is the size and placement of the subject on the page. Remember that it is vital to compose your figure in relation to the overall page. Do not make the figure so small that it "floats" against the background. Conversely, the figure shouldn't be so large that it goes beyond the limits of the page or touches the top or bottom of the sheet, creating uncomfortable tangents.

In classical academic life drawing, it's advisable to fit the figure approximately half an inch to an inch (1.25–2.5cm) from the top and bottom of the page. Working large in this way not only fills the page compositionally, but also allows you to see proportional relationships easily.

Good proportion is based on division; bad proportion is based on addition and subtraction. You first need to establish the outer dimensions of your subject and keep this size unchangeable. Then you can consider the correct division of the parts within the whole. On the other hand, when you add to or subtract from the outer dimensions of the subject in an attempt to repair incorrect proportions, your drawing can fall into a continual state of flux with proportions spiraling out of control and figures that don't fit on the page. With a little discipline, you can avoid this.

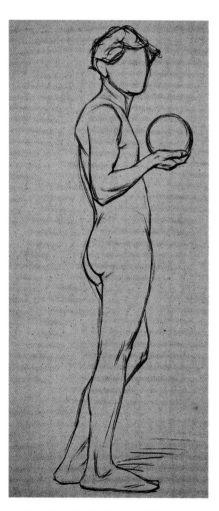
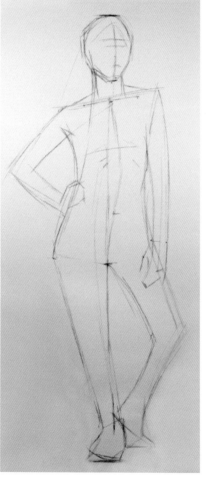

DEFINE THE UPPER AND LOWERMOST POINTS

This illustration is a typical academic life-drawing format. The first marks you make should indicate the extremities of your subject's longest dimension. For a standing figure, these marks should define the uppermost and lowermost points of the figure. (The horizontal marks indicate the extremities.) Do not alter or deviate from these marks. By keeping them sacred, you create a definite baseline against which incorrect proportions can be adjusted and corrected. If you were to "fix" proportional inaccuracies by adjusting the overall height of the figure, you would soon find that your correction in one area threw everything out of whack in another, leading to adjustment after adjustment.

YOUNG MAN IN PROFILE HOLDING A BALL
Charles Bargue
Lithograph, 24" × 18" (61cm × 46cm)

The Body's Landmark Points

Before we discuss strategies for measuring the figure, it is important to first draw by eye so that you can use your estimated drawing as a basis for comparison. The measurement strategies described here should be employed after you have made an initial line drawing, such as the one below.

As you study the principle lines of the figure, you will notice that they relate to the boney landmarks of the skeleton. This brings up an important point: It is the skeletal frame that determines proportion, not the muscles. The boney landmarks are the nails upon which the body's whole structure depends for solidity. To determine the proportions of the figure, look for major points on the skeleton that can serve as landmarks. To check your initial proportions on a frontal view of the figure, locate the chin and the pubis. For a back view, locate the base of the skull (or if it is not visible, use the 7th cervical vertebra, located at the base of the neck) and the coccyx, at the base of the torso.

Whether the pose is foreshortened or not, these landmarks are the basis for good figure proportion. Once you have completed your initial line drawing, to ensure your drawing has correct proportions, measure whether these two landmarks are correct. If they are, you can move on to placing and refining smaller forms within the figure. If you find that these landmarks are incorrectly placed, adjust them and re-measure. Once they are correct, you can move on to other parts of the drawing, knowing that your figure's foundation is accurate.

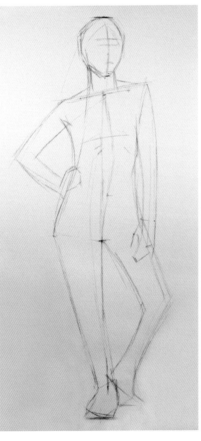

USE BONEY LANDMARKS TO FIND THE ACTION

After marking the extremities of your drawing, find the action both inside and outside using light and breezy lines that relate to the figure's most important projections (usually boney landmarks).

Remember that the head is a crucial shape that can telegraph good proportion (or bad). It should be drawn at the outset. Lightly indicate the surface centers (median lines) of the head, rib cage and pelvis; these lengths are the basis of good proportion.

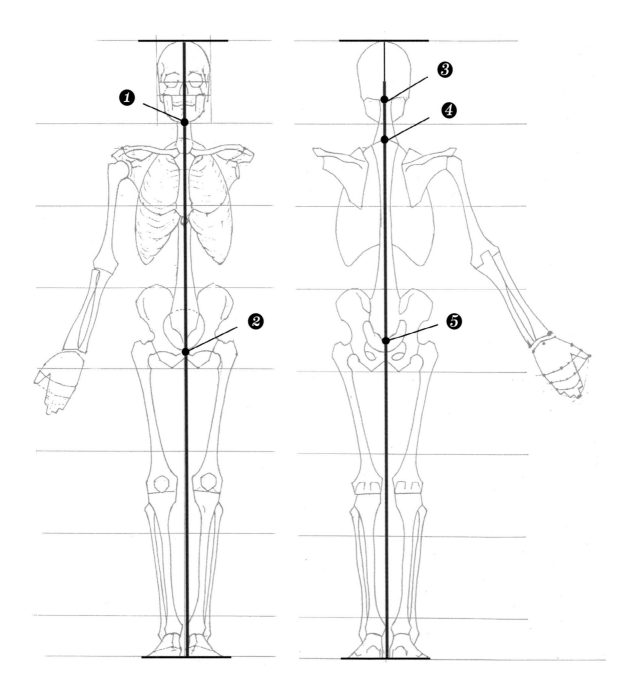

MEASURING FROM FRONT AND BACK VIEWS

When measuring the front view of the figure, it's easiest to focus on just two significant proportional landmarks. On the front of a figure, the landmarks are the bottom of the chin and the pubis. The chin is vital because it gives you a correct head proportion—an important unit of scale to your drawing. The pubis, or groin, locates the base of the torso. Once you've found these two landmarks, the other body parts will fall into place.

On the back view of the figure, use the base of the skull as the first landmark if it is visible. If not, look for the 7th cervical vertebrae, which generally protrudes prominently near the bottom of the neck. The second landmark is the coccyx, or tailbone, at the base of the torso.

1. *Bottom of chin*
2. *Pubis*
3. *Base of skull*
4. *7th cervical vertebrae*
5. *Coccyx*

Measuring the Internal Landmarks

There are a variety of ways to determine whether you have accurately placed landmark points on your drawing. Some artists use comparative measuring, sometimes called counting heads—seeing how many head lengths fit into the overall figure and comparing the length of various parts to the length of the head. I find this method tedious and inaccurate because the head unit doesn't always align itself to a convenient landmark. I prefer the technique of optical reduction, introduced to me by my teacher Michael Aviano. It's an empirical method for locating the figure's proportional landmarks. All it requires is a stick for measuring, such as a knitting needle or bicycle spoke.

One advantage of optical reduction is that you don't have to fully extend your arm, which eliminates a common source of error. (Comparative measuring, in contrast, can only be done with the arm fully extended.) However, when using optical reduction, your measuring stick must remain vertical and parallel to the picture plane, as shown in the illustration below. Your drawing paper must also be vertical.

This measurement technique takes a little manual dexterity, but once you become adept with it, you'll find it to be the most efficient and practical of all measuring techniques. It is, in essence, a linear proportional device: It compares the length of a part of the body to that of the whole. The technique can also be used along a horizontal line—if you are drawing a reclining model. In this case, simply mark the extremities of the figure's width, and then locate the head and pubis along a horizontal length. Optical reduction can also be applied specifically to the head if you're drawing at a close enough distance.

By using optical reduction, you can rectify any proportional problems early on. This allows you to develop your drawing with the confidence which comes from knowing that what you've drawn is accurate. This tool guarantees accuracy, reduces frustration and enhances creativity, all for the price of a knitting needle.

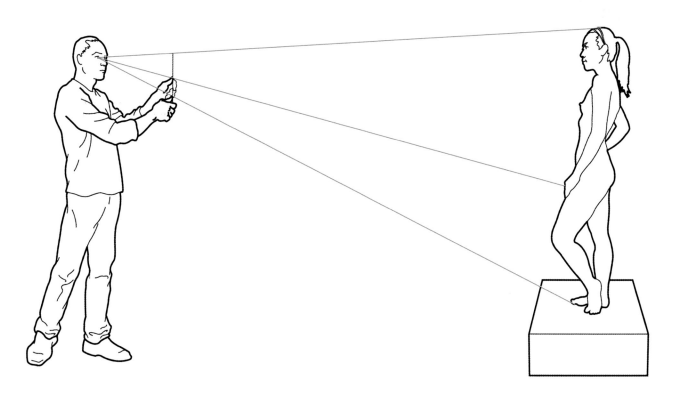

OPTICAL REDUCTION
Remember to keep both your measuring stick and your drawing surface vertical when evaluating your proportions.

Check Proportion With Optical Reduction

Follow the steps to use optical reduction to check the proportions and internal landmarks of your figure sketch.

MATERIALS

- crayon or chalk holder (porte-crayon)
- Cretacolor black charcoal lead (medium)
- kneaded eraser
- single-edge razor blades
- Strathmore drawing paper (white)
- thin knitting needle or bicycle spoke

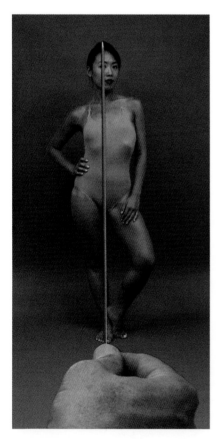

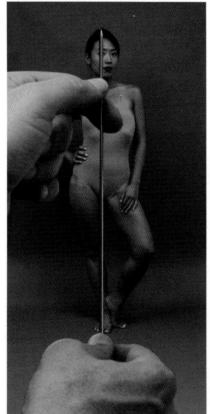

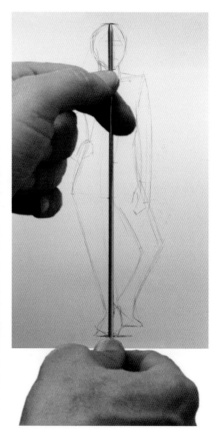

1 Check General Proportion

Hold your measuring stick so that the top aligns with the top of the model's head, while the tip of your thumb aligns with the bottommost point on the figure.

2 Check the Chin Position

To check whether you have drawn the chin in its correct position, "point off" the chin with your free thumb. Holding the stick as still as possible, place your free thumb tip at the bottom of the chin. Align the needle with your drawing and compare the tip of your top thumb (the chin's location on the model) to the chin's location on your drawing. Here, the measurement shows that the chin in the drawing is located in the correct spot.

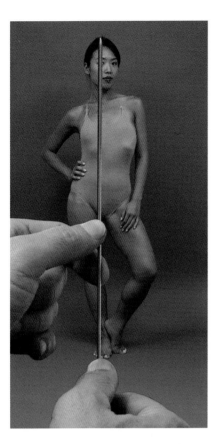

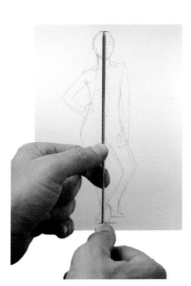

3 Check the Pubis Position

Use the same pointing-off technique to check the location of the pubis, the second proportional landmark. Keep your fingers at the same points on the measuring stick, and hold it in front of your drawing. Move the stick forward or back to align both thumbs with the top and bottom of your drawing. Make sure both the stick and your drawing surface are absolutely vertical. If your drawing does not align with the tips of your thumbs, adjust the drawing as necessary and then re-measure.

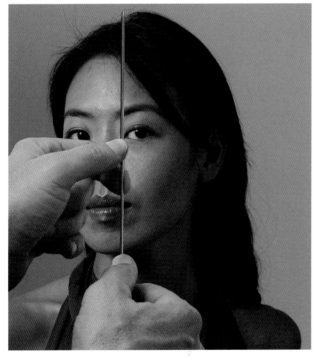

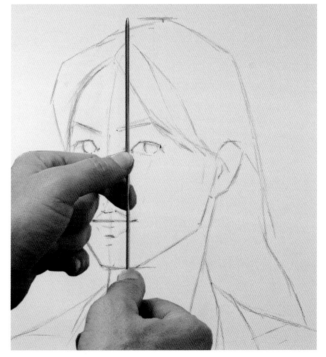

OPTICAL REDUCTION APPLIED TO PORTRAITS

Optical reduction can also be applied to the head. Use it to check the location of the tear duct—the primary proportional landmark on the front of the head. Once you're sure the tear duct is correct, it can serve as the determinant for the proportions of the head's other features.

Draw the Figure From Behind

MATERIALS

- crayon or chalk holder (porte-crayon)
- Cretacolor black charcoal lead (medium)
- Cretacolor white chalk lead
- Ingres charcoal paper (laid finish)
- kneaded eraser
- single-edge razor blades

The eye doesn't take snapshots—it sweeps. So let your eye sweep over what the model is doing. Your first impression or response should be the motive or steam behind your drawing. Movement is the life of the drawing and without it, the drawing will become static.

Follow the steps to draw a figure from behind.

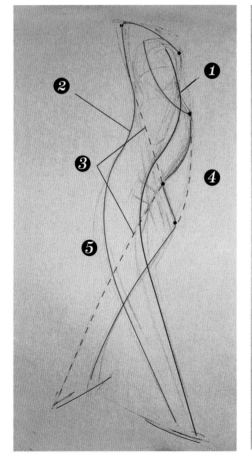

1 Sketch the Main Lines

Lightly draw the main lines, which can be either the moving inner axis that runs through the middle of the figure or the outside sweeping lines that abbreviate the many contours found within. Whatever lines you choose, they should express the figure's action in the most simple and direct way. In the first stages of the drawing, the goal is not accuracy but expression.

1. *Line of action*
2. *Sweeping action of the outside shape*
3. *Interrelationship of lines*
4. *Compression side*
5. *Stretching side*

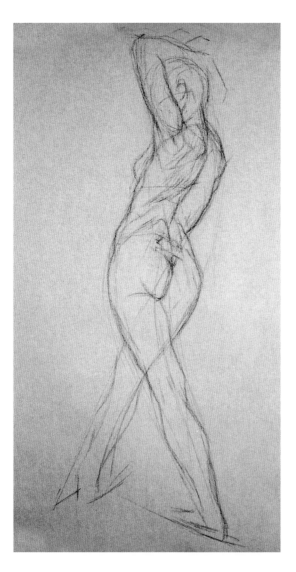

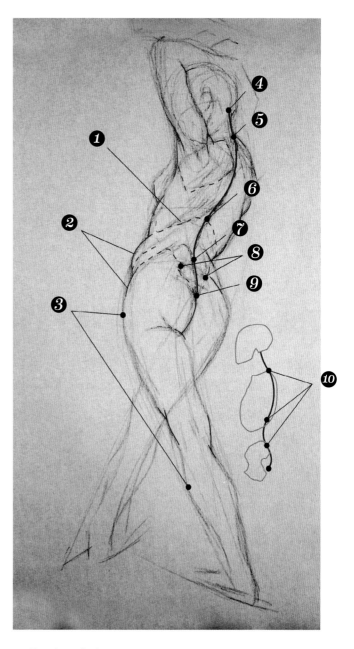

2 Establish Inside Landmarks and Base Boundaries

After the main outlines are established, look for the important landmarks that are inside the model, usually beginning with the vertebrae if they're visible. The correct relationship of these landmarks is what gives the figure its proportion, so it's vital that you memorize what they are.

After the boney landmarks are established, focus on the main forms found inside the figure, which are the base boundaries. This is where you can check if the parts fit within the whole. The base boundaries will profoundly influence the figure's contour (optical boundaries), and as a result, you can start to visualize the figure's most important overlaps, which will dramatically enhance its third-dimension. Remember to continually relate the optical boundaries to the base boundaries and visa versa. Points of inflection occur at the 7th cervical, 12th thoracic and 5th lumbar vertebrae.

1. Base boundaries
2. Optical boundaries (overlaps)
3. Peak points
4. Base of skull
5. 7th cervical vertebrae
6. 12th thoracic vertebrae
7. 5th lumbar vertebrae
8. Posterior points of the iliac spine
9. Coccyx
10. Points of inflection

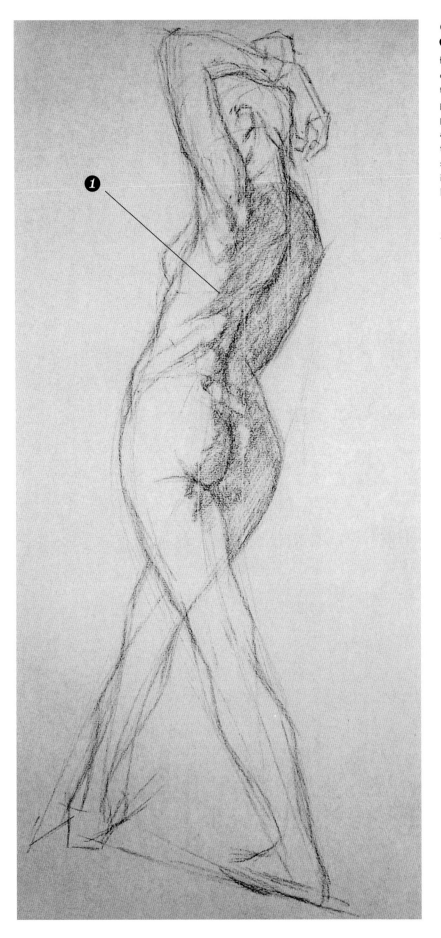

3 Lay In the Shadows

Look for the line that separates the lights from the shadows. In this case it is at the side of the torso and rib cage. Begin by graining the shadows lightly so you can see the shadow pattern in relation to the lights, which is the paper's tone. Then deepen the shadows and work into the halftones while keeping them proportionally lighter (no matter what stage). Remember that the darkest halftone in the light is still going to be lighter than the lightest shadow in the shadows.

1. *Light indication of the separation of light and shadow*

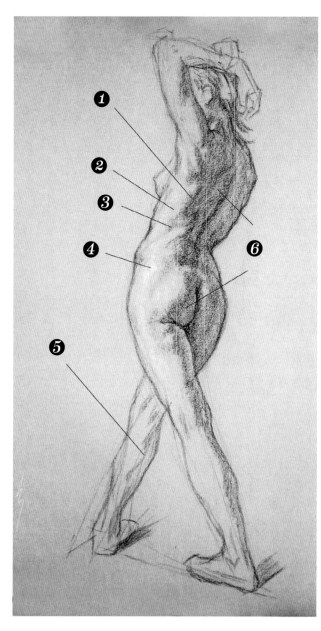

4 Strengthen Shadows and Add Highlights

Strengthen the shadows, particularly the form shadows, while leaving the reflected-light shadows proportionally lighter. The reflected-light shadows are the highlights of the shadow and express the curvature of the form. Add the lightest light and highlights with white chalk to heighten the third dimension. The paper will become the middle value of the model.

1. *Strengthened second phase of shadows*
2. *Middle light (paper)*
3. *Halftones*
4. *Lightest lights and highlights*
5. *Lighter first phase of shadows*
6. *Reflected lights come through to indicate the form's curvature.*

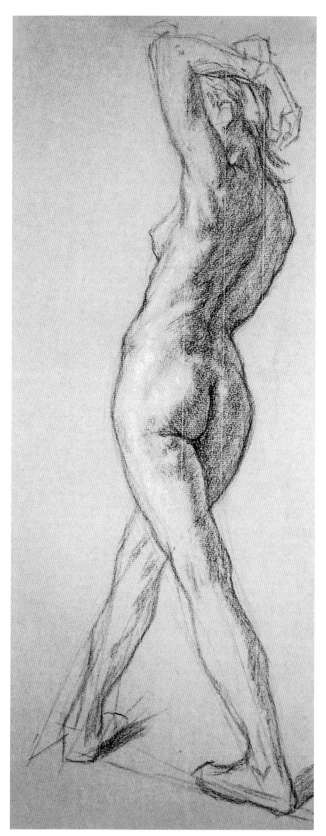

MAYA—BACK VIEW
Jon deMartin, 2015
Black and white chalk on toned paper
22" × 15" (56cm × 38cm)

PRINCIPLES OF FORESHORTENING

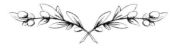

At its simplest, foreshortening is the visual illusion that causes an object to appear smaller than it actually is when it recedes from the eye. Technically, every part of the figure is always in foreshortening because the laws of perspective apply to everything we see on the picture plane.

But in certain heavily foreshortened poses, such as when a model's arm is pointing toward you, the effect is especially pronounced and challenging to depict.

Next, we'll cover some basic strategies that will help simplify the complex task of drawing foreshortened subjects.

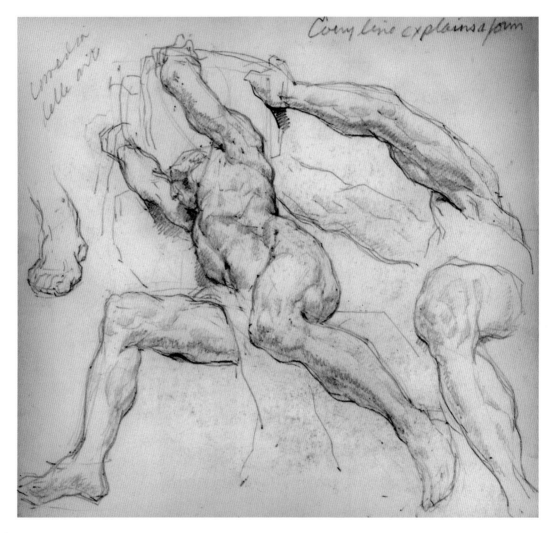

**DRAWING FROM *THE RIVER RHINE SEPARATING THE WATERS*
BY CLAUDE MICHEL CALLED CLODION, 1765**
Jon deMartin, graphite, 7" × 7" (18cm × 18cm)

Drawing the figure in a simple, straight-on view presents difficulties, but when you change the point of view so that the subject involves foreshortening, your structural knowledge is really put to the test. In order to depict a foreshortened figure, you must apply knowledge of the picture plane, the lines of action and the geometric solids that underlie the forms of the body.

PICTURE PLANE: THE KEY TO PERSPECTIVE

Before we discuss foreshortening, we must touch on the profound importance of the picture plane, which can be thought of as a transparent pane of glass between the viewer and the scene beyond it that is being depicted. Our line of vision travels in a straight line from the eye, through the picture plane, to the subject.

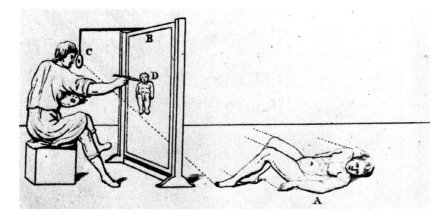

LINES OF VISION DETERMINE SUBJECT PLACEMENT

In this nineteenth-century French engraving, dotted lines represent the artist's lines of vision. The artist's drawing is determined by the points at which his lines of vision pierce the picture plane. In this way, the lines of vision give the subject its placement and size on the picture plane. The farther the lines travel, the smaller an object will appear.

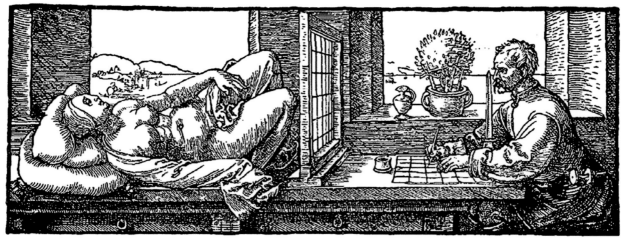

ILLUSTRATION FROM *THE TREATISE ON MEASUREMENT*
Albrecht Dürer, 1525
Woodcut, 3" × --" (8cm × 23cm)

In this well-known print by Albrecht Dürer, an artist looks through a grided window, which serves as the picture plane. Even though the figure he sees is three-dimensional and in a highly foreshortened pose, the artist can consider the subject as a flat, two-dimensional appearance on the picture plane. His picture plane and his drawing surface have matching grid lines, a method to help ensure an accurate representation of what he sees. This aspect of drawing—conceiving of the subject as a two-dimensional representation on the picture plane—is a crucial first step in seeing a subject's shape accurately. However, beyond drawing an accurate shape, you must also reconcile this image with what truly exists—a three-dimensional subject in space.

GEOMETRIC SOLIDS & SIMPLIFYING THE FIGURE

In order to draw the forms of the human body in perspective, it's helpful to think of them in terms of underlying geometric shapes—something artists have done for centuries in order to create drawings of tremendous power. To achieve a lifelike figure, you must be able to reduce such complex forms as heads and limbs to simple geometric solids and understand how to depict these shapes in perspective. In the drawing below, for example, the head closely resembles an ovoid, or egg shape. If you cannot draw an egg, a cube, or a cylinder in perspective from life and from your imagination, you will find it a challenge to draw a convincing figure.

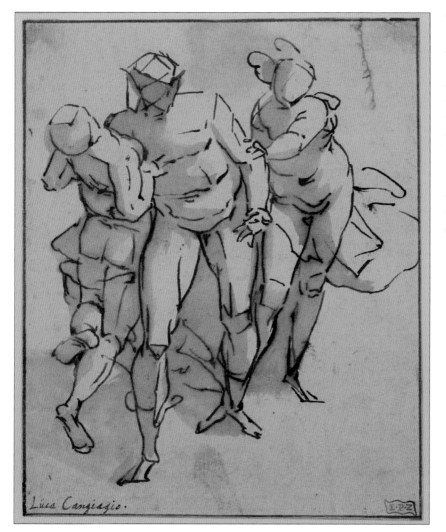

Luca Cangiagio.

THE CUBISTIC FIGURE IN SPACE

It's hard not to mention Luca Cambiaso when discussing cubes in foreshortening. In this drawing, which was most likely done from his imagination, we can see how effortlessly Cambiaso could compose the cubistic figure in space. This capability allows an artist to run through a gamut of poses before even consulting the live model. Reducing the masses of the body into simple geometric solids and viewing them in different orientations also serves to reveal the graphic, underlying power of a pose.

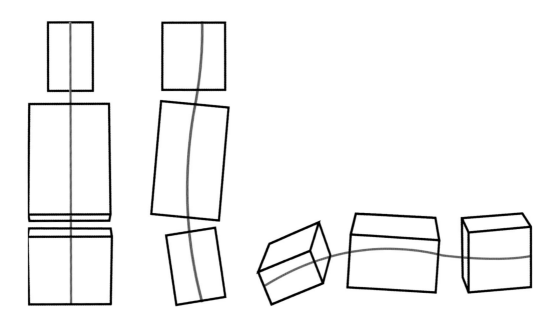

THREE MAIN MASSES OF THE FIGURE

The three cuboids in each of these images approximate the three main masses of the figure—the head, the rib cage and the pelvis. In each view, the red line indicates the line of action of the pose. This can also be visualized as the spine which runs through the masses and allows for flexibility of movement. In the front, side and reclining views, we can clearly see the spaces between the masses because of their essentially parallel orientation to the picture plane.

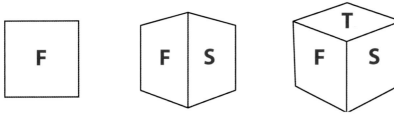

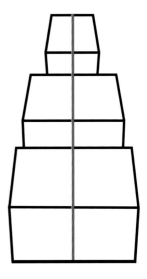

START WITH SIMPLE VIEWS TO GET FAMILIAR WITH DRAWING GEOMETRIC SOLIDS

Here we see three basic views of a cube. The first is seen straight on, revealing only its front plane. The second is turned so that the corner is directly in the center, revealing its front and side planes. The third is seen from above, revealing its top, front and side planes. If you are just beginning to practice drawing objects in space, try drawing cubes, cylinders and ovoids. Draw them in basic positions first, then in more complex ones, with the forms tipped, turned and tilted at odd angles. A good perspective book will help familiarize you with the principles of one-, two- and three-point perspective.

OVERLAPPING OF FORMS

This figure tilts away from the picture plane, demonstrating an important principle of foreshortening: As they recede in space, foreshortened forms are blocked by other forms, and we can no longer see the spaces between the masses. Artists refer to this visual phenomenon as the overlapping of forms, which can be a powerful tool in creating depth. (This principle actually applies to all views, but it is more pronounced in foreshortened ones.)

CREATING THE ILLUSION OF DEPTH

As a figure turns diagonally away from the picture plane, the overlapping of the masses increases, as does the illusion of depth. In the first example, a figure recedes in a fairly straight diagonal line. Accordingly, the central axis (shown in red) is relatively straight. In the second example, the masses are turned toward each other, creating a compressed side and a stretched side. This creates an even more dynamic sense of action, which can also be seen in the increased curvature of the red axis. The third example on the far right shows the most dynamic and three-dimensional illusion of all, with the masses turning, tipping and tilting.

1. *Stretching side*
2. *Compression side*

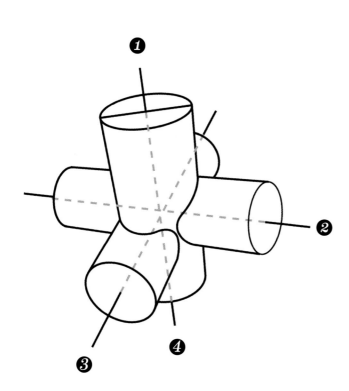

The three cylinders represent height, width and depth.

1. *Height*
2. *Width*
3. *Depth*

Here the three cylinders combine with each axis moving three-dimensionally, showing how these three facets together reveal a subject's orientation in space.

1. *Height*
2. *Width*
3. *Depth*
4. *Axis*

DRAWING FORESHORTENED LIMBS

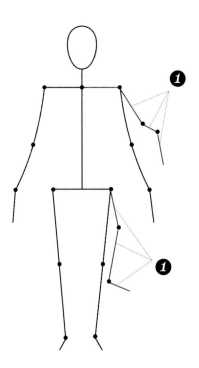

Of course you don't want to actually draw a limb as a cylinder, but you can conceive of it as one in your mind. It's a geometric solid that can help you quickly determine the direction of the limb. When drawing an arm or a leg, you must first establish the directions of the axis. Think of the axis as an imaginary line running through the middle of a form. Together, the axes of individual forms set the larger action of what you're drawing.

Even though the lines you draw on your paper are flat, you should try to conceive of them as moving through three-dimensional space. We want to develop the capability to construct forms believably in space without relying solely on the flat appearance of a shape. In other words, you want to create shapes based on both direct observation of the model and on your knowledge of anatomy. This will allow you to construct forms when confronted with difficulties, such as a model moving his or her arms or legs, It will also allow you to fashion drawings that simply cannot be done from life, such as the view drawn by Giovanni Paolo Lomazzo, shown on the next page. It is the essence of great drawing when artists use both what they see and what they know.

1. *Axis foreshortened*
2. *Cross section indicating direction*
3. *Overlapping forms*
4. *Compression side*
5. *Axis*
6. *Action (axis)*
7. *Stretching side*

MAIN JOINTS CREATE THE FIGURE'S ACTION

The red lines represent the limbs in foreshortening, so they appear shorter in length than the unforeshortened limbs shown in black. Look for the action first, then for the points at which the action changes direction, located at the joints. Once the axis is drawn, "clothe" it with volume. Study the skeleton to ascertain the relative lengths of the arms, hands, legs and feet.

DEMONSTRATION DRAWING AT BAY AREA CLASSICAL ARTIST ATELIER
Jon deMartin, 2012
Black and white chalk on blue paper, 18" × 24" (46cm × 61cm)

In this unfinished drawing, the white chalk marks estimate the figure's significant landmarks. These points help us visualize the figure's relevant proportions seen in foreshortening. Although I did not draw the overlapping masses of the head, rib cage and pelvis as cubes, I did visualize them in perspective. This would have been impossible had it not been for my understanding of what a cube looks like in perspective.

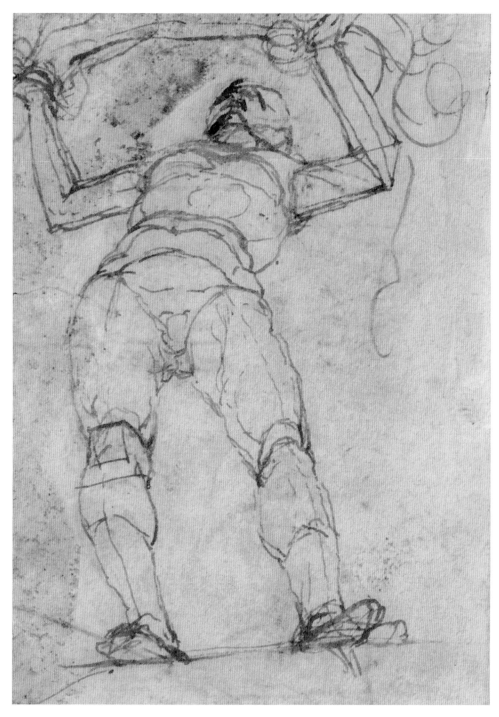

STUDY OF STANDING FIGURE
Giovanni Paolo Lomazzo, ca. 1565–1571
Black chalk and brown ink, 8" × 5" (20cm × 13cm)
Collection: Princeton University Art Museum, Princeton, New Jersey

This view would have been impossible if it were copied directly from life, but any conception is permissible as long as you're constructing a three-dimensional figure in space. To draw such views, you must equip yourself with strong structural knowledge. The limbs can become truncated cones, the arms elongated rectangular cubes, the rib cage an egg. Notice the curve moving through space on the underplane of the jaw. Notice the cross-sections explaining the girth of the upper rib cage, abdomen and pelvic girdle, as well as the cross-section indicating where the tapering of the torso occurs.

COPYING THE
MASTERS

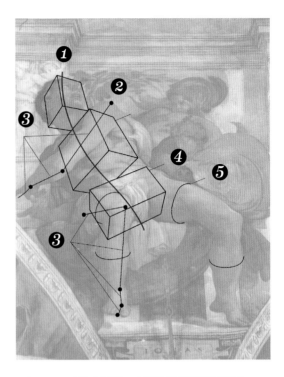

You can apply these foreshortening concepts not only when drawing the model from life but also when copying the works of the masters. For example, in his painting of Jonah, we see Michelangelo's profound ability to conceptualize the human figure in three-dimensional space.

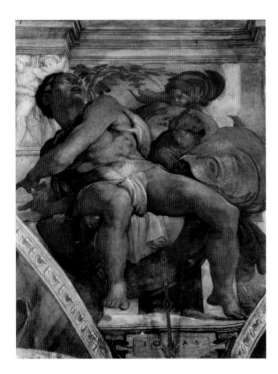

JONAH, DETAIL
Michelangelo, 1508–1512
Fresco

It's exciting to study how the Old Masters designed poses to meet their specific narrative needs. Many Renaissance and Baroque artists chose views to dramatize the illusion of depth, and we can see outstanding examples of foreshortened figures by Michelangelo in the Sistine Chapel.

DON'T JUST COPY—APPLY CONCEPTS

Take a great figurative masterwork that inspires you and overlay it with tracing paper. Try drawing convincing cubes and cylinders that fit the figures. Include the axis of each solid and look for significant overlapping forms. A copy of a work becomes much more meaningful and edifying when you apply concepts as opposed to just copying.

Putting cubes and solids in perspective in this way may seem simple, but it is not easy. Practicing it will immediately expose both your weaknesses and strengths. It will also remind you of the importance of learning how to draw simple geometric solids in space from life—the essential underpinning of a well-constructed figure drawing.

1. *Action (axis)*
2. *Rib cage mass overlaps the head*
3. *Axis*
4. *Pelvic mass overlaps the rib cage*
5. *Cross-section indicating direction*

CONSTRUCTING & MODELING A FORESHORTENED FIGURE

Let's walk through the process of drawing a foreshortened figure, from placing initial measurements to modeling lights and shadows, with a focus on creating a believable, three-dimensional form. We've looked at various methods of measurement and tactics for drawing foreshortened forms. Now let's put those skills together into a reliable method for drawing an entire foreshortened figure. We'll focus on creating the structural basis of a figure through measurement and line—the most challenging part of the process. We'll also explore how to enhance the figure's rhythmic action and three-dimensionality. Finally, we'll touch on how to model the figure once the line drawing is in place.

Accuracy itself does not make a great drawing, but it is necessary to learn how to be accurate before you can venture into freer, more expressive types of drawing. You must learn to walk before you can run. With this in mind, we'll begin the drawing process by using measurement to place the figure's key locations on the page.

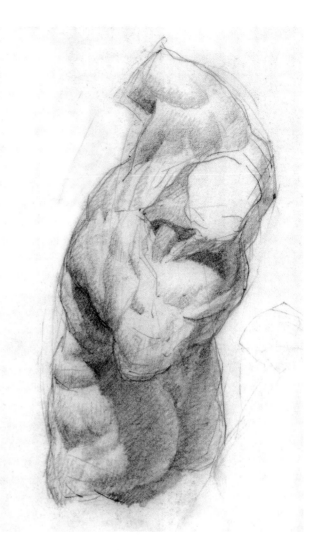

DRAWING AFTER SCULPTURE
Jon deMartin, 2012
Graphite, 9" × 6" (23cm × 15cm)

This drawing is a foretelling of the drawing process shown on the following pages. The extreme twist of the torso creates a dynamic movement that shows the surface centers of the rib cage and pelvis simultaneously. Dramatic poses usually come in the form of short poses, because the model can only hold them for a short time. Great figurative sculptures, as well as their plaster casts, show a dramatic action and don't move. This makes them a great resource for the figurative artist. You can test your construction ability from various points of view, which will help you to understand construction more in depth. In addition, the position of the light and shade on the sculpture remains constant.

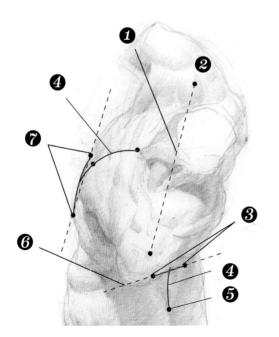

1. Lines of contrast
2. Acromion processes
3. Posterior superior iliac spine
4. Surface center
5. Coccyx
6. Lines of contrast
7. 7th ribs

Setting the Height-to-Width Proportion

Normally you would draw by eye first and then check your work for accuracy. But I'm going to show you a way to control the size, placement and proportion of the figure on the page, sooner rather than later. As the late artist Deane Keller said, "Remember that drawings do not develop always in some strict accordance to rules, or always in the same way. Experience reveals that some ideas work better than others." Some of these ideas and strategies are offered here.

To draw a figure you must be confident that your drawing's proportions are accurate—you want to control the subject's shape. Ascertain your subject's correct height-to-width proportion by comparing these two measurements in relation to each other. Measure both height and width from the figure's greatest extremities—i.e., from the farthest left point on the model to the farthest right, and from the highest point to the lowest.

This technique is not foolproof, and your eye must be the final judge. Yet, it will get you within striking distance of your subject's overall proportions. The system is not limited to use on the figure; you can use it to ascertain the height and width of any subject, from a still-life object to an entire landscape.

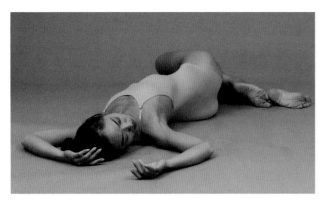

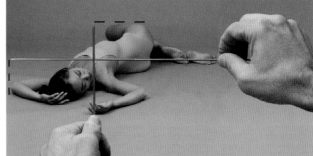

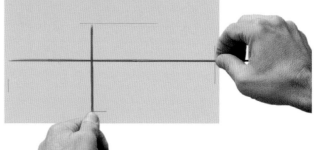

SETTING WIDTH PROPORTIONS

In this pose, the model's horizontal length is greater than her vertical height. But by how much? Use the optical reduction method to find out. Take the longer of the two lengths (the width, in this case) and make that your standard. Once you mark the extremities of this measurement on your paper, the length will remain unchanged throughout the rest of the drawing process. You will judge the figure's other length (the height) in relation to this standard.

The two marks on the left and right sides of the paper reflect the horizontal extremities of the pose. This will be the standard distance against which to compare other distances. It is important to set one length as a standard that remains unchanged. If you don't do this, the drawing will always be in flux, with changes to one measurement forcing changes elsewhere.

SETTING HEIGHT PROPORTIONS

To capture the figure's height-to-width proportion you must simultaneously find the figure's four peak points: its highest, lowest, left-most and right-most extremities. You'll need two measuring sticks. (Knitting needles work well for this.) Hold your sticks in front of the model in a cross shape. The sticks must be parallel to the picture plane, not tilted forward or backward. Move each stick so that its tip is located at one of the figure's extremities, and position your hand at the opposite extremity. The model's extremities usually do not line up exactly (i.e., the highest point won't be directly above the lowest point), so you need to mentally project lines from the points that you're measuring from.

Keep your sticks in the same position and move them in front of your drawing. Move the sticks forward or back so that the horizontal measurement lines up with the width that you've already marked on your paper. Mark the top and bottom extremities—indicated by the tip of the vertical stick and the point where you're holding it.

Indicating Landmark Points

The next step is to mark the location of several key points on the figure. In many cases these points are boney landmarks that project to the surfaces of the body—the model's chin, for example. Indicating the location of these key points will help with the proportions of your drawing and will anchor your figure in space.

The shape of the head should be studied for its peak points in the same way you found the figure's extremities, but making too many measurements can restrict your freedom. Limit the landmarks you measure to as few as possible. Once you have marked the most important landmarks horizontally and vertically, you are free to continue to look for the figure's big relationships and interrelationships.

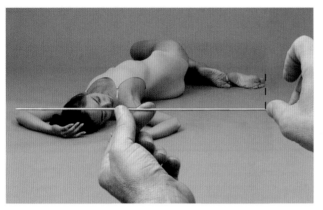

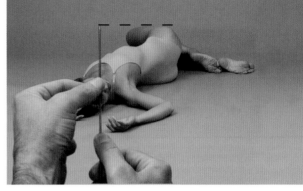

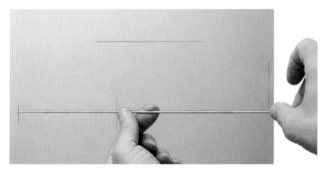

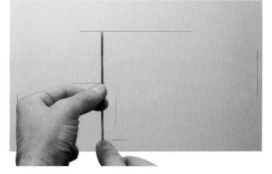

MARK THE HEAD'S PEAK HORIZONTAL POINT

Find any landmark within your established height or width by aligning the measuring stick vertically or horizontally along the figure's extremities. To place the head correctly within the established height and width, hold the measuring stick horizontally so that its tip touches the figure's left extremity and your thumbnail falls at its right extremity. Holding the stick as still as possible, place your thumbnail at the point of the chin. Keeping your thumb at this point, move your stick in front of your paper so that it lines up with the horizontal-extremity markings on your drawing. At the spot indicated by your left thumb, draw a line that reflects the location of the chin.

MARK THE HEAD'S PEAK VERTICAL POINT

Mark the head's peak point along the body's vertical length using the same process. This time, line your stick up so that its tip and your thumb fall at the model's vertical extremities. With your other thumb, indicate the highest point on the head—in this case the model's left cheek. Then transfer this point to your drawing. This measurement technique can also be applied to check your work after drawing by eye.

Finding the Gesture and Orienting Forms

Once you establish the figure's main proportional relationships, turn your attention to its rhythmic movements. You should always gather some sense of this aspect of the figure, sometimes referred to as the gesture, before you enter the construction phase of your drawing.

The figure's line of action is a long inner axis that describes its gesture. This line has little to do with the figure's outside shape. Rather, it is a conceptual line that serves as the core of the figure's movement. If you don't discover the line of action, the figure's outer shape may wind up being static.

The figure's surface centers are also profoundly helpful in orienting the body's main masses in space. Surface centers are imaginary median lines that run vertically along the masses of the head, rib cage, and pelvis. As you become familiar with the significant landmarks that run along these centerlines, your ability to see proportional relationships will increase dramatically.

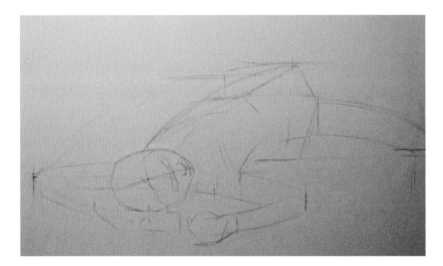

RHYTHMIC RELATIONSHIPS AND THE GESTURAL LINE

After looking for the gestural line, use your landmarks to draw the size and shape of the model's head. This gives scale to the figure and subsequently serves as the basis for relating the most significant outlines of the model. After estimating the shape of the head, look for lines of contrast. These are imaginary lines running across the figure that indicate its position in space. Draw a line between the acromion processes, the two outer points of the shoulders. (In all poses the skeleton has a profound influence on the shapes we draw; so the more we learn about the figure's skeletal landmarks, the more we can aim our lines and draw with purpose.) This line of action shows the angle of the shoulders in relation to the hips—a key piece of information for orienting the figure in three dimensions.

1. *Acromion processes*
2. *Larger outer relationships*
3. *Larger interior relationships*
4. *Great trochanter*
5. *Line of action*

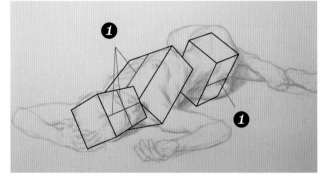

TWISTING AND ARCHING CYLINDER WITH SURFACE CENTERS

Visualizing the head, rib cage and pelvis as simple geometric solids with their surface centers indicated—a twisting cylinder, or a series of cubes—enables you to better understand the orientation in space of these basic body volumes and their complex relationships to one another.

1. *Surface centers*

THE FIGURE'S SURFACE CENTERS

Here we see the centerlines of the three main masses in blue. The head's centerline begins with the hairline and ends at the chin. The rib cage's centerline runs through the pit of the neck and the bottom of the sternum. The pelvis's centerline (a back view, in this case) passes from the lumbar vertebrae down to the tip of the coccyx.

1. *Xiphoid*
2. *Surface center*
3. *Suprasternal notch*
4. *Coccyx*

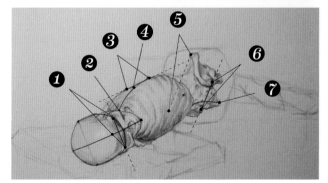

HORIZONTAL LANDMARKS

This is where knowledge of the skeleton is vital. You need to relate the essential boney landmarks of the head, rib cage and pelvis to the surface centers that were found in the previous stage. On the head, it can be any convenient landmark; in this view, it's the brow ridge. For the rib cage, it's the cartilage of the 7th ribs. Because the pose is twisting, you see the front of the face, the side of the rib cage and the back of the pelvis, so here you can identify the pelvis's posterior superior iliac spines. Even though other landmarks may be hidden, try to find them so you can grasp the entire mass as an accurate and well-conceived volume, rather than use the landmarks as just surface details.

1. *Brow ridge*
2. *Suprasternal notch*
3. *7th ribs*
4. *Xiphoid*
5. *Anterior superior iliac spine*
6. *Posterior superior iliac spine*
7. *Coccyx*

Identifying the Base Boundaries

It is important to identify the main parts of the figure—the shapes found within the figure's outer boundary, or contour. By learning these shapes, you can conceptualize where one form ends and another begins. This will make you more sensitive to changes of the surface when you model the form. The base boundaries between the body's parts are created by bones, muscles and fat—all of which influence surface form.

The figure's contour is the result of form emanating from the inside and spilling over to the outside shape; so the more aware you are of the body's interior forms, the more informed and lifelike your drawing's contours will be. Look for how the contours undulate as the muscles weave in and out of one another. The line's overlapping quality as it wraps in front of and behind the edge of the figure enhances the figure's three-dimensionality.

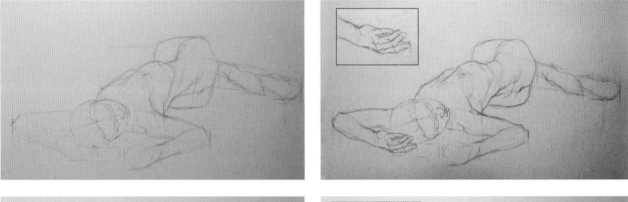

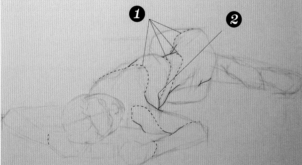

BASE BOUNDARIES AND OVERLAPS

First add the more important shapes that create the figure's main intersections—in other words, draw the larger parts before the smaller ones. Only when all parts fit within the outside shape should you develop the figure further. Draw your base boundaries with almost imperceptible lightness so that they can serve as a map for the placement of the darker lights when you model form later. (The dotted lines indicate the base boundaries. The solid lines indicate the overlapping forms.)

1. *Base boundaries*
2. *Overlapping forms*

DEVELOPING LIMBS AND EXTREMITIES

Initially, it's a good idea to leave the hands in an abbreviated stage because you're focusing on constructing the more important masses. A live model's arms, hands, legs and feet are more likely to move over the course of time, so it makes sense to develop them later. The hands especially are apt to change. (In this case, I drew each hand in a twenty-minute window of time.)

Modeling Shadow and Light

Up to this point in the drawing process, our focus has been on constructing a convincing three-dimensional figure in line. Light and shadow, however, are also extremely important to the appearance of the figure. The modeling or shading of form is relatively easier than the linear construction of form. This should be your first priority. Light is transient, but form is permanent.

The fundamental rule of modeling form is: All shadows must be darker than all lights. A shadow filled with reflected light will be the lightest shadow in your drawing, but it must be darker than your darkest light.

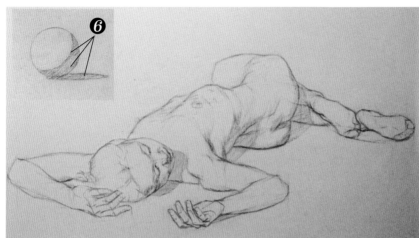

MASS IN THE LIGHT SHADOW VALUES

To begin modeling, look for the exact point on the form where the light ends and the shadow begins. This is the most important phase of modeling because if this shadow line is misinterpreted, then the values, or modeling factors, will not fit.

Once you've found this boundary, faintly mass in the shadows using an even, relatively light shadow value. By starting with a light shadow value, you leave yourself free to darken shadows as the drawing progresses.

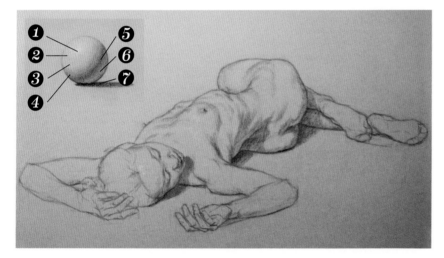

WENDY RECLINING
Jon deMartin, 2014
Black and white chalk on toned paper
18" × 24" (00cm × 00cm)

1. Highlight
2. Light light
3. Middle light (paper)
4. Halftone
5. Form shadow
6. Reflected-light shadow
7. Cast shadow

DISTINGUISH THE FORM SHADOW, REFLECTED-LIGHT SHADOW AND CAST SHADOW

As you push the form and cast shadows darker, let the lighter reflected lights show through. These describe the curving parts of the form, enhancing its three-dimensionality.

After stating the different qualities of shadow, focus on the area of the figure in light. Apply subtle values to the darker light areas (the halftones), which further show the curvature of the form. The halftones are the darkest of all the lights and their values vary depending on the relationship of the form's plane to the light source. The steeper the plane (the less directly it faces the light), the darker the value. The flatter the plane (the more directly it faces the light), the lighter the value.

Introduce the dark lights moving from darkest to lightest, making sure they are lighter than the shadows. Let the toned paper come through your drawing to explain the middle-light plane, and then use white chalk to convey the model's peak forms facing the light (the light lights and the highlights). Because toned paper acts as a middle value, working on toned paper lessens the amount of time it takes to model the figure.

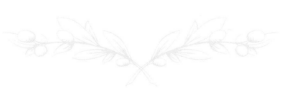

5

THE FEATURES

One of the major challenges of drawing realistic human figures is to depict the body convincingly when seen from different perspectives. Up to this point, we've explored ways to conceptualize the figure in foreshortened views. But you shouldn't focus solely on the body's major forms, such as the head and torso, at the expense of its minor forms.

When drawing a head in perspective, not only is the head foreshortened, but so are all of its features. For this reason, it's important to study the main structural characteristics of the features and how they appear in various views.

In this chapter, you will learn:

- the structure of the mouth, nose, eye and ear
- how to construct a solid convincing illusion of a three-dimensional form
- how to draw features from different perspectives, from a simple straight-on view to more complex foreshortened ones.

GILDA WITH TURBAN
Jon deMartin, 2006
Black and white chalk on toned paper
20" × 15" (51cm × 38cm)

LINE

Before getting into the details of facial features, let's review some important principles of line making.

Drawing is relating extremities. A line, whether straight or curved, is the result of a path between two points. It doesn't matter whether you physically place a point before drawing the line, or mentally conceive of it. What does matter is that you think about where you're aiming the line. This was emphasized by the artist John Gadsby Chapman, who in 1847 wrote in *The American Drawing-Book,* "Observe well, before you touch your paper, where the line is to begin, what direction it is to take and where it terminates."

Below is a series of lines shown in the variety of basic ways they can be used. We will employ all of these in the exercises that follow.

ANATOMY OF A LINE

POINT
Position and placement

LINE
A path of points, direction

SHAPE
A path of enclosed points

VOCABULARY OF LINES

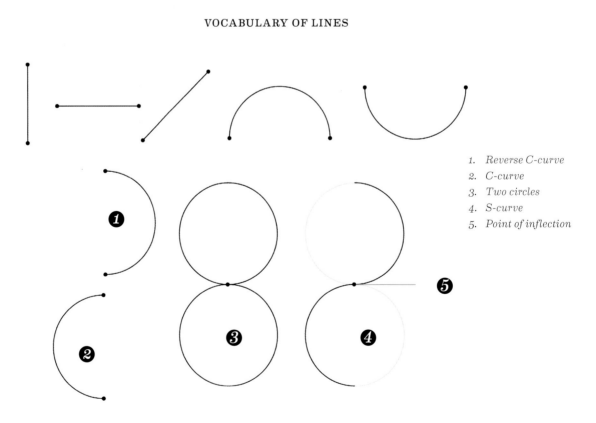

1. *Reverse C-curve*
2. *C-curve*
3. *Two circles*
4. *S-curve*
5. *Point of inflection*

Relative Angles of Lines

Keep in mind the words of John Singer Sargent, who advised, "Get your spots in their right place and your lines precisely at their relative angles." Here, relative angle refers to the angle of a line relative to a horizontal or vertical. In the depiction of any subject, there is only one true horizontal and one true vertical, but there are an infinite number of diagonals. You can rely on horizontal and vertical plumb lines to assist yourself in drawing any straight or curved line. In a similar manner, to better perceive various rates of curvature, you can relate a curved line to a straight line.

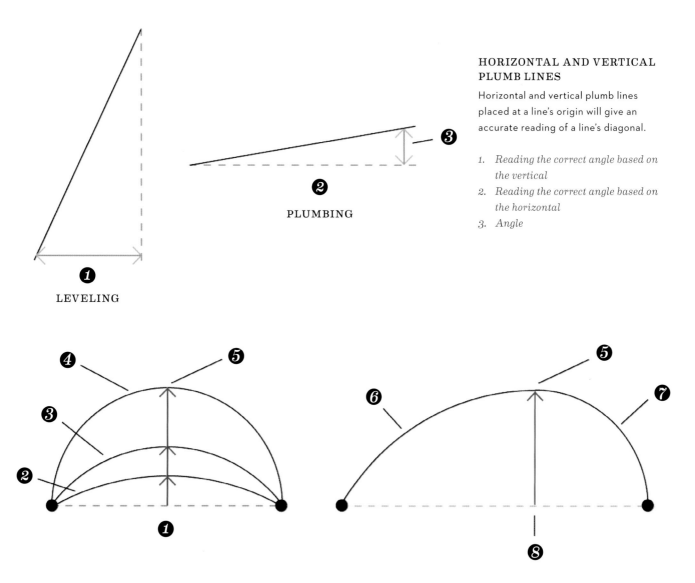

LEVELING

PLUMBING

HORIZONTAL AND VERTICAL PLUMB LINES

Horizontal and vertical plumb lines placed at a line's origin will give an accurate reading of a line's diagonal.

1. *Reading the correct angle based on the vertical*
2. *Reading the correct angle based on the horizontal*
3. *Angle*

DRAWING CURVES

To accurately draw a curve, look for its highest peak—called the point of amplitude—and judge it relative to its horizontal baseline. Remember, however, that most curves in nature are irregular, such as the curve seen in the illustration on the right. Here, the point of amplitude does not fall in the exact middle of the curve, yielding one side that curves slower and one that curves faster.

1. *Finding the arc on a horizontal baseline*
2. *Low relief*
3. *Medium relief*
4. *High relief*
5. *Point of amplitude*
6. *Slow curve*
7. *Fast curve*
8. *Finding the arc on an irregular curve*

THE MOUTH & NOSE

Leonardo da Vinci explained that the major types of features are those that lie flat along a baseline, those that rise above a baseline and those that fall from a baseline. The crucial line on a mouth is the line indicating the parting of the lips. This line reveals the width and orientation of the mouth and communicates its feeling and expression.

Many years ago, I was drawing a self-portrait and wanted my mouth to have a relaxed and pleasant expression. But when I finished, it looked severe and serious. My teacher, Michael Aviano, pointed out that I had neglected to find my mouth's action line before moving on to other more subtle aspects of its form. This was a lesson I never forgot: Always find the action line first!

The same principles apply when drawing the nose. If you find the leading base points that contain the form's shape, you'll be able to place the nose in any position in space.

MOUTH-DRAWING DEMONSTRATION
John Gadsby Chapman

Chapman began with the action line, connecting the endpoints of the mouth. Then he drew the gentle curved line following the parting of the lips.

Draw the Mouth in a Frontal View

Follow the steps to draw the mouth in a straight-on frontal view.

MATERIALS

- 90-lb. (190gsm) Stonehenge spiral pad (cream)
- crayon or chalk holder (porte-crayon)
- Cretacolor black charcoal lead (medium)
- kneaded eraser
- single-edge razor blades
- thin knitting needle or bicycle spoke

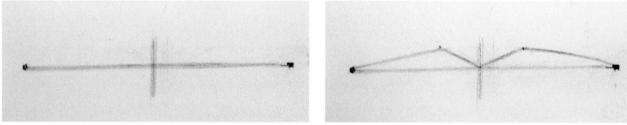

1 Draw the Action Line

Begin with an action line connecting the endpoints of the mouth to indicate its width and direction. It's also a good idea to include a small vertical mark at the line's midpoint.

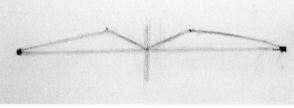

2 Indicate the Mouth Line's Shape

Draw a line that represents the model's top lip. Pay attention to the points of amplitude in the curves that make up this line—use these points as your guide. When the mouth is closed, the forms of both lips touch at the mouth line.

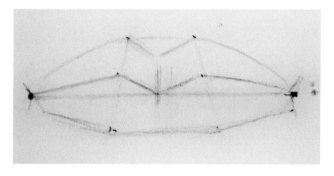

3 Fill In the Upper and Lower Lip Shapes

Once the top lip lines are in place, fill in the shapes of the upper and lower lip, still paying attention to key points of amplitude.

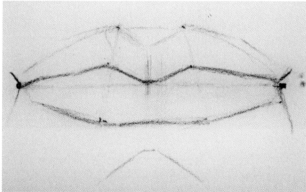

4 Define the Mouth Line

Make the mouth's centerline darker than the lines indicating the outline of the lips. A dark line usually indicates a contour, a hole or a depression, and is appropriate for the line where the upper and lower lips meet.

DEMONSTRATION

MATERIALS

- 90-lb. (190gsm) Stonehenge spiral pad (cream)
- crayon or chalk holder (porte-crayon)
- Cretacolor black charcoal lead (medium)
- kneaded eraser
- single-edge razor blades
- thin knitting needle or bicycle spoke

Draw the Mouth in Various Perspectives

Follow the same sequence of steps to draw the mouth from various perspective views.

Three-Quarter View

As the mouth turns, its center will no longer be exactly halfway between the endpoints of its baseline, and all of the leading landmarks will change locations.

1 Draw the Action Line
Notice that the center of the mouth is no longer in the middle, as the head has turned to a three-quarter view.

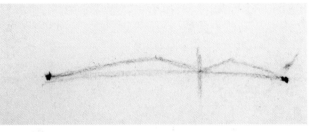

2 Indicate the Mouth Line's Shape
The line variations shift right based on the points.

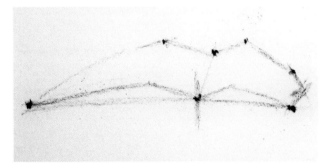

3 Fill In the Upper and Lower Lip Shapes
The points of the upper lip shift right.

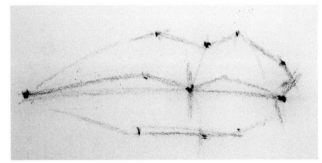

4 Define the Lower Lip
The points of the lower lip shift right.

Side View

For a better understanding of a form's plane orientations, it helps to visualize it from multiple directions. The side view shows especially clearly how the planes run up and down the form.

1 Draw the Action Line

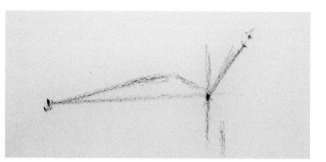

2 Indicate the Mouth Line's Shape

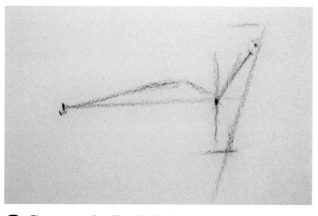

3 Connect the Peak Points

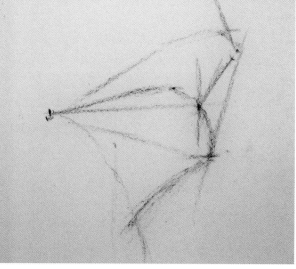

4 Fill In the Upper and Lower Lip Shapes

5 Darken the Under Planes

1. *Top plane*
2. *Under plane*

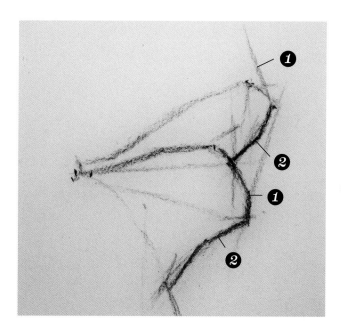

View From Below

Keep in mind that your lines are three-dimensional, even though they sometimes appear flat or straight. The parting of the lips appears straight when seen from a frontal perspective, but it actually wraps around the cylindrical shape of the teeth and jaw, as you can see in the final step.

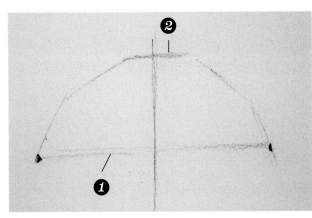

1 **Draw the Action Line**

2 **Indicate the Top Lip**

1. *Horizontal baseline*
2. *Point of amplitude*

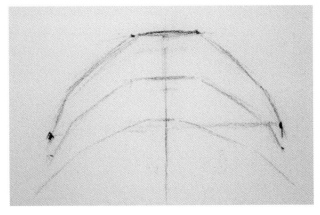

3 **Fill In the Mouth Line and Lower Lip Shapes**

Leading Landmarks in Frontal vs. Three-Quarter View

The illustrations below show how the mouth's leading landmarks compare a frontal view versus a three-quarter view. Get to know these landmark points. They make it easier to follow the mouth's construction, no matter what the view.

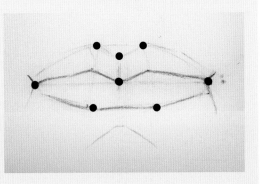

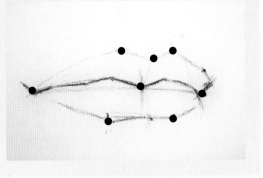

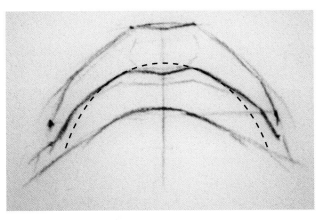

4 **Define the Mouth Line**

The mouth should wrap around the cylinder shape of the teeth. (Here, the teeth shape is indicated with a dotted line.)

View From Above

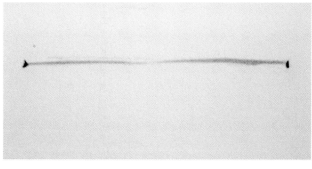

1 Draw the Action Line

2 Indicate the Mouth Line
Each point indicates a plane's direction *after* the larger lines.

3 Fill In the Upper and Lower Lip Shapes

4 Define the and Darken the Mouth Line

Oblique Angle Views

Here are some perspectives where the mouth is neither straight-on horizontally, nor vertically. This is the phenomenon which you're most likely to encounter.

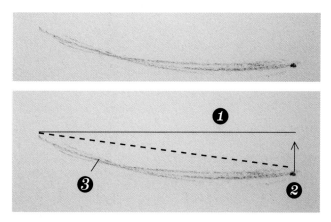

1 Draw the Action Line

1. *Reading the correct angle based on the horizontal*
2. *Angle*
3. *Action begins at the mouth's corners*

2 Indicate the Shape of the Mouth Line and Lower Lip
Each point represents a plane change.

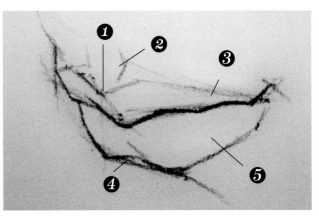

3 Fill In the Upper and Lower Lip Shapes

1. *Two planes*
2. *Three planes*

4 Define and Darken the Mouth Line

1. *Tubercle of the upper lip*
2. *Philtrum*
3. *Wing of the upper lip*
4. *Groove of the lower lip*
5. *Lobe of the lower lip*

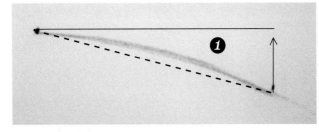

1 Draw the Action Line

Remember, the action begins at the mouth's corners.

1. *Reading the correct angle based on the horizontal*

2 Indicate the Top and Bottom Lip Lines

The points marked on the bottom lip represent the arc's point of amplitude.

3 Fill In the Upper and Lower Lip Shapes

Take care not to lose the action underneath the lip.

4 Define and Darken the Mouth Line

The upper lip presents three masses, and the lower lip presents two masses.

Draw the Nose in a Frontal View

Follow the steps to draw the nose in a straight-on frontal view.

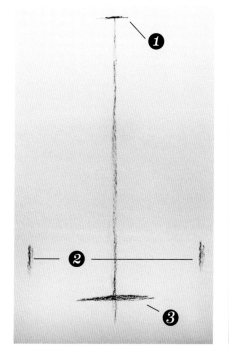

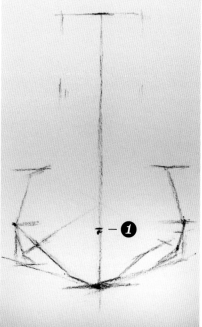

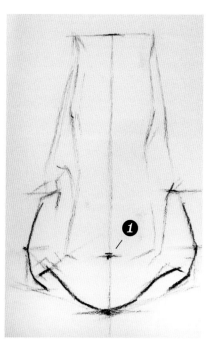

1 Establish Height-to-Width Proportions

As you begin, remember that the nose projects away from the skull. Keep aware of its attachment to the head at four key points. These indicate the extremities of the nose's height-to-width relationship. The nose's top point is located where the glabella meets the nasal bone. The bottom point is located at the base of the nose's bulb, which meets the philtrum at the center of the upper lip. The left and right points of the nose's wings attach to the superior maxillary portion of the skull. Be careful to get these proportions right. If the nose is drawn too thin, it will appear too long; if it is too wide, it will appear too short.

1. *Glabella meeting nasal bone*
2. *Width of wings*
3. *Bottom of bulb*

2 Indicate the Outer Boundaries and Locate the Peak of Convexity

Locate the nose's outer points that touch the "scaffolding" of its outside shape. Remember that the wings recede from the lip's center at the philtrum and that the nose's entire baseline wraps three-dimensionally around the cylinder of the teeth.

Locate the peak of convexity, found at the juncture where the top plane meets the under plane of the nose's bulb. This is where the highlight on the nose occurs. (A highlight is the result of two planes meeting convexly.)

1. *Peak of convexity*

3 Construct the Remaining Lines

Once you have your key points marked, construct the remaining important lines to complete the nose.

1. *Peak of convexity*

Draw the Nose in Various Perspectives

Practice drawing the nose from various other perspectives. Whatever the angle, begin by establishing the nose's height-to-width relationship, anchored by the four key extremities. Then find the nose's peak of convexity, which gives shape to the bulb. With these points established, it is not difficult to construct the remaining lines needed to fill out the rest of your drawing.

MATERIALS

- 90-lb. (190gsm) Stonehenge spiral pad (cream)
- crayon or chalk holder (porte-crayon)
- Cretacolor black charcoal lead (medium)
- kneaded eraser
- single-edge razor blades
- thin knitting needle or bicycle spoke

Side View

1 **Establish Height-to-Width Proportions**

2 **Indicate the Outer Boundaries and Locate the Peak of Convexity**

3 **Construct the Remaining Lines**

1. Point of convexity (peak point)

Three-Quarter Downward View

 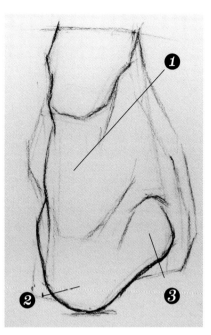

1 Establish Height-to-Width Proportions

2 Indicate the Outer Boundaries and Locate the Peak of Convexity

3 Construct the Remaining Lines

1. *Cartilage*
2. *Bulb*
3. *Wing*

Three-Quarter Upward View

1 Establish Height-to-Width Proportions

2 Indicate the Outer Boundaries Locate the Peak of Convexity

The four main planes of the nose are indicated here. Note that the third plane is hidden from view.

1. *Peak of convexity*

3 Construct the Remaining Lines

1. *Baseline*

THE EYE

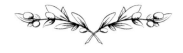

Now let's turn our attention to the eye. We'll begin with a simple frontal view, followed by more challenging perspective views. Before we dive in, let's quickly review the main steps of our process for drawing as we did with the mouth and the nose.

When drawing the eye, remember the three-dimensional nature of its parts. The eyelids are bands of flesh wrapping over the spherical form of the eyeball. The top eyelid contains an under plane where it meets the globe of the eye; the bottom eyelid contains a top plane where it meets the globe of the eye. The iris is a circle wrapping over the globe and should be drawn as such—not as a flat circle.

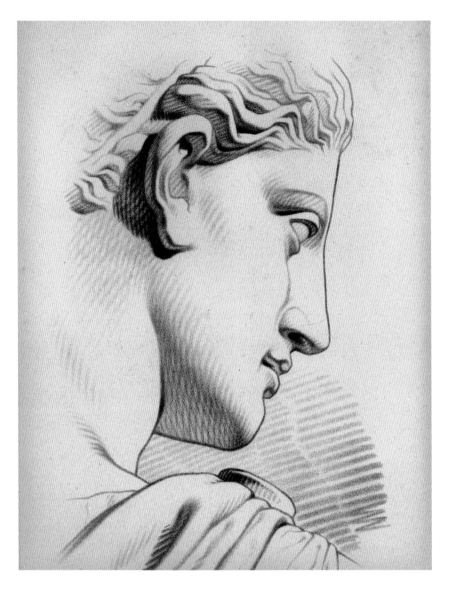

STUDY AFTER *THE ANTIQUE DIANE*
Bernard-Romain Julien
Lithograph, 18" × 13" (46cm × 33cm)

The outer corners of the eyes are farther back on the skull than the inner corners. This is evident when looking at a head in a three-quarter view. Notice that the tear duct is in front of the outer corner.

Draw the Eye in a Frontal View

Follow the steps to draw the eye in a straight-on frontal view.

1 Establish the Width of the Eye Opening

Place your first mark at the inner corner of the eye, the tear duct. This is a stable landmark, making it a good reference point for future marks.

2 Position the Outer Corner and Peak Points

Find the position of the outer corner of the eye, which in most perspectives is higher than the inner corner, by projecting a horizontal plumb line from the inner corner of the eye. These two points together go a long way in describing how the eye is oriented in space. Once you find the eye's width and direction, look for the peak points of the eyelids at both the top and bottom of the eye. The eyelid's top peak is closer to the inner corner; the bottom peak is closer to the outer corner. The inner tear duct will be lower than the outer corner.

1. *Peak points of the upper and lower eyelids*
2. *Inner tear duct*

3 Fill In the Outer Edges of the Eye

After you've marked the peak points, use them as guides to draw the lines marking the outer edges of the eye. The base boundaries of both the upper and lower eyelids should meet with the globe of the eye (sclera).

4 Add the Iris and Pupil

After the main boundaries are in place, add the iris and the pupil. At this point, you've constructed the basic form of the eye, and the viewer will understand its form and orientation in space.

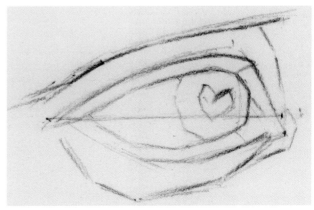

Draw the Eye in Various Perspectives

Although these perspectives may seem difficult at first, by locating the same key points and by finding the same lines, you can convincingly depict the eye in any perspective.

MATERIALS

- 90-lb. (190gsm) Stonehenge spiral pad (cream)
- crayon or chalk holder (porte-crayon)
- Cretacolor black charcoal lead (medium)
- kneaded eraser
- single-edge razor blades
- thin knitting needle or bicycle spoke

Three-Quarter View

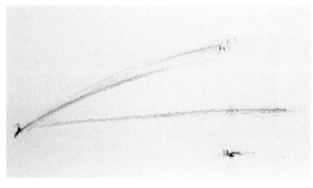

1 Establish the Width of the Eye Opening

2 Position the Outer Corner and the Peak Points

3 Fill In the Outer Edges of the Eye

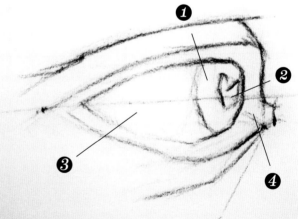

4 Add the Iris and Pupil

1. *Iris*
2. *Pupil*
3. *Sclera*
4. *Carancula lacrimalis (inner tear duct)*

Three-Quarter Upward View

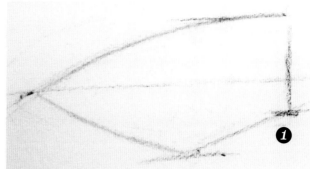

1 Establish the Width of the Eye Opening

2 Position the Outer Corner and the Peak Points

1. *Inner tear duct lower than the outer corner*

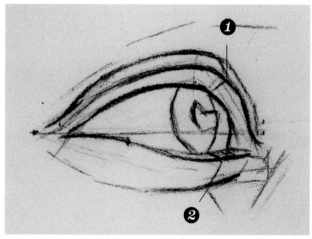

3 Fill In the Outer Edges of the Eye

1. *Point of inflection of S-curve*

4 Add the Iris and Pupil

1. *Thickest area of the eyelid*
2. *Cross-section of the eye to confirm construction*

SIDE VIEW OF THE EYE

1. *Top and under planes of the upper eyelid meeting globe of eye*
2. *Base boundaries where eyelids meet the globe of the eye*
3. *Top and under planes of the lower eyelid meeting the globe of eye*

THE EAR

The ear is the most complex of all the features, but it can also be the most fun to draw. Much of the challenge (and the fun) of drawing the ear comes from the fact that it has distinct interior forms within its outer boundaries.

Before you begin drawing the ear, it's worthwhile to consider how the interior forms relate to the larger shapes. The outside shape of a form is sometimes called the optical boundary or the contour. It is the edge of the form, the last part of the form that the eye can see. You can also find optical boundaries of interior forms, such as cartilaginous protrusions of the ear. The edges of attached forms, where the base of one form is attached to the surface of another, are called base boundaries. The contours of these interior forms come where the form lifts away from the base boundaries and presents an edge that the eye can see around.

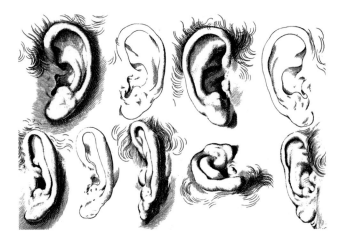

STUDY OF EARS
José de Ribera, ca. 1620s
Etching, 6" × 8" (15cm × 20cm)
The ear varies as a shape more than any other feature. Its outer framework is entirely cartilaginous. The ear's spiraling, arabesque lines that move three-dimensionally in space can be a sleigh ride for the eye, as seen in these studies by José de Ribera.

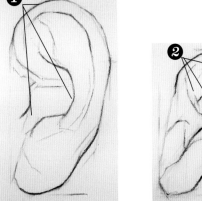
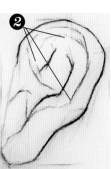
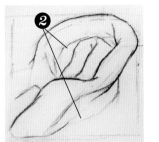
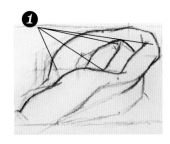

CONTOURS AND BASE BOUNDARIES OF THE OUTER AND INNER EAR

As the ear tips further away, the interior contours become more pronounced. The base boundaries become more foreshortened and their optical boundaries become more distinct. It's like observing a mountain range from an airplane—as the airplane descends, you begin to see the edges of the mountains in front of one another.

For centuries, artists have been sensitive to the qualities of these different types of boundaries. It's common to use a darker line to express an optical boundary and a lighter line to convey a base boundary. This can result in an expressive, sculptural, three-dimensional drawing. It also affords an opportunity to draw multiple studies of a form in a short time span because of its shorthand way of expressing the third dimension. As you draw the ear, use stronger lines for contours of the exterior and interior forms and lighter lines to delineate the base boundaries of the interior forms.

1. *Optical boundaries*
2. *Base boundaries*

Draw the Ear in a Frontal View

Follow the steps to draw the ear in a straight-on frontal view.

MATERIALS

- 90-lb. (190gsm) Stonehenge spiral pad (cream)
- crayon or chalk holder (porte-crayon)
- Cretacolor black charcoal lead (medium)
- kneaded eraser
- single-edge razor blades
- thin knitting needle or bicycle spoke

1 Establish Height
Beginning with the outside shape, indicate the ear's height by marking its highest and lowest extremities.

2 Establish All Four Extremities
Compare the ear's height to its width, and mark its left and right extremities.

1. *Helix*
2. *Concha*
3. *Tragus*
4. *Antitragus*
5. *Lobe*

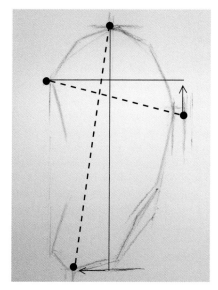

3 Sketch the Outer Shape
Lightly sketch the ear's outer shape, using the peak points as your guide. Relate the four peak points by plumbing and leveling.

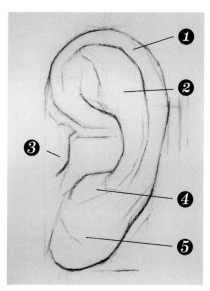

4 Indicate the Interior Lines and Refine the Curves
Construct the interior forms to fit within the whole. Finish by indicating the most important interior lines and refining the curves of the form.

 DEMONSTRATION

Draw the Ear in Various Perspectives

Continue to practice drawing the ear in perspective—a side view and two tipping views that become progressively foreshortened. Note that these steps follow the same pattern we've used throughout this chapter. Begin by marking the form's extreme points, then use those marks to delineate its outer shapes, and finally, find the major interior forms and selectively refine and emphasize their curves.

MATERIALS

- 90-lb. (190gsm) Stonehenge spiral pad (cream)
- crayon or chalk holder (porte-crayon)
- Cretacolor black charcoal lead (medium)
- kneaded eraser
- single-edge razor blades
- thin knitting needle or bicycle spoke

Tilting View

1 **Mark the Highest and Lowest Extremities**

2 **Mark the Left and Right Extremities**

3 **Sketch the Outer Shape**

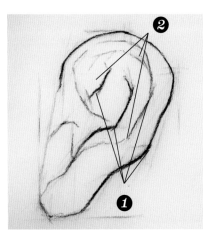

4 **Indicate the Interior Lines and Refine the Curves**

1. *Optical boundaries*
2. *Base boundaries*

Far-Tilting View

Being familiar with the parts of the features will help you make more informed decisions as you draw. At the same time, you don't want your drawings to be just an accumulation of parts; you want them to be a unified whole. This is why it's best to begin by defining the outer boundaries of a form and then constructing the smaller forms contained within it. In other words, work from outside to outside, and then inside to inside.

By putting a line around a form, you're grasping its existence and, as a result, you can model the form with planes so that it appears three-dimensional. As the nineteenth-century artist and instructor John Gadsby Chapman said, "It is not enough that the pupil should be able to draw an object before him, but he should understand and learn to remember its form and character." Without this understanding, you're merely copying the flat two-dimensional appearance of an object, as opposed to understanding and presenting its three-dimensional construction.

1 Mark the Extremities

2 Sketch the Outer Shape
Draw all of the form's optical and base boundaries.

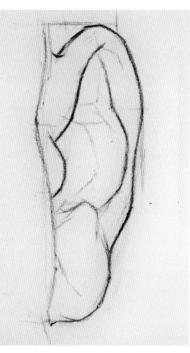

3 Indicate the Interior Lines and Refine the Curves

The separation of the ear's optical and base boundaries adds a third dimension to the form.

1. *Optical boundaries*
2. *Base boundaries*

Side View

1 Mark the Extremities

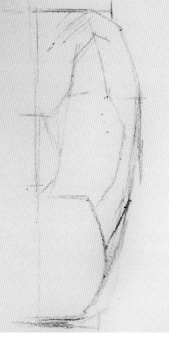

2 Sketch the Outer Shape

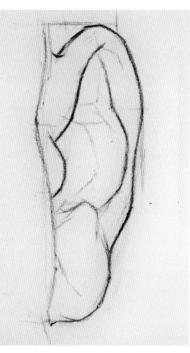

3 Indicate the Interior Lines and Refine the Curves

MODELING FORM

If you don't understand a form's true character and shape, you're merely copying two-dimensional shadow shapes, and your drawing will not have a sense of life and dimension. The importance of understanding a form's shapes before modeling can be seen in the drawing of the hemisphere below. As the result of finding the sphere's base boundary, you can decipher the form's three shadows: the form shadow, the reflected-light shadow and the cast shadow. The same principle applies when drawing the features, as shown in the illustrations of the ear.

Remember that learning to draw means acquiring knowledge. Drawing is most enjoyable when you're actively engaged in every step of the process. It's the process that's most important. A good process will yield a good drawing.

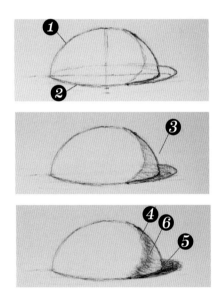

PROGRESSION OF SHADOWS ON A HEMISPHERE

The form shadow is on the form itself, defining the exact point where the light ends. The lighter, reflected-light shadow occurs within the larger form shadow and further reveals the curving of the form. The cast shadow is located on the ground plane, the result of the hemisphere blocking the light. The base boundary of the sphere marks the exact point where the reflected light ends and the cast shadow begins.

SHADOWS ON THE EAR

After the ear is constructed with an understanding of its optical and base boundaries, you can discern where different shadows belong on the form and shade the drawing accordingly.

1. *Optical boundaries*
2. *Base boundaries*
3. *All shadows shaded lightly*
4. *Form shadows*
5. *Cast shadows*
6. *Reflected-light shadows*

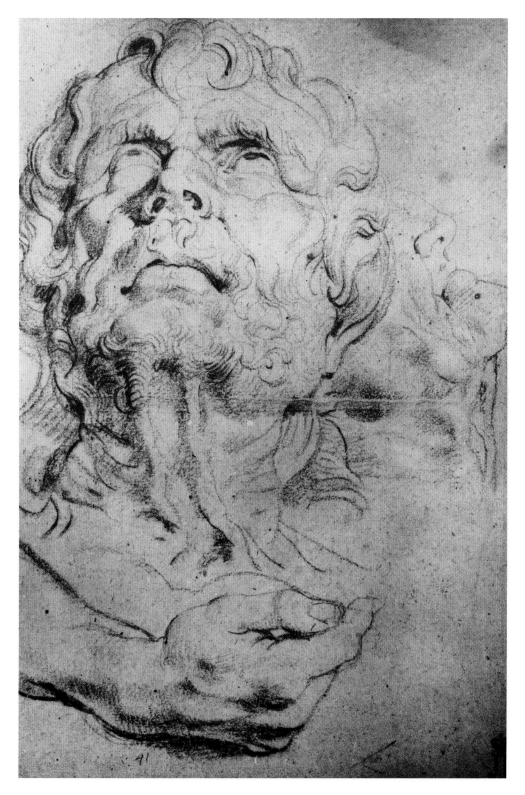

HEAD STUDY
Peter Paul Rubens, ca. 1618
Black and white chalk, 13" × 9" (33cm × 23cm)
Collection: Hermitage Museum, St. Petersburg, Russia

The importance of this approach can be seen in this head study by Rubens where the modeling is based on the artist's ability to construct a line drawing with great graphic power. You can see how the artist's strong conception of the forms' optical and base boundaries enhances their three-dimensionality.

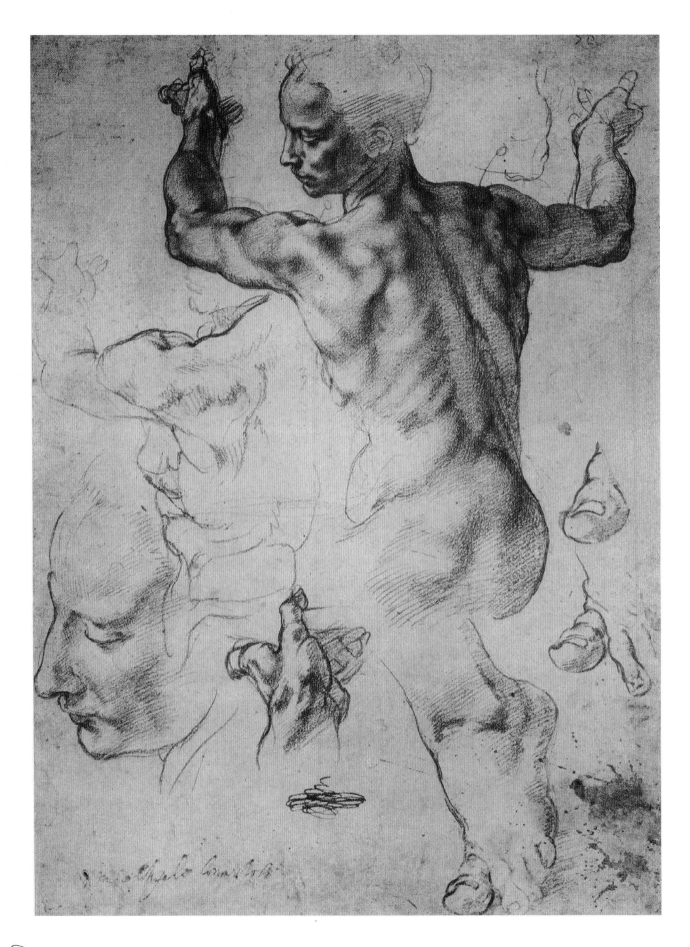

6

THE HEAD, HANDS & FEET

The great cinematographer Gordon Willis once said that he wanted to become an artist, but he could never learn to draw hands. I've often heard both professional artists and students say that hands and feet are the most difficult to draw. Why is this so? It could be that if you tried to simply copy a hand or foot, it would be impossible to draw convincingly. Even when working from a live model, it is difficult to trust what you see. Hands and feet cannot merely be copied; they must be constructed with knowledge and understanding.

Attaining the correct proportions of a subject as complex as the human head can also seem like a daunting task. But by studying basic techniques for using proportion and measurement wisely, and by breaking human proportions down into understandable parts, you can master techniques that will greatly help you achieve a realistic likeness of your subject. Although the focus of this chapter will be the head and extremities, keep in mind that the techniques covered here are universal and apply to all subjects.

In this chapter you will learn:

- different methods for checking your drawing for proportional accuracy
- the leading structural characteristics of the head, hands and feet, including the most important aspects of their underlying anatomy
- how to use line to convincingly depict the head, hands and feet in space
- how to draw the head, hands and feet from various angles, including foreshortened views.

STUDIES OF THE LIBYAN SIBYL
Michelangelo
Red chalk on white paper , 11" × 9" (28cm × 23cm)
Collection: The Metropolitan Museum of Art, New York, New York

GETTING STARTED: THE INITIAL SKETCH

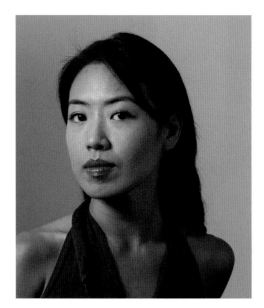

Proportion is, in essence, ratio. Determining correct proportion is a matter of measurement and comparison. As we draw, we are continually relating one thing to another, and relating various parts to the whole. We may not realize it, but when we draw, we perform these sorts of comparisons all the time.

Before we dive into a discussion of measurements, it is important to emphasize that it is not wise to begin a drawing by measuring, or to use measurement as the sole means of creating a drawing. You first must draw your subject by eye so that you can then use measurement to compare and check your drawing for accuracy. Ultimately, the eye must be the judge of a well-proportioned drawing. Duke Ellington once said, "If it sounds good, it is good." The same principle applies to drawing. If it looks right, it is right.

Keeping this in mind, it is important to lightly sketch your whole subject before finishing any single part. If the entire subject is not depicted on the paper, at least as a sketch, the eye cannot accurately scan and monitor the inter-relationship of the parts. To begin by sketching the entire subject is a guiding principle of drawing. It will go a long way to help you to see proportional relationships.

Before drawing, you should mark the head's length. You will not adjust these marks as the drawing progresses—rather, you will adjust everything else to fit these marks. In most views, the head's height will be greater than its width. So, for a drawing of the head, it is good to use its height as your standard. Stick to these two marks to ensure that the head does not constantly grow and shrink as you make corrections.

Before you can advance to modeling form, your proportions must be accurate—a challenging task, incorporating many small problems. How do you "prove" your drawing if the proportions are eluding you and you're struggling to find them? One option is to figure it out the hard way, through extensive trial and error. But there are better methods, which approach the challenge systematically and allow you to obtain the correct proportions more easily.

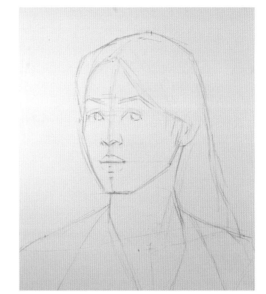

DON'T MEASURE FOR THE INITIAL SKETCH

The initial sketch should be drawn by eye, not based on measurement. As the American artist Frank Fowler wrote, "Never measure in any way when beginning a drawing, but strike out bravely, resolving to depend upon the eye only. After the first outlines are put in and the proportions are as nearly correct as you can make them, it is perfectly legitimate to 'prove' a drawing through measuring."

It's also important to keep things simple at first. Reduce your subject to the fewest lines possible. This makes the bigger relationships more identifiable. It's easier to correct simple shapes than more complicated ones.

I recommend drawing the head slightly smaller than life-size. This makes it easier to compare your drawing to the model by minimizing the size discrepancy. It also makes the head look graceful and natural.

FIRST MEASUREMENTS: HEIGHT & WIDTH

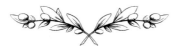

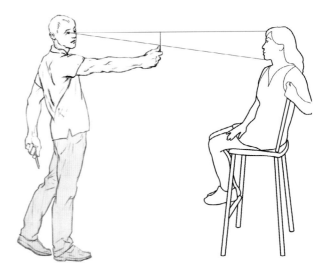

Before you explore the different ways of checking proportions, it's important to note two things. First: Excessive measuring can become a crutch. An overly measured drawing will appear stiff and mechanical. As Ingres said, "The painter who trusts his compass is leaning on a ghost." Use measurement wisely and economically, lest it severely compromise rhythm and expression in your drawing.

Second: Remember there is a disconnect between the way you draw and the way you measure. When you draw, the outlines you create move up, down and across the paper. But they also appear to move in and out through space. A drawing, in essence, depicts your subject's three-dimensional qualities.

ESTIMATING THE OUTSIDE SHAPE OF A SUBJECT

The first proportional question you need to ask yourself is: *Does the height exceed the width, or is the opposite true?* To determine the answer, use a metal stick to practice the technique of comparative measuring.

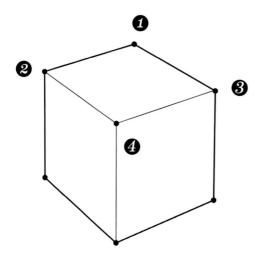

MEASURING AND THE PICTURE PLANE

When measuring, you temporarily flatten your subject's appearance on the picture plane. In other words, measuring has nothing to do with depth. Think of the picture plane as an invisible pane of glass between you and the subject. Only when you visualize your subject in this way can you correctly ascertain proportional relationships by judging the way they appear flattened on the picture plane.

1. *4th in depth (furthest point)*
2. *3rd in depth*
3. *2nd in depth*
4. *1st in depth (closest point)*

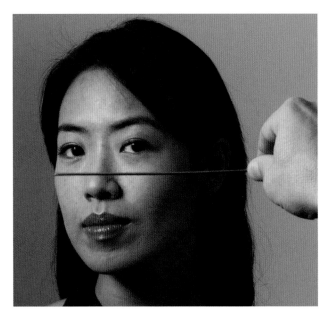

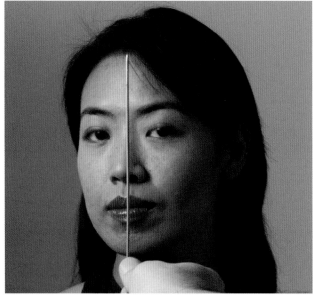

MEASURING THE WIDTH OF THE HEAD

Once you mark the top and bottom of the head on your paper and sketch your subject, check your proportions by measuring. Start with the width of the model's head. Hold your measuring stick, close one eye, and fully extend your arm. Align the tip of the measuring stick with one side of the head's outermost extremity. Place your thumbnail on the stick at the opposite side's extremity. The distance between the end of the stick and your nail is the width of the head.

COMPARING WIDTH TO HEIGHT

Rotate your width measurement and compare it to the vertical length of the head's height. By comparing the height to the width measurement, which is indicated by the placement of your nail—you learn the ratio of the head's height to its width. (In this case, the width falls at the model's hairline and is shorter than the height.)

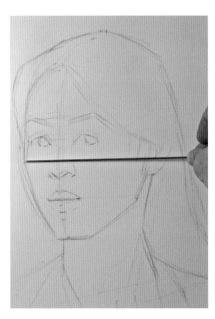

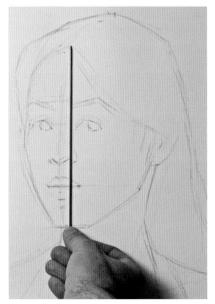

CHECKING MEASUREMENTS

Compare the width of the head in your drawing to its height using the same process you used to measure the model. If the ratio on your page is the same as it is on the model, the overall proportions of the head are accurate. If the ratio between the height and width of the model's head differs from the ratio on your drawing, make the necessary corrections and then re-measure before advancing your drawing.

If adjustments are needed, it's critical that you only adjust the width. Never compromise your original benchmarks (in this case, the height). If you change the original benchmark, you no longer have a basis for comparison. At this stage, keep the drawing as simple as possible to allow for corrections to be made easily.

After drawing the outside shape, you can orient the head in space by discovering its imaginary surface centerlines, which traverse the head horizontally and vertically. These lines help to place the features accurately because they allow you to base the features on a three-dimensional concept rather than a flat, two-dimensional one. Also consider that the head is not often viewed straight on. Remember to carefully relate how the head sits on the cylinder of the neck.

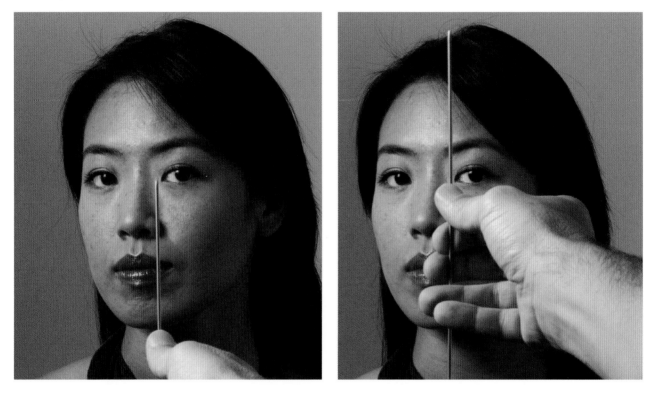

CAPTURING LANDMARKS

The first landmark to capture on the head is the tear duct because it's the most stable and unchanging of all the features. The eyelids move up and down, but the tear duct always holds its place. It serves as a good anchor to which other features relate. If the tear duct is placed correctly, then the features will fit. If the tear duct is placed incorrectly, they won't. I recommend drawing the tear duct that is closest to you, then placing the other one in relation to it.

First mark the tear duct by eye, then use measuring to check its placement. Measure using linear proportion—the comparative lengths of the segments marked along a line (in this case, the vertical line from the top to the bottom of the head). Fully extend your arm, keeping one eye closed. Position the stick vertically, align the tip with the tear duct and place your thumbnail to match the bottom of the chin. Note where the tip of the stick lies in relation to the top of the head. In this case, both these segments appear to be the same length—meaning the tear duct is located very near the middle of the model's head.

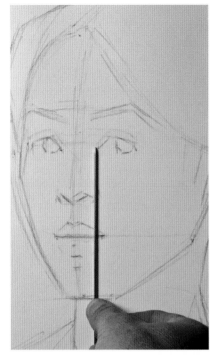

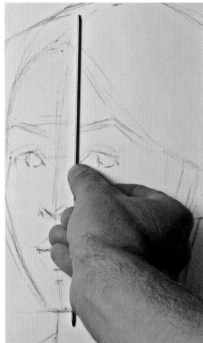

EVALUATING YOUR DRAWING

The relative position of the tear duct should be the same in your drawing as it is on the model. When I did my measurements, I found that the tear duct was located almost exactly halfway down the length of the model's head. However, when I measured my drawing, I found that I had drawn the tear duct beneath the halfway point. An adjustment was in order.

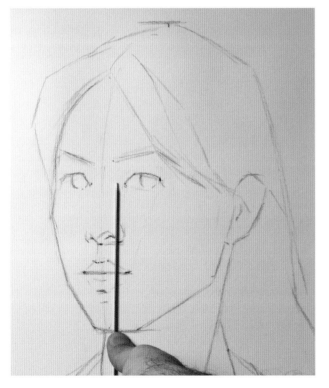

MAKING CORRECTIONS

Redraw the position of the tear duct and then re-measure. Do not change the height of the head, since this is one of your fixed benchmark measurements. For my drawing, I redrew the tear duct slightly higher. When I measured again, I found that the re-drawn tear duct matched the location of the model's tear duct.

Tips From the Old Masters

John Singer Sargent advised, "When drawing the model, never be without the plumb line in the left hand. Everyone has a bias, either to the right or the left of the vertical. The use of the plumb line rectifies this error and develops a keen appreciation of the vertical." I would go further and recommend keeping a measuring stick at hand to help determine angles from both vertical and horizontal reference lines. A measuring stick also lends itself readily to comparative measuring.

Vertical and horizontal reference lines can be used to find how landmarks relate to one another. The artist Thomas Couture advised students to "establish, either in imagination or in reality, a horizontal and a vertical line in front of the objects one is reproducing." It is best to compare your subject's diagonal lines to standard vertical and horizontal reference lines. Comparing one diagonal to another can be confusing and can create new problems. But simply by trusting your eye and confirming what our eye sees through basic measurements, you can attain an accurate likeness.

CLASSICAL PROPORTIONS

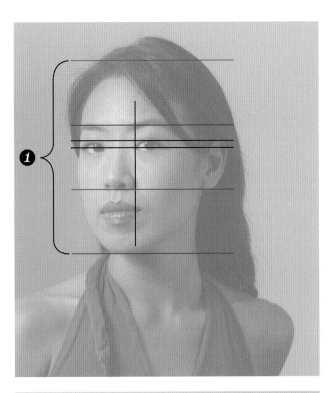

When making these measurements, it's helpful to have some knowledge of the classical canons of proportion. This allows you to better appreciate ways in which every model's proportions differ from the classical norm. Looking at an ideal head straight on, the three areas from the hairline to brow, from the brow to the bottom of the nose, and from the bottom of the nose to the chin will be equal thirds. You can use comparative measuring to find these relationships on your model and judge if and where they differ from the ideal.

The correct proportional relationships of the features are vital to a likeness; they give character to each individual. A likeness is the result of an accurate drawing, and these proportional relationships, which are informed by knowledge of classical proportions, are a way to assure yourself that you are making an accurate drawing.

Additional Useful Tools for Checking Accuracy

It can be easy to convince your eyes that what you drew was accurate, so the more ways you can look at your drawing objectively, the better. In addition to a measuring stick, try looking at your drawing upside down, from a distance or in a mirror or anything that lets you to see it in a new way. The sudden change of view will enable you to see problems you've been predisposed to ignore. I find the mirror, in particular, to be an effective tool, especially when drawing the head. When I draw a model in my studio, I'm never without a mirror behind me.

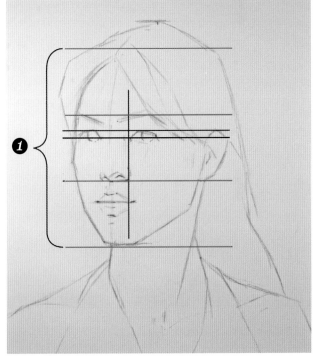

IDEAL PROPORTIONS OF THIRDS

Here the proportions of the thirds (red lines) along with reference lines (black lines) overlaid on the model's head and on the drawing. The top third begins approximately where the top plane of the skull meets the side plane of the forehead—marked by the top red line. From this comparison, I was able to determine that the drawing accurately depicts these proportions.

1. *Ideal proportions of thirds*

Model the Head on Toned Paper

MATERIALS

- Conté à Paris crayon pencil
- crayon or chalk holder (porte-crayon)
- Cretacolor white chalk lead
- kneaded eraser
- single-edge razor blades
- Strathmore 500 Series charcoal and pastel paper (Fog Blue)

Follow the steps to draw the head on toned paper. This method of modeling on toned paper is typical of most Old Master drawings created in the sixteenth, seventeenth and eighteenth centuries. Painters wanted to accelerate the process of drawing, so toned paper with chalks was their preferred medium. The Carlo Maratta drawing in chapter 3 is a good example of this.

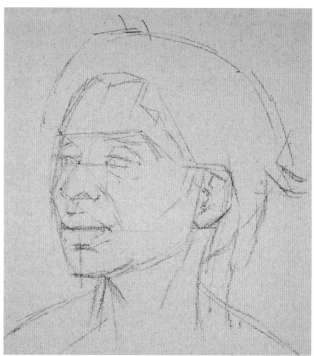

1 Sketch the Outside Shapes

Your first lines should be the estimations of the head's outside shape (optical boundary). Your second lines should be the adjustments—make these as light and even as possible so that later corrections and changes will be easier to make. Work outside-to-outside first, then work outside-to-inside, looking for the shape of the hair that borders her face. You want your lines to be large sweeping arcs that relate to the head's most significant projections that affect the outside and inside shapes. Straighter line segments generally depict quicker changes of the form's direction, like the hair that borders the face, ear, angle of the jaw and neck. Longer line segments are more characteristic of sweeping arcs, like the outside shape of the hair and the left side of the face.

2 Sketch the Inside Shapes and Place the Key Features

Once you've drawn your best attempt of the head's outside shape, focus on the inside shapes while continually relating one to another. Then set up the surface centers for the placement of the features (the feature guidelines). Try to draw the features in their simplest terms so that you can move them easily if adjustments are needed.

The most important feature landmark is the inner tear duct. Draw the one closest to the viewer first. If this is located correctly, chances are the other features will be proportionally correct, and a likeness will result. Memorize the classical proportions of the ideal head so that you can see where the model's proportions may differ.

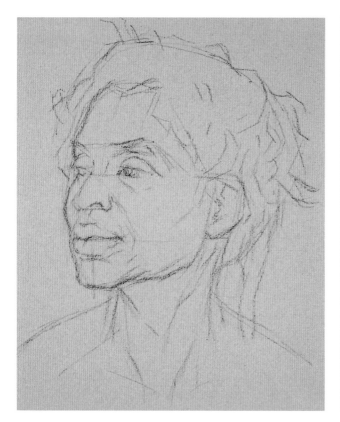

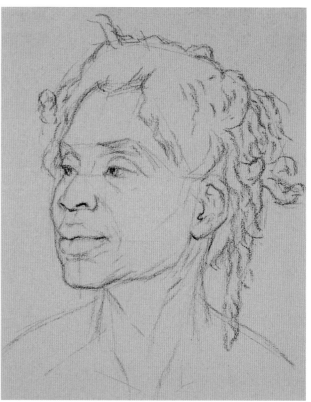

3 Refine the Shapes

After correctly relating the parts within the whole and setting up the features, refine the form's shapes while solidifying their three-dimensional construction. Using line to sculpt the most significant optical boundaries through the overlapping of forms helps achieve this aim.

Look for the most emphatic base boundaries, which exhibit themselves at the edges of form that have the deepest relief—the globe of the eye that meets the upper eye socket, the base of the nose and the parting of the lips, for example. Bring these forms out first and then progress to the shallower forms in their order of relief. Not unlike modeling with values, which follow the same order of impression, the shadows come first, then the darkest lights (halftones) and finally the light lights.

4 Strengthen the Features and Differentiate the Optical Boundaries From the Base Boundaries

Strengthen the orifices—the nose, mouth and ears. These are, in essence, the "holes in the head." The pupil and iris of the eye also give rich accented darks that expand the drawing's value range. Even the locks of hair should be "sculpted" because anything that is not first grasped in line can be modeled with any degree of understanding.

Keep your lines varying in weight according to the form's relief. Generally speaking, the optical boundaries should be darker than the base boundaries. Base boundaries also have varying line qualities, depending on the angle at which one form meets the surface of another form. Use lighter lines to show the low relief forms that land softly on their base boundaries, which are obtuse. Use darker lines to indicate forms that land more abruptly or acutely on their base boundaries. This is the last phase of linear construction before modeling with values.

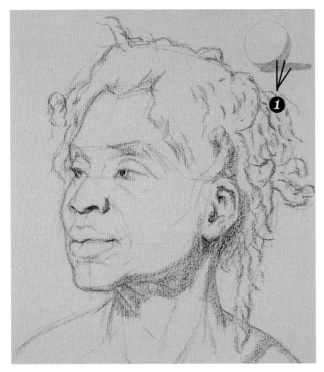

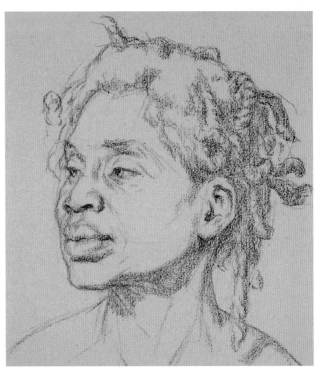

5 Lay In the Shadows

This is a crucial stage to the modeling of a drawing because you must be aware of which parts of the form are in shadow and which parts are not. Lightly grain in all the shadows. This will make it easier to darken them as you differentiate their qualities as the drawing progresses. The three main shadows are form shadows, reflected-light shadows and cast shadows. A good rule of thumb is to begin with your highest value reflected-light shadow.

1. Reflected-light shadow values

6 Deepen the Shadows

Deepen the shadows so that you can model your most significant dark lights (halftones) that express the forms that have the deepest relief. The process of modeling is no different than a photographic image emerging from a developing bath. As the shadows deepen, the halftones begin to appear, but always in their proper relation to the shadows—no matter what stage of the drawing. The old adage that a drawing should look good at every stage is based on this principle.

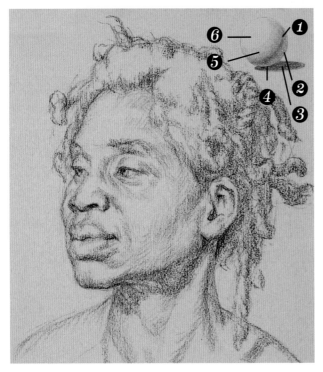

7 Continue Modeling Up to the Middle Light Value

As the shadows deepen, the values of the halftones gradually expand showing the subtler inclinations of the form's surface. They expand all the way up to the paper value, which serves as the middle light value. The middle light is generally reserved for the side plane. Up to this point, you have modeled only the halftones—the most important values for "rounding" form. The lightest lights and highlights have been omitted. This type of drawing is called a stopped-modeled drawing, because the gradations stop at the paper—the middle light value. (See the sphere on the upper right.)

1. Form shadow
2. Reflected-light shadow
3. Cast shadow
4. Accent
5. Halftones
6. Middle light (paper)

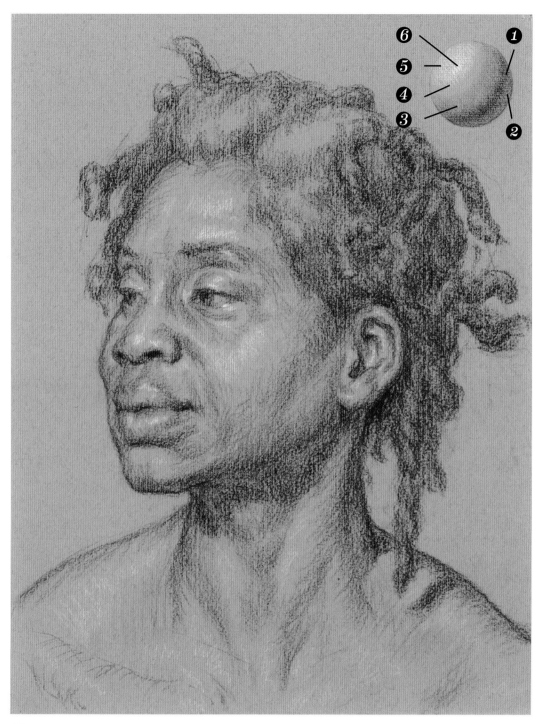

8 Strengthen the Shadows and Finish

Continue strengthening the shadows. This will allow you to give a full range of values from the darkest shadows all the way up to the highest highlights, which should be added with the white chalk. Working on toned paper accelerates the modeling because it allows the middle-light value to show through, creating its own modeling factor. (See the sphere in the upper right.) Since the subject's hair is a darker local color than her complexion, white chalk is not applicable.

MARILYN
Jon deMartin, 2015
Red and white chalk on toned paper
11" × 9" (28cm × 23cm)

1. *Form shadow*
2. *Reflected-light shadow*
3. *Halftones*
4. *Middle light (paper)*
5. *Light light*
6. *Highlight*

FORESHORTENING THE HEAD

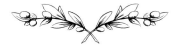

It is easy to be intimidated by foreshortening—the task of depicting forms that lie at an angle to the picture plane. It requires you to make skilled use of perspective for these forms to read as believable. However, by simplifying your subjects and breaking down the problem, you can approach foreshortening in an effective and manageable way.

The Underlying Shape of the Head

Drawing a head, especially in perspective, is not a mimetic endeavor. You cannot merely copy a head and expect it to appear realistic as a volume in space; it will be flat and unconvincing. Instead, you must understand the head as a solidly constructed, three-dimensional volume. Only then will you be able to draw heads from any angle so it appears to truly exist in the space.

If you develop the ability to reduce complex forms to simple ones, you will give power and accuracy to your art. Learning to draw the head (or anything else, for that matter) begins with understanding the basic, simplified essence of what you are depicting. Children usually draw the head as a circle, or a shape that resembles an egg. They're on to something. The head does, in fact, resemble an egg, or ovoid. In order to draw the head, you must first master this simple form.

DRAWING A THREE-DIMENSIONAL OVOID

The key to drawing an ovoid in three dimensions is to pay close attention to its centerlines—the imaginary lines that run down and across the shape, vertically and horizontally. Depicting the centerlines on an ovoid helps you see and depict the form's orientation in space. Here we see how you can use horizontal and vertical centerlines to help depict an ovoid tipping, turning and tilting. The first image (1) shows the shape facing straight forward at no angle to the picture plane. It appears flat and two-dimensional. As the ovoid turns, the vertical line no longer runs straight down through the middle of the shape—it begins to curve (2). As the shape tips up or down, the horizontal centerline also curves (3 and 4). The more it tips, turns and tilts, the more the illusion of 3-D increases because the centerlines are also seen to curve in multiple directions (5 and 6). Mastering these difficult views can serve as testimony to an artist's virtuosity, as with many Baroque artists who reveled in this illusion when depicting saints looking heavenward.

STUDIES OF HEADS AND HANDS
Hans Holbein the Younger
Pen and ink, 5" × 7" (13cm × 19cm)

For centuries, artists have used centerlines to help convey the three-dimensional appearance of the head. Renaissance artist Hans Holbein practiced drawing the underlying egg shape of the head and inscribed it with centerlines to help convey its orientation. These views clearly demonstrate his knowledge of the head in perspective. His use of construction lines conveys the head's position in space.

Other early drawing instructors, such as the seventeenth-century artist Willem Goeree, advised students to paint a wooden egg with lines indicating the location of the features. He recommended drawing this egg in various positions—first from life, then from memory.

HEAD STUDY FOR *FAITH IN THE WILDERNESS*
Jon deMartin, 2006
Black and white chalk on toned paper, 21" × 14" (53cm × 36cm)

Foreshortening is challenging, but by paying attention to the basic shapes
that underlie complex forms, you can learn to represent subjects as they twist
and turn in space.

Foreshortening and Proportions

Now that you've had some practice drawing the head in basic classical proportions in a simple frontal view, let's explore the principles of drawing the head in foreshortened proportion.

As shown in the illustrations below, the vertical centerline goes down the middle of the head, bisecting the nose and the mouth. This line will enable you to correctly place the features. The horizontal centerline, meanwhile, runs through the tear ducts or inner corners of the eyes.

There are several useful conventions regarding the height of the head that can also help you place the features correctly. As a basic rule, the vertical length of most of the head can be divided into thirds. These three segments span the distances from the hairline to the eyebrow, from the eyebrow to the base of the nose and from the base of the nose to the point of the chin.

The lower third of the face—from the base of the nose to the point of the chin—can also be divided into thirds. The upper third runs from the bottom of the nose to the center of the mouth. The middle third runs from the center of the mouth to the upper chin. The lower third runs from the upper chin to the bottom of the chin.

The width of the human head can be divided into equal parts as well. These are generally based on the width of the eye, with the head being five eyes wide. The distance between the two eyes is the width of one eye.

These proportions will be more-or-less consistent in a frontal view of the head—although they vary slightly depending on the exact proportions of the model. But when the head tilts forward or back, foreshortening occurs. Farther-away distances become smaller, indicating that forms are receding in space. For instance, when the head tilts back, the distance between the top third of the head (from the hairline to the eyebrows) appears smaller than the middle third (from the eyebrows to the base of the nose), which in turn, appears smaller than the bottom third (from the base of the nose to the chin).

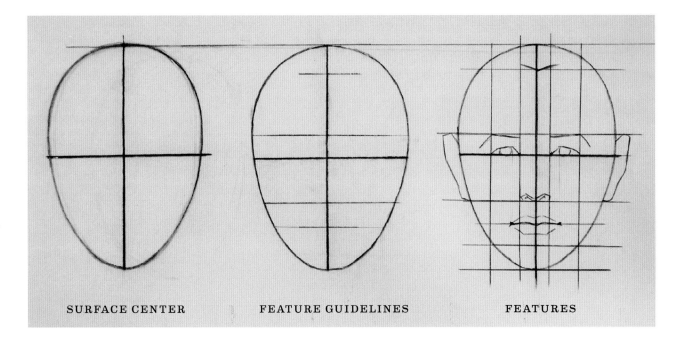

SURFACE CENTER FEATURE GUIDELINES FEATURES

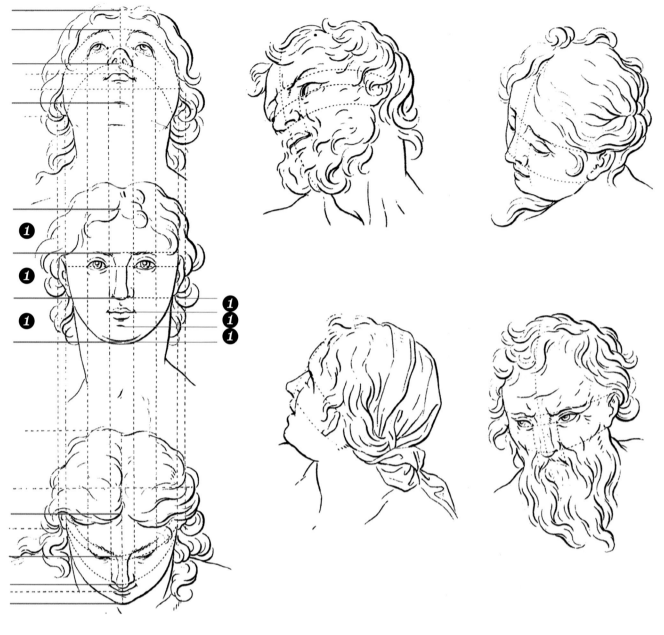

THE HEAD IN VARIOUS FORESHORTENED VIEWS

This eighteenth-century engraving shows the head from various angles, all with foreshortened proportions. Notice that when the head tips backward, the proportional thirds diminish near the top of the head, and the nose appears above the lower extremity of the ear. Inversely, when the head tips forward, the top third appears larger, and the nose is drawn below the lower extremity of the ear. The other views display the head's tipped, tilted and turned orientations along with their construction.

1. *One third*

The Skull

In addition to becoming familiar with the ideal proportions of the head, it is helpful to know some basic information about the skull. It is especially important to pay attention to the skull's proportions, because they determine the spacing of the head's features and the lengths of the features in relation to one another. It is this spacing, even more than the details of features, that most determines a likeness.

The great draftsman and teacher Deane Keller said, "Construction of the head depends on determining the relation of the parts to each other by constant comparison, especially since the head is constructed bilaterally… It is necessary to develop the drawing of the head with constant comparisons side to side, and by using the important reference of the median line."

To conduct these critical side-to-side comparisons, you must pay attention to the landmark points on the head.

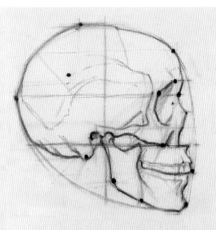

CONSTRUCT THE SKULL FROM VARIOUS VIEW POINTS

After learning the skull's landmark points in straight-on views, you can use these points to help accurately construct the skull from every imaginable view. No matter what position the head is in, you will be able to draw the correct relationship of part to part.

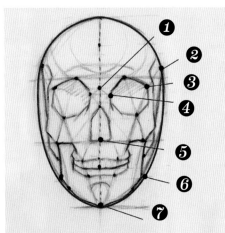

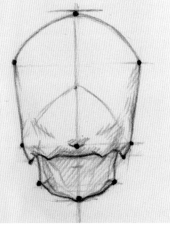

THE SKULL—FRONT, SIDE AND REAR VIEWS

Here we see the skull in front, side and back views marked with what I've found to be the most significant points that help anchor the head in space. (Notice how the skull in frontal view closely resembles an egg.) A well-constructed head depends in part upon knowing these important landmarks. Once you are familiar with these points, you can correspond them to their partners on the opposite side of the head's centerlines.

1. *Top of nasal bone*
2. *Widest part of skull*
3. *Brow ridge*
4. *Tear duct*
5. *Base of nasal bone*
6. *Angle of jaw bone*
7. *Point of chin*

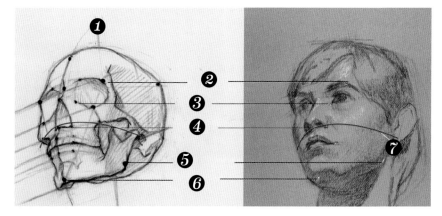

Simplified Head Studies

The correct placement of the head's features hinges on how well you set up the head as a three-dimensional volume with centerlines and sections. The mass of the head is what you hang the features on.

1. *Axis*
2. *Brow ridge*
3. *Tear duct*
4. *Base of nasal bone*
5. *Angle of jaw bone*
6. *Point of chin*
7. *Construction line for base of the nose and the lower ear*

LANDMARKS INFLUENCE FEATURES

By comparing the skull sketch to the head sketch, you can see how the landmarks of the skull influence the features of the head. Note that the bottom of the mastoid bone, the bottom of the cheekbone and the bottom of the nasal bone are all about the same level. This line becomes an important construction line when indicating the head in perspective.

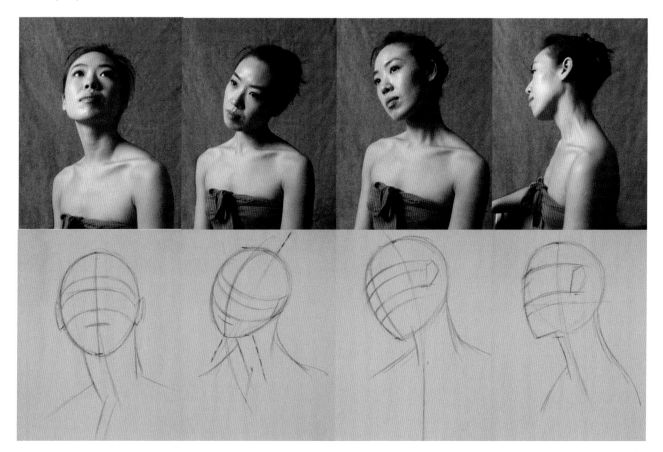

MOVEMENT STUDIES

These images depict the basic tilting of the head with its centerlines curving to further illustrate the head's orientation in space. The object of this exercise was not to achieve a likeness or add the features, but to correctly orient the head and its construction in three dimensions.

Try drawing these simplified forms until you can reliably convey the basic shape and orientation of the head as it turns and tilts. Note that as the head turns to a profile, it resembles less of an egg than it does in a frontal view. As with any drawing, remember that the action, or gesture, is all-important. In this case, the action is seen in the line that unites the head with the neck.

Even though the centerlines and sections are imaginary, they are as important as any other lines in the drawing. They help you determine the proper position and balance of the features and are invaluable when drawing children or restless models. These views are not easy for a model to hold, so it's beneficial to capture the pose in as little time as possible.

Constructing With Line

Light is transient; form and structure are permanent. When drawing a figure from life, modeling with values is secondary to the task of constructing a three-dimensional drawing in line. This is a formidable challenge in any view, let alone a foreshortened one. But when the head is constructed well in line, modeling with value is relatively easy.

Even when drawing professional models, you will find that the head—especially in a tilted position requiring foreshortening—seldom stays in the same position throughout the pose, or when resuming the pose after a break. This makes it all the more important for you to begin by constructing the basic form of the head with line, which can be accomplished before the head's position changes. Once the line drawing is set and you progress to modeling values, you can use the model more as a reference than as something to be copied.

Construction lines are like training wheels. When you've developed enough confidence, you can hold them in your mind and leave them off your paper. But don't be shy—if you think they will help you, draw them! Don't worry about construction lines ruining or interfering with the look of your drawing; be more concerned with getting the head right. A polished drawing means nothing if it's poorly constructed. The famous teacher Robert Beverly Hale noted that in the process of learning to draw, an artist will mess up thousands of drawings with construction lines. Even master draftsmen drew construction lines. Just look at Holbein's head study sketches.

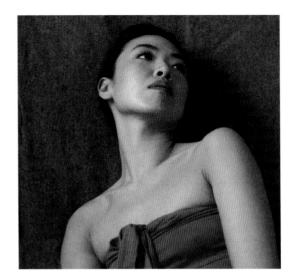

THE MODEL

THE LINE OF ACTION

THE SIMPLE SHAPE OF THE
HEAD AND SHOULDER AXIS

SURFACE CENTERLINES AND
SECTIONS

FEATURE DEVELOPMENT

The features on the head are like bumps
on the larger egg-shaped mass.

FURTHER PLACES

In order to master drawing the head in any perspective, lots of practice is needed. A great exercise for beginners and experienced artists alike is to draw from a plaster cast of a head marked with construction lines. After you've gained some proficiency, draw from a cast without the construction lines. Then progress to drawing from a live model.

When drawing the head in a foreshortened pose, remember that the head as well as all the features will be in perspective. Because of this, it can be good practice to try drawing each feature in every conceivable position. (See chapter 5.)

To help keep your skills sharp, try drawing from classical sculpture, which provides figures and heads in very exciting views. Drawing from sculpture also has the benefit of allowing you to study for a prolonged amount of time without worrying about the model moving or needing breaks. Drawings don't always need to be shaded. It's more important to practice your linear construction. Shading can never redeem a poorly constructed drawing. Remember your anchor points while relating them to perspective.

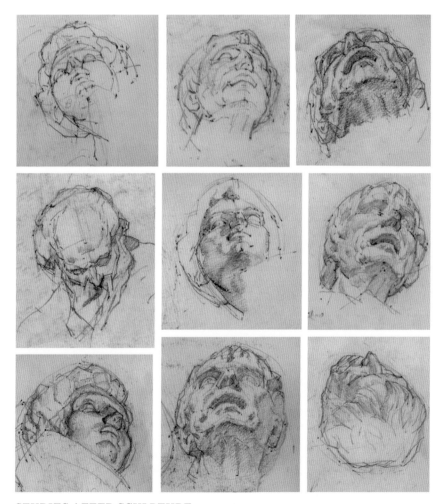

STUDIES AFTER SCULPTURE
by Jon deMartin
Graphite, heads range from 2"–3" (5cm–8cm)

Draw a Foreshortened Head

Follow the steps to draw the head in a foreshortened view.

MATERIALS

- crayon or chalk holder (porte-crayon)
- Cretacolor black charcoal lead (medium)
- Cretacolor white chalk lead
- Ingres charcoal paper (laid finish)
- kneaded eraser
- single-edge razor blades

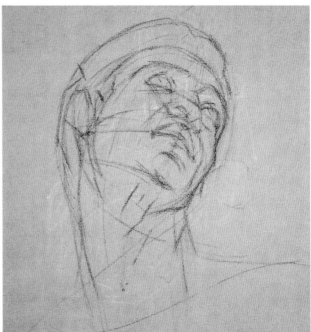

1 Sketch the Outside Shapes

Draw the general outside shape of the head in relation to the neck. To orient the head in perspective, first choose the vertical surface center, which starts from the hairline to the point of the chin. Then draw the horizontal surface center that defines the placement of the tear ducts, which makes the other features relatable.

The length proportions of the features must fit before the drawing can be advanced. Keep your shapes as abstract and simple as possible and never change the size of the head to accommodate the features!

2 Develop the Features and Check Your Measurements

Develop the features in perspective while relating them to the surface centers. Find the construction line from the base of the nose to the bottom of the ear. For checking alignments, use only vertical and horizontal reference lines because checking is always flat! Continually check your fixed landmarks by bilaterally corresponding them to laws of perspective. If one of these lines is off, the whole drawing will be wrong. Remember to keep all lines light and even so any necessary changes will be easy to make.

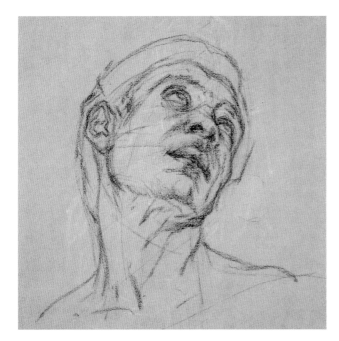

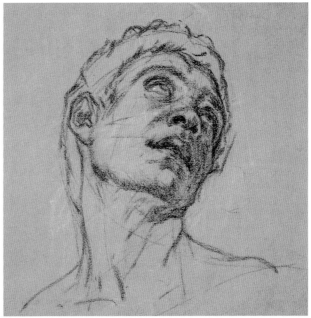

3 Locate the Optical and Base Boundaries and Build the Structure With Lines

Look for the head's optical and base boundaries for its sculptural relief. Understanding the form's interior shapes (base boundaries) and their overlaps (optical boundaries) will help solidify the head's construction before modeling with light and shadow.

Don't rely on shadow shapes for your construction. Instead build a solid structure in line before modeling. However, shadow shapes are a helpful way of confirming your construction when you compare their shapes in relation to the lights.

4 Indicate the Shadows and Develop the Halftones

To further enhance the third-dimension, indicate the shadows by graining them lightly and then darkening them in degrees. Then develop the halftones while keeping them proportionally lighter, no matter what stage. Remember that the darkest halftone in the light is still going to be lighter than the lightest shadow in the shadows.

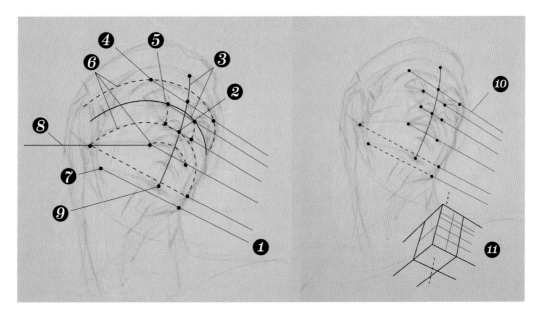

1. *Perspective lines*
2. *Base of nasal bone*
3. *Surface centers*
4. *Brow ridge*
5. *Tear duct*
6. *Feature guidelines*
7. *Angle of jaw bone*
8. *Horizontal level*
9. *Point of chin*
10. *Perspective lines (must converge)*
11. *Head—tipped, turned and tilted*

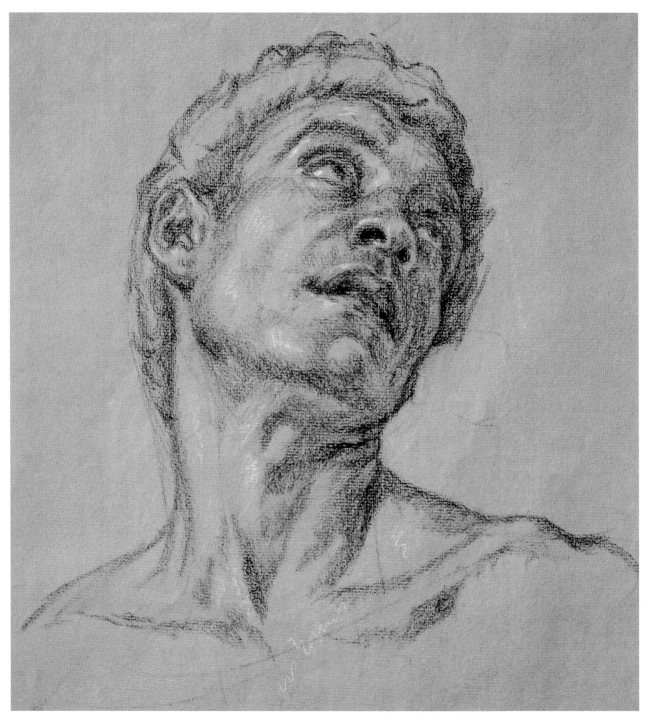

5 Add the Light Values and Highlights to Finish

As the shadows and halftones are strengthened, indicate the lightest lights and highlights with white chalk to heighten the head's relief. Remember to let the paper serve as the middle light. In this way, your modeling can be more abbreviated, which is advantageous, especially with difficult-to-hold poses such as this one.

PEDRO
Jon deMartin, 2015
Black and white chalk on toned paper
18" × 12" (46cm × 30cm)

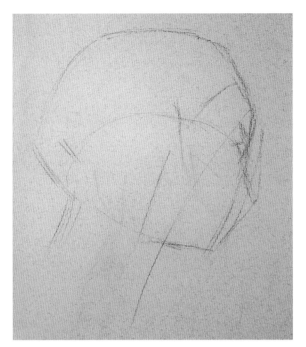

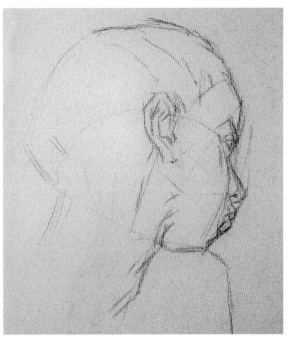

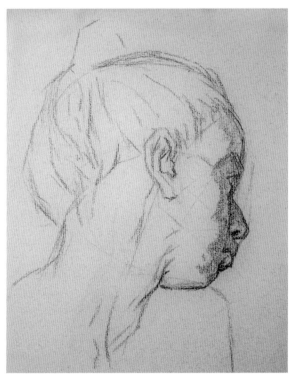

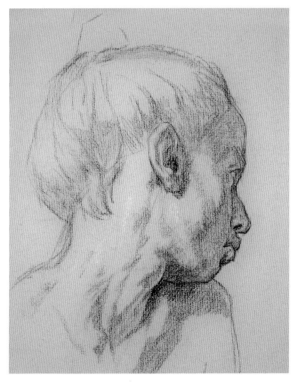

ALTERNATE FORESHORTENED HEAD IN FOUR STAGES

The goal for excellence in figure drawing is that the linear construction remains evident throughout the entire process of creating your drawing. These lines should be as accurate as possible and be drawn aesthetically and carefully in all stages of your work—from the first line to the last. If your thinking is correct, your drawing will beautifully convey three-dimensional form throughout every stage of its development.

VASTA

Jon deMartin, 2015
Black and white chalk on toned paper
14" × 9" (36cm × 23cm)

PROPORTIONS & ANATOMY OF THE HAND

As with all forms, it's best to practice drawing simple views of the hand before attempting more complex angles. Understanding the basic anatomy and proportions of hands is key to depicting them realistically in your drawings.

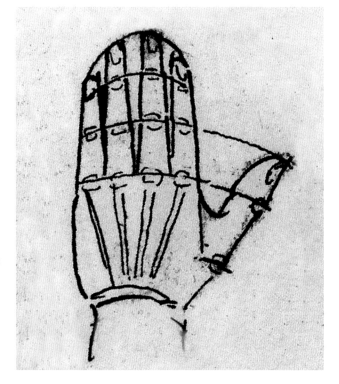

18TH-CENTURY ETCHING

Hans Holbein the Younger, ca. 1497–1543, pen and ink

The bones of the hand determine much of its appearance and movement, so it's good to know a little about them. The carpal bones of the wrist—found just beyond the ulna and radius in the forearm—comprise two rows of eight irregular bones. The five metacarpal bones form the palm portion of the hand. The finger bones—fourteen in total—are the phalanges. With the exception of the thumb, each finger has three phalanges: The phalange closest to the metacarpals is called the proximal phalange. Next comes the middle phalange and finally, the distal phalange. The thumb has only two phalanges—proximal and distal. As you can see, the joint between the thumb's two phalanges aligns with the row of the knuckles in a straight-on view.

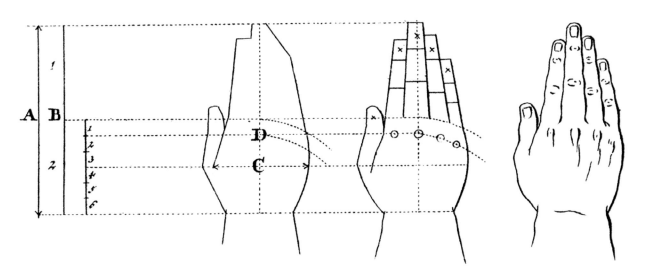

PROPORTIONS OF THE HAND, STRAIGHT-ON VIEW

This eighteenth-century etching shows the important proportions of the hand from a straight-on view. The mid-point of the hand occurs where the middle finger begins, just above the knuckles. Notice that the middle finger's knuckle is located at the apex of a curving line that gradually crosses the hand. Similar curves passing through the finger joints radiate all the way up to the fingertips. When spread slightly, all the fingers (except the thumb) converge upon a point at the center of the wrist.

PERSPECTIVE & MOVEMENT

A draftsperson is only as effective as his or her ability to visualize form in three-dimensions. You must always pay attention to how your subject appears in space and apply perspective accordingly.

HAND AND HEAD STUDIES (DETAIL)
Hans Holbein the Younger, ca. 1497–1543, pen and ink

We can also visualize the carpal and metacarpal bones as a single curved block and the fingers as elongated rectangular boxes. Notice how each finger is spread out in a different direction.

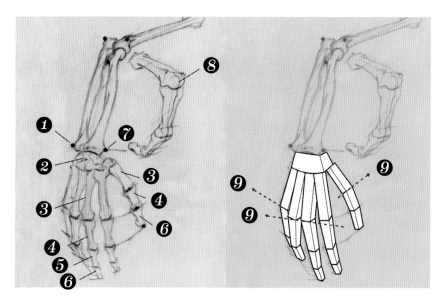

FINGER BONES (PHALANGES)

Each of the fingers angle at a different direction in space, due to the curvature of the metacarpel bones.

1. *Ulna*
2. *Carpals*
3. *Metacarpal*
4. *Proximal phalanx*
5. *Medial phalanx*
6. *Distal phalanx*
7. *Radius*
8. *Knuckle*
9. *Vanishing point*

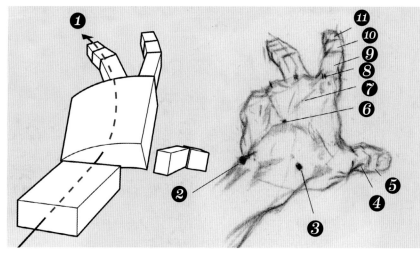

IN PERSPECTIVE

By conceptualizing the hand as an arrangement of numerous simple geometric solids in perspective, you can visualize what is happening to the hand and fingers in space.

1. *Axis*
2. *Ulna*
3. *Radius*
4. *Proximal phalanx*
5. *Distal phalanx*
6. *Carpals*
7. *Metacarpals*
8. *Knuckles*
9. *Proximal phalanx*
10. *Medial phalanx*
11. *Distal phalanx*

THE LINE OF ACTION

When drawing the hand, it's best to begin with a line of action, which describes the main thrust of the hand and arm. The line of action is as important to the hand as a stem is to a leaf—it dictates the direction of its shape.

Next, you mark the extremities of the distal phalanges, or fingertips. Together, these marks summarize the outside shape of the form—again, something like finding the extremities of a leaf.

Then you draw. Keep your drawing in the simple abstract phase for as long as possible. This way, when you need to adjust something, you only have to move a few simple lines.

Once you are happy with your abstracted "skeleton," you need to think structurally and identify the hand's important interior landmarks. These determine its proportions. The most reliable of these landmarks are the joints, or knuckles. They are easy to see because they're close to the skin. By placing them early, they will serve as anchors for the rest of your drawing. Even if the model's hand moves, you will have gleaned enough information to continue drawing it with confidence. Remember, drawing does not mean simply copying.

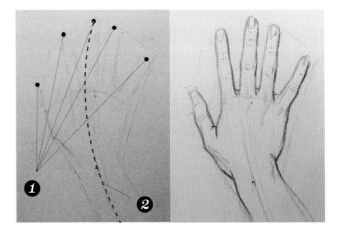

BEGIN WITH THE LINE OF ACTION

It is important to begin with a line of action to give your drawing direction and coherence. I began this drawing with a curving line of action that captures the graceful movement of the arm flowing into the hand.

The nineteenth-century sculptor and teacher Édouard Lantéri described what happens when an artist doesn't first consider the action when drawing: "I can only compare it to a piece of ornament, which lacks a chief line, where every detail, be it a flower or leaf, is placed by chance, regardless of a definite law of direction, and the result is confusion."

1. *Extremities*
2. *Line of action*

The series of drawings below shows the stages of hands drawn in different positions, all following the same basic steps. This approach goes back hundreds of years.

To practice, first try tracing the outline of your own hand on the paper to give yourself a "live" model of a hand's proportions. Start with simple views and build to more complex ones.

Drawing hands well (or anything else for that matter) requires a deep understanding of structure and perspective, as well as many years of study. These are the hallmarks of true classical drawing. But far from being constrictive, a classical approach will let you enjoy more freedom than you ever thought possible.

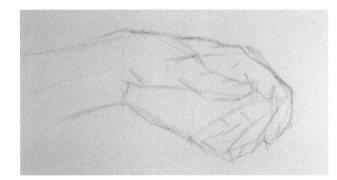

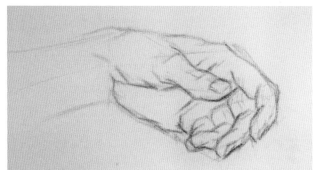

STAGE 1

Light lines are used to describe the large sweeping abstractions based on the hand's most important projections. These can be observed both optically (their contours) and structurally (their boney landmarks).

STAGE 2

In the middle phase, look for subtler forms, such as the bending of the knuckles, while considering their form's three-dimensional appearance in perspective. Up to this point, lines are kept light and even.

STAGE 3

Once you are sure that the parts relate well to the whole, use line to sculpt the hand's three-dimensional appearance in space. This gives permanency to the form, and as a result, makes it easier to control the placement of lights and darks. The model's hand might move, but it will matter little because it is already solidly constructed.

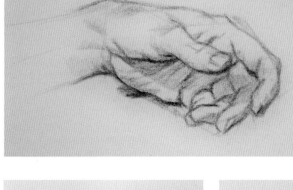

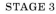

STAGE 1

STAGE 2

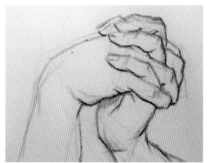

STAGE 3

PROPORTIONS & ANATOMY OF THE FOOT

It may not be the most glamorous of subjects, but the human foot is composed of beautiful arcing lines and interesting shapes. You just need to know where to look for them.

Artists often underestimate the feet. We generally don't spend as much effort learning to draw them as we do other parts of the figure, such as the hands. In life drawings we often pay the feet little attention. Perhaps we don't feel they're as important as the rest of the figure, or perhaps we just want to avoid their complexity. Whatever the reasons, the feet are frequently ignored.

But I've got good news: A foot is easier to draw than a hand because its underlying form is easier to grasp, and its range of movement is narrower.

The skeleton of the foot is close to the skin, hence the bones have a profound impact on its three-dimensional shape. The bones of the foot are divided into three groups, dictated by boney landmarks. The ideal foot can be divided into thirds, with the divisions between those thirds corresponding to significant boney landmarks.

THE FOOT BONES

The bones of the foot are divided into three groups: tarsals, metatarsals and phalanges. The seven tarsals are interlocking bones near the back of the foot. One of these, the calcaneus, or heel bone, is the foot's largest bone. Another is the navicular bone, whose curved tubercle is a highly visible landmark on the inside of the foot. The five metatarsals extend out from the tarsals, one toward each toe. The toes are made of three phalanges each, except the big toe, which has only two.

1. *Transverse movement*
2. *Calcaneus*
3. *Indicates lowest points of the foot*
4. *Base of 5th metatarsal*
5. *Head of 5th metatarsal*
6. *Head of 1st metatarsal*
7. *Navicular tubercle*
8. *Phalanges*
9. *Metatarsals*
10. *Tarsals*

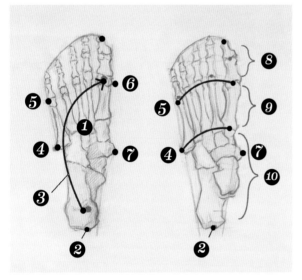

BOTTOM OF RIGHT FOOT TOP OF LEFT FOOT

DIVIDE THE FOOT INTO THIRDS

This seventeenth-century engraving shows how the foot can be divided into thirds, corresponding to significant boney landmarks. The first third spans the heel to the front of the tibia, or shinbone. The middle third extends from the shinbone to the head of the fifth metatarsal bone, at the base of the little toe. The final third extends from this point to the front of the foot.

LANDMARK POINTS OF THE FOOT

You will gain a deeper understanding of the foot's landmarks by studying a model's foot and comparing it with what you know of the skeleton. If you know what you're looking for, you can find important landmarks to guide your drawing, whatever the view. As Sir Joshua Reynolds said, "The eye sees only what it knows."

Inside View

From this perspective, the main landmarks are the navicular tubercle and the head of the first metatarsal.

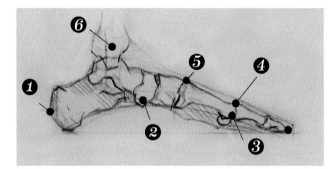

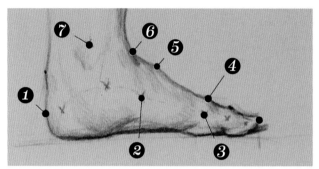

1. Calcaneus
2. Navicular tubercle
3. Head of 1st metatarsal
4. Juncture of metatarsals and phalanges (knuckles of the foot)
5. Juncture of metatarsals and tarsals
6. Medial malleolus of the fibula

1. Calcaneus
2. Navicular tubercle
3. Head of 1st metatarsal
4. Juncture of metatarsals and phalanges (knuckles of the foot)
5. Juncture of metatarsals and tarsals
6. Tibia meeting the foot (inside tendons)
7. Medial malleolus of the fibula

Outside View

The main landmarks seen from this angle are the head and the base of the fifth metatarsal. To identify the phalanges (toes), look for their joints.

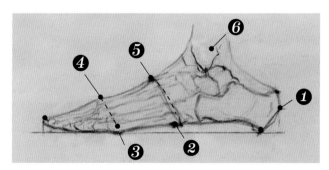

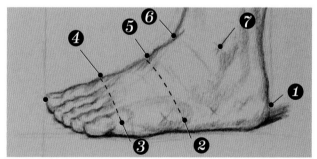

1. Calcaneus
2. Base of 5th metatarsal
3. Head of 5th metatarsal
4. Juncture of metatarsals and phalanges (knuckles of the foot)
5. Juncture of metatarsals and tarsals
6. Lateral malleolus of the fibula

1. Calcaneus
2. Base of 5th metatarsal
3. Head of 5th metatarsal
4. Juncture of metatarsals and phalanges (knuckles of the foot)
5. Juncture of metatarsals and tarsals
6. Tibia meeting the foot (inside tendons)
7. Lateral malleolus of the fibula

Foreshortened Views

Now that you're tuned in to the foot's structural landmarks, you'll be better prepared to draw it in foreshortened views.

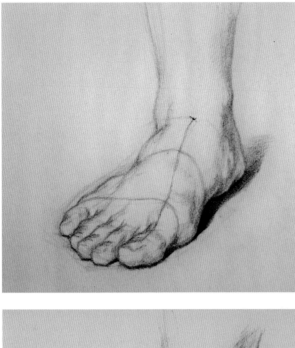

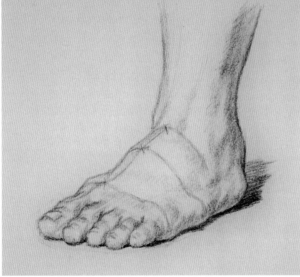

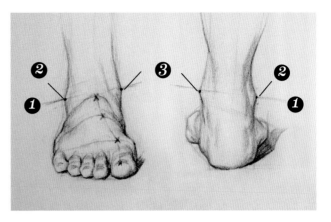

FORESHORTENED FRONTAL AND REAR VIEWS

The frontal view shows that the foot contains a series of three irregular arches crossing it from side to side. These arches occur along the rows of joints where the foot's bones intersect. The highest arch occurs where the tibia meets the foot. (In fact, this point is the keystone where all the weight of the body is poised.) The middle arch occurs where the tarsals meet the metatarsals. The lowest arch is found at the intersection of the metatarsals and the phalanges.

Both front and rear views reveal an important fact about the ankle bone's alignment: It is higher on the inside and lower on the outside. You can imagine an inclined axis running through this bone and even include it in your drawing as a construction line. Notice the three prominent cross-contour lines beginning at the front of the tibia, which indicate the division of the foot into thirds.

1. *Axis*
2. *Lateral malleolus of the fibula*
3. *Medial malleolus of the tibia*

MODELING THE FOOT

Effectiveness in modeling the foot is tied to the ability to put lines around the outside of the form (contours) and lines around the inside of the form, which describe its topography (cross-sections). The cross sections traveling along and across the foot reveal its highest points. You can perceive how the many planes of the foot slope in multiple directions, lengthwise and widthwise.

In all aspects of its construction, the shape of the foot reflects its purpose as a weight-bearing support. The foot gets flatter as it moves downward to the toes, which act as buttresses.

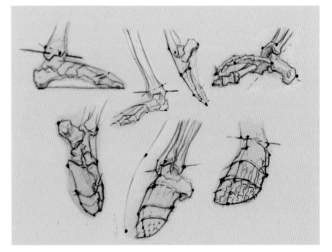

DRAW THE SKELETON TO PRACTICE

Drawing the skeleton in views such as these challenges you to locate the foot's boney landmarks and use them to guide your drawing. These views also show how the foot meets the leg at a hinge joint.

 DEMONSTRATION

Draw the Foot

You'll want to use a systematic and reliable method to draw the foot from a model, with a clear objective at every stage of your drawing. Follow the steps to learn this process, beginning with the initial contour and construction lines and finishing with the addition of shadows and halftones. Keep a few things in mind during this process:

- Continually assess the parts that lie within the whole. The outline of the form is of paramount importance because, if the outer shape is correct, the foot's interior parts will fit. If the parts don't fit, you need to reassess your outside shape.
- It's easier to see and compare the foot's parts when drawing at life size or near life size.
- It's always better to keep correcting your drawing, or to begin a new one, than to move forward if what you have done is poorly constructed. Don't get discouraged. You'll feel better about solving problems than you will about polishing a drawing you know is incorrect.

MATERIALS

- crayon or chalk holder (porte-crayon)
- Cretacolor black charcoal lead (medium)
- kneaded eraser
- rough newsprint pad
- single-edge razor blades

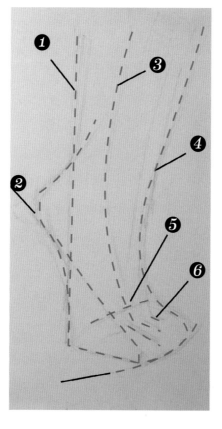

1 Sketch the Contour and Interior Points

Convey a general impression of your subject with as few lines as possible. At this early stage, examine the principle points that pull the shape together. You can gauge their relationships to one another by projecting vertical and horizontal plumb lines. Make your lines as light as possible so that you can easily make revisions. Use both straight and sweeping lines, which connect key points on the contour of the foot. Also draw a few interior lines indicating the foot's most significant parts.

1. *Calf relating to the ball of the foot*
2. *Heel relating to the big toe*
3. *Line of action*
4. *Sweeping action of the outside of the foot*
5. *Knuckles of the foot*
6. *Indicates separation of the toes*

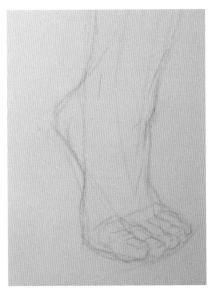

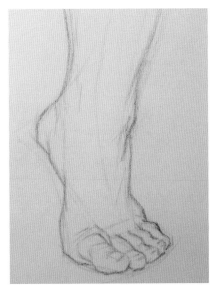

2 Refine and Reveal Volume

Begin to refine your initial lines and add detail, using line to understand and communicate the volume of the form. Look for the main cross-sections and depict them with light lines. Show the overlapping of the main forms, which will reveal the beautiful inner arch of the foot and enhance the sculptural, three-dimensional quality of your drawing. Such lines help to make the form of the foot more pronounced.

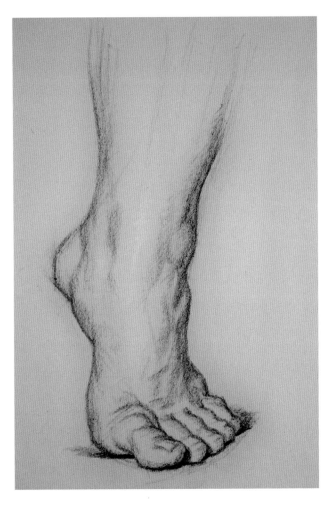

3 Add Values to Finish

Once your line drawing is complete, you can add values. The shadows come first. Build them up lightly so you can make adjustments. To create an even tone, use parallel strokes. Form shadows will emerge out of these light strokes, followed by cast shadows in the darker areas. Look for reflected-light shadows, which are the proportionally lighter areas within the darker shadows. These help convey the curvature of the form.

Add tone in the light areas to develop halftones, which express the curvature of form. Use varying degrees of pressure to control the precise darkness of the value. After adding select shadows and halftones, the result will look accurate, expressive and three-dimensional.

As you progress with your art, you'll want to keep developing your drawing skills while continually strengthening your structural understanding. Study the Old Masters—drawing from their sculptures and paintings will enrich your vocabulary of form and action. (I was inspired by how Tintoretto conceived one of the feet in his immense painting, *Miracle of Saint Mark Freeing the Slave*. It was a small detail, yet it inspired me to want to draw.)

It doesn't matter where your inspiration comes from as long as it comes. So, always have your sketchbook at the ready. You never know what will inspire you—perhaps one humble foot will set you off on a new creative pathway.

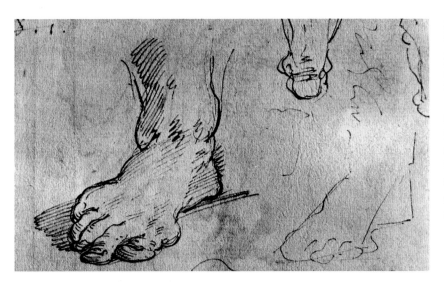

SKETCHES AND FORMULAS (DETAIL)
Agostino Carracci
Pen and ink, 9" × 7" (23cm × 18cm)
Collection: National Galleries of Scotland, Edinburgh, Scotland

Begin your drawings with the important lines that characterize the shape. In the right portion of this sketch, you can see how Carracci began by conceptualizing the foot as a very simple and concise shape, which he likely drew before moving on to the more finished foot at left.

DRAWING AFTER *TINTORETTO* (DETAIL)
Jon deMartin, 2013
Graphite, 7" × 7" (18cm × 18cm)

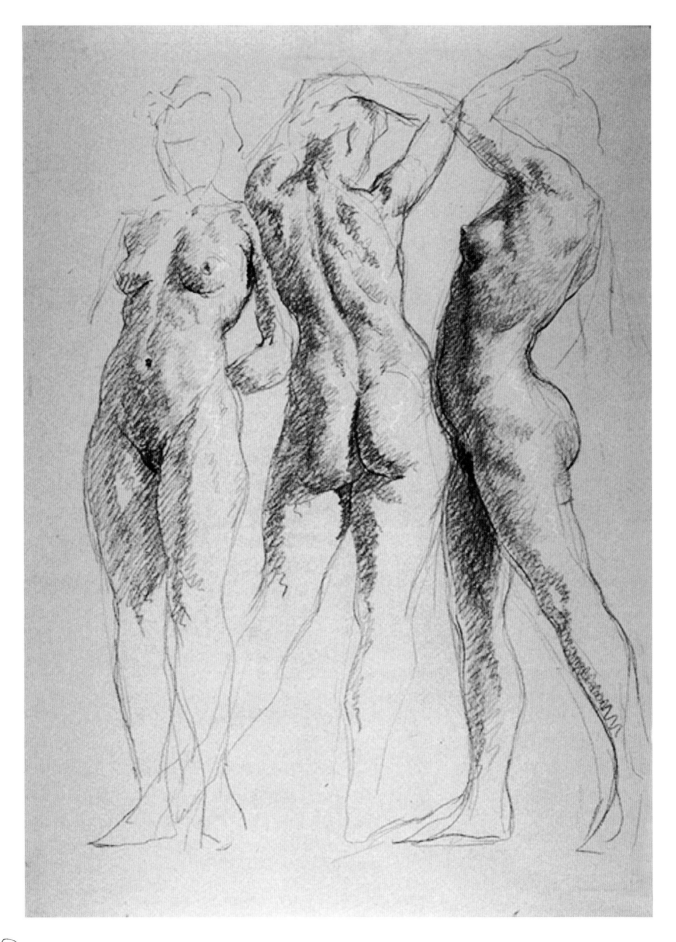

7

THE FIGURE IN ACTION

"When you draw, take care to set up a principle line which you must observe all throughout the object you are drawing; every thing should bear relation to the direction of this principle line."
— *Leonardo da Vinci*

We began our study of drawing the figure with an exploration of ways to draw the human body so that it appears three-dimensional. We discussed the importance of finding the inner axis, the most expressive line of action. We looked at how the figure's surface centerlines help convey the illusion of the figure's masses in space.

Now it's time to apply those principles to portraying the figure in movement. The techniques covered in this chapter are not offered as the only way to draw—no one method is appropriate for every artist—but they represent a sound approach. Hopefully, this advice has something to offer both beginners and more experienced artists alike. The following strategies can be thought of as behind-the-scenes thinking. They can help to make your drawing process more intuitive.

In this chapter, you will learn:

- a variety of ways lines can enhance rhythmic action from both inside and outside the figure
- how to use anatomy as a guide to capturing exterior form
- how to use line to create movement.

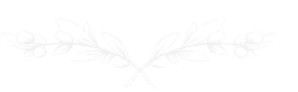

GILDA AS THE THREE GRACES
Jon deMartin, 2002
Red and white chalk on toned paper
26" × 19" (66cm × 48cm)

THE INNER AXIS & SURFACE CENTERLINES

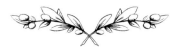

While teaching his life drawing class, Frank Reilly would ask his students, "If you were to draw a pearl necklace, what would you draw first—the string or the pearls?" To the surprise of some of his students, he pointed out the more logical answer would be to draw the string before adding the pearls. This is because a single key line, referred to as the line of action, can rhythmically link multiple parts of a complex structure. In the case of the necklace, the string is the line of action that runs through the middle of the pearls.

In the human figure, the line of action often coincides with the inner axis, which runs through the middle of the head, rib cage and pelvis. It is similar to the armature a sculptor uses to establish the action of a figure. The line of action is so important that the late Gustav Rehberger claimed that most mistakes are made in the first three seconds of a drawing. In other words, if the line of action is not immediately realized, a drawing may be doomed to failure. Finding lines of action can make the difference between your figure looking static and looking alive. By finding and sketching both a form's inner line of action and various centerlines on its surface, you can better represent a figure's gesture and orientation in space.

There is no hard-and-fast rule as to where to draw the line of action. The general rule is to look for the line that will most effectively link the parts together for the sake of unity in the drawing, and any strategy is acceptable to achieve this important aim. To obtain the most possible unity in the action of the drawing, it's a good practice to look for the longest line of action you can find.

Lines of action do not only run through the middle of forms, they run on the surface of forms as well. If this is the case, these lines can be described as surface centerlines, a structural device that artists have used for centuries.

The first response to the figure's action, or gesture, should be an emotional one—the drawing needs to be felt first if you're going to approach your work with any real momentum. When you see a sunset, you don't analyze its hue, value and chroma; you simply take it in with wonder and astonishment. In a way, you can think of the inner axis, which expresses the gesture of the figure, as representing the emotional response to a drawing. The surface centerlines, meanwhile, are more a part of the structural (intellectual) response. Great figurative drawing combines both of these elements.

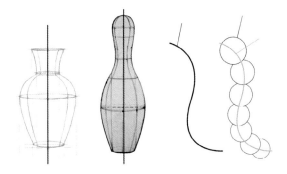

MAN MADE VS. HUMAN SUBJECTS

Man made objects such as vases and bowling pins have straight, vertical, central axes and round, symmetrical cross-sections. However, unlike the vase and bowling pin, the human figure's cross-sections are irregular. Its axes are continuously changing, even in the most static poses. Think of the figure's cross-sections more like a string of pearls.

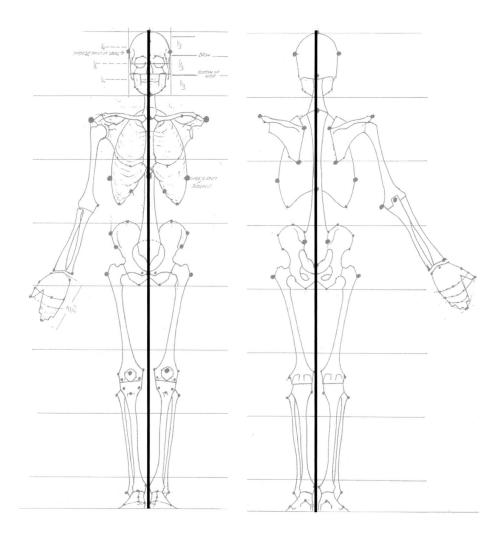
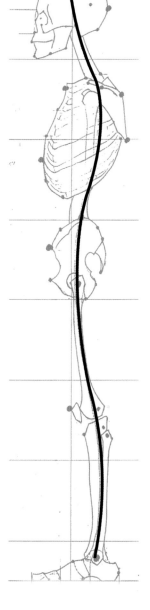

COMPARE FRONT, BACK AND SIDE VIEWS

In a straight-on front or back view of the human skeleton, the figure's axis looks no different than that of the vase or bowling pin—it appears vertical, and the sides appear symmetrical, as seen in the front- and back-view skeletons. In the side view of the figure, however, it's quite a different story. In this view, the line of action runs in a serpentine way through the head, rib cage and pelvis. It continues down into the legs, still following a subtle serpentine line. There are no straight lines on the human figure, and because you will rarely draw completely straight-on views of the figure, the line of action will almost never be straight.

NINE STUDIES OF FIGURE

Thomas Eakins, ca. 1883
Pen and ink and graphite, 4" × 10" (10cm × 25cm)
Collection: Smithsonian Institution, Washington, DC

This diagrammatical drawing by the nineteenth-century American artist Thomas Eakins shows multiple traced-over views of the figure with the goal of discovering their lines of action. The late artist and teacher Deane Keller explained that finding the line of action, as Eakins did, links the parts of the drawing together into one whole. "Rhythm is defined as the nature of the connection of the parts," Keller explained. "Not seeing this can cause major problems in the final drawing, which may look disconnected and jarring, or lacking rhythm." With this in mind, think how disconnected a drawing of a pearl necklace would be if the artist were to draw the pearls before the string.

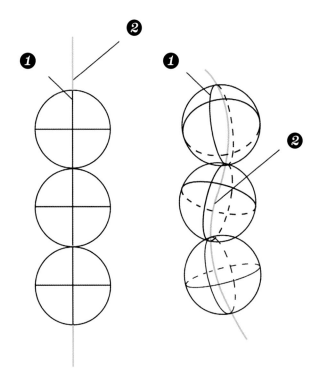

SURFACE CENTERLINES

Here we have a view of pearls with their surface centerlines. When the pearls' string (axis) is completely straight, their surface centerlines also appear straight. However, you will very rarely work from such straight-on views. The second image shows how the string affects the pearls when it moves. The pearls' surface centerlines change, and as a result, each pearl appears to have a different orientation in space.

1. *Surface centers*
2. *Axis*

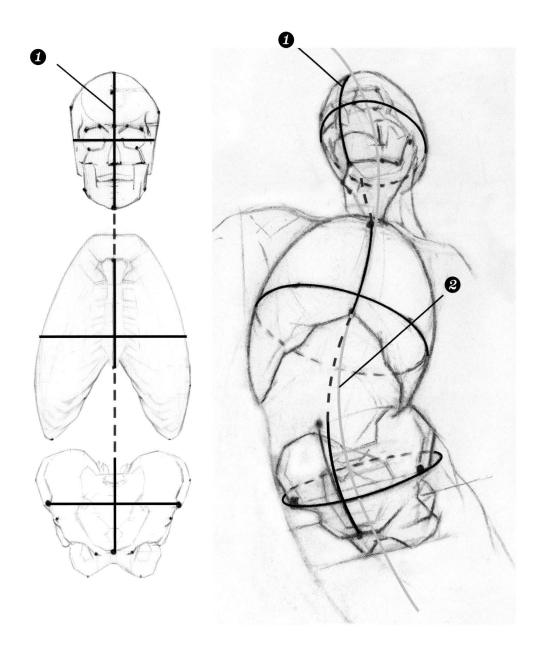

APPLY THE CONCEPT OF SURFACE CENTERLINES TO THE HUMAN FIGURE

Here are views of the head, rib cage and pelvis with their respective surface centerlines. The dotted, red portions of the lines represent the free spaces between the head, rib cage and pelvis. They, too, appear straight when the figure's axis is straight, as in the first illustration. It's important to note that the centerlines are always at right angles to one another—although the head is the only mass of the body in which the horizontal centerline, which aligns with the eyes, is in the middle of the vertical centerline. Surface centerlines are relatively meaningless on pearls or other spheres. However, surface centerlines are a crucial construct for correctly representing the head in space. The second illustration shows what happens to the masses of the head, rib cage and pelvis when their axes move, as they will in the vast majority of poses. In these views, the surface centerlines allow you to more easily and accurately appreciate and visualize how the form tips, turns and tilts in space.

1. *Surface centers*
2. *Axis*

FIGURE SKETCHES FROM SKETCHBOOK

Jon deMartin, 2010
Graphite, 9" × 6" (23cm × 15cm)

These illustrations show a series of rapid sketches after sculptures in the Pitti Palace in Florence, Italy. The figures' rhythmic action struck me immediately, as the sculptor no doubt intended. I chose to draw the inner axis first, because this was the most effective way to express the dynamic action of each pose. The first marks of a drawing should not be academic and measured, but spontaneous and alive—you can always revise and correct later. A drawing can be accurate, but if you think about nothing other than correctness, the result will be lifeless.

1. *Axis*

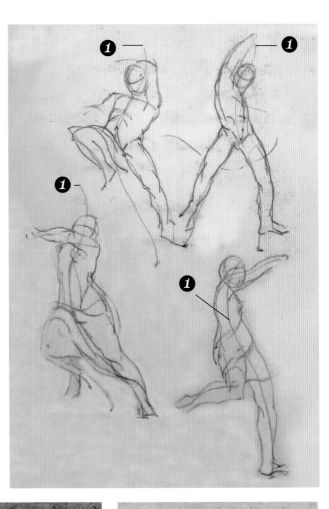

ANALYSIS OF THE INNER AND OUTER LINES OF ACTION IN AN OLD MASTER FIGURE DRAWING

Find an Old Master drawing that shows an expressive gesture of the figure. On tracing paper, draw the inner line of action, then find the surface centerlines. In my drawing, I also added cross-sections to convey the limbs' direction in space, another very important consideration.

1. *Axis*
2. *Surface centerlines*
3. *Cross-section*

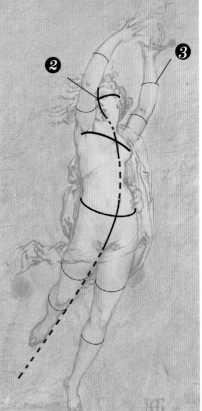

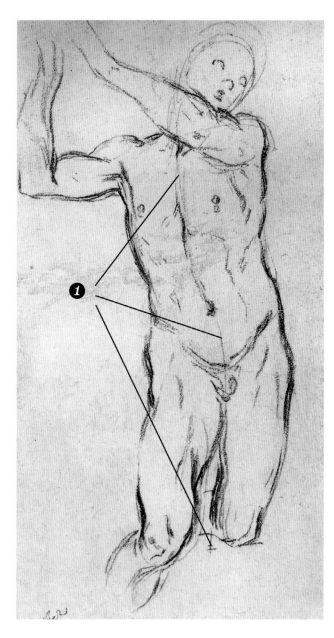

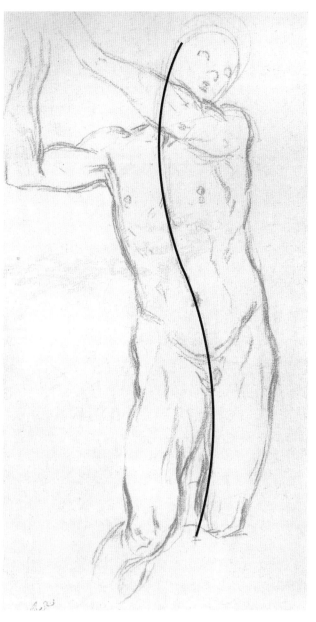

STUDY FOR THE FIGURE OF DANIEL
Gian Lorenzo Bernini
Black chalk on gray paper

1. Line of action

In this drawing by the seventeenth-century sculptor Gian Lorenzo Bernini (who virtually created the Baroque style), we get a glimpse of his thought process. Notice that he used his line of action to run along the outside of the head and neck, along the rib cage and pelvis' surface centerlines, and then down the inside of the left leg. It's clear that Bernini's objective was to link everything together with one rhythmic line. In this case, it was the outside shape and the surface centerlines that nailed the action.

All poses are different, and sometimes the line of action may not be apparent at all, such as in poses that are static or foreshortened. But lines of action and surface centerlines are strategies that help you accomplish the challenging task of drawing the figure. The more strategies you know, the more insight you can bring to your drawing. Even the most static poses can be enlivened if you're aware of these concepts, because you will be in a better position to animate the pose and make it appear livelier than it really is. After all, as Bernini's drawings show us, art is the intensification of life.

LINE: THE FOUNDATION OF A FIGURE DRAWING

There are many different line types, and it's important to explore what they are. Before looking at the specific types, it's helpful to recall that a line is a path between two points, or anchors. It's not necessary to draw every anchor point on every line, but paying attention to where your lines start and end will help you draw with more purpose. Think of this as "aiming" your lines.

In his book, *The Analysis of Beauty*, eighteenth-century British satirical artist, William Hogarth described the S-curve as a line of beauty and grace. He wrote that these graceful curves are essential to art because of their "varied play ... twisting together in a flame like manner." Hogarth, like many of his contemporaries, became remarkably skilled at catching the momentary actions and expressions of the figure. He developed a form of visual shorthand by retaining objects linearly in his mind. (This was not uncommon in the days before photography.) To do so, he would reduce his objects to C-curves, S-curves, straight lines, and angles. Hogarth likened this aspect of learning to draw to developing the facility of writing letters with the alphabet.

When you expand your vocabulary of line usage, your self-expression will increase, much in the way that expanding your vocabulary helps you become more articulate in speech and writing. The different combinations and variations of straight lines and curved lines produce an endless variety of forms. Taking advantage of this variety can give your work graphic power.

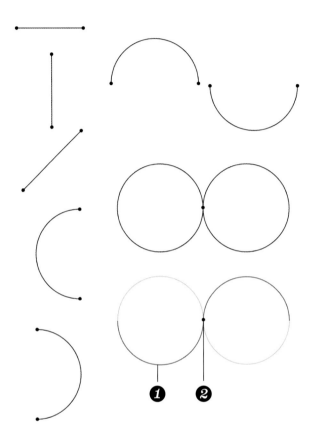

BASIC LINES

A line is the quickest way to convey a direction, a length or an angle. Here the different basic lines are represented: a vertical, a horizontal and a diagonal. In the upper-right and lower-left of the illustration, notice the series of simple curved lines: an arch, a sag and two curves that resemble a "C"—one that bows to the right and one that bows to the left. In the bottom-center of the illustration are two circles stacked on top of each other touching at only one point, creating a tangent. In the lower-right two grayed-down circles reveal the structure of an S-curve. The S-curve is the result of two opposing C-curves meeting at one tangent point. Notice that the tangent point—also called the point of inflection—is where the curve changes direction. It should be noted that unlike the geometric curves in this example, the C-curves found in nature are organic and irregular.

1. *S-curve*
2. *Point of inflection*

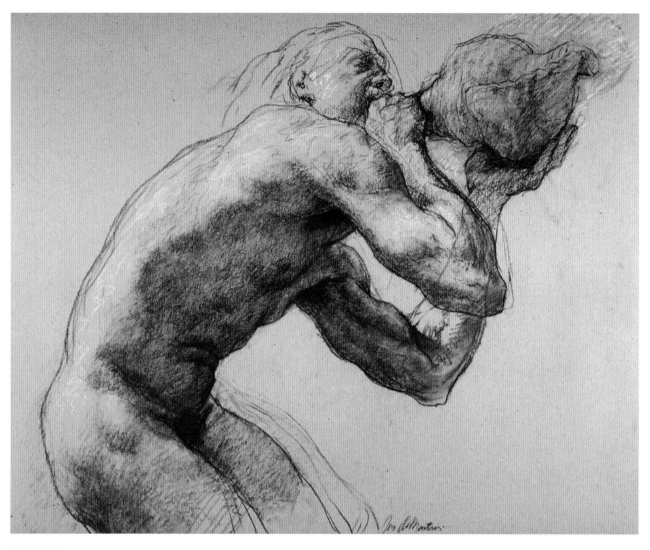

TRITON

Jon deMartin, 2002
Red and white chalk on toned paper
18" × 24" (46cm × 61cm)

I always carry around a sketchbook because you never know what will inspire you, especially when visiting museums. This drawing from a live model was based on a sketchbook study I made from a small porcelain figurine titled *Triton* at the Boston Museum of Fine Arts.

The pose was very difficult to hold, so it required the model to take multiple breaks. After one session, I was satisfied with the result and I didn't feel the need to continue. I've heard it said that spontaneity knocks but once!

USING ANATOMY AS A GUIDE

Earlier I mentioned the importance of "aiming" your lines. But when you draw the human figure, what are you aiming for? In life drawing, you can't just accept what you see, you also have to draw what you know.

From as far back as the Renaissance, artists have relied on their understanding of anatomy, particularly the human skeleton, as the basis for the figure's action and proportion. The Italian sculptor and painter Benvenuto Cellini wrote, "Since the important thing in these arts is to draw a nude man and woman well, and remembering them securely, one must go to the foundation of such nudes, which is their bones, so that when you will have memorized a skeleton you can never make a mistake when drawing a figure, either nude or clothed; and this is saying a lot."

More recently, artist Michael Aviano explained, "The points are at the joints ... and that's where the action is."

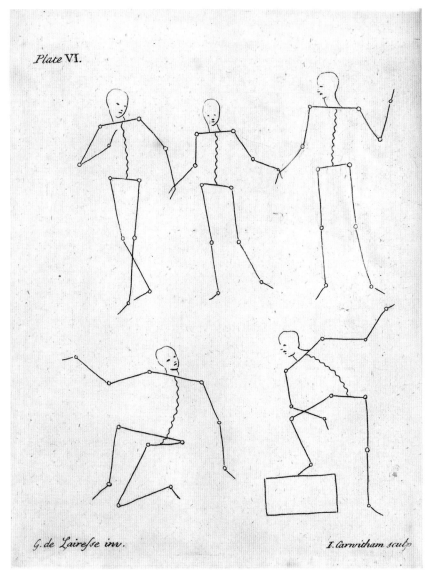

FROM A TREATISE ON THE ART OF PAINTING IN ALL ITS BRANCHES
Gerard de Lairesse, ca. 1707
Engraving

The seventeenth-century artist Gerard de Lairesse, a contemporary of Rembrandt, demonstrated how effective and efficient a stick figure could be in translating a figure's action. The anchor points of his lines were located at the most essential skeletal joints. The wiggly line represented the flexible spine. Through this attention to the basics of anatomy, de Lairesse was able to capture the figure's movements with great vibrancy for such simple sketches.

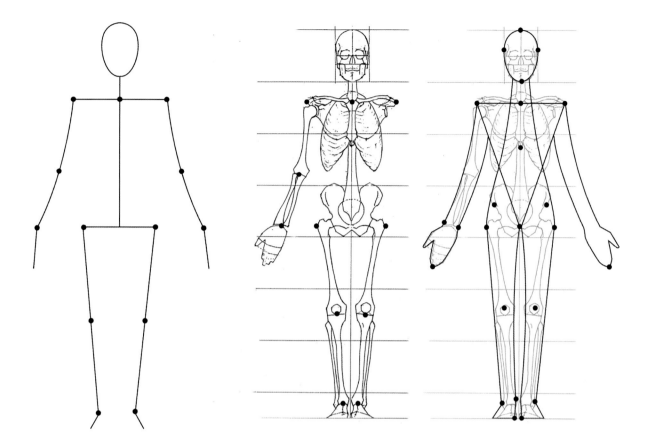

SKELETAL CHART

Jon deMartin, 1982
Pen and ink

The first illustration shows a simple armature, based on the de Lairesse engraving, which relates the key joints on the stick figure to the human skeleton in the middle image. The third image on the far right adds several additional important points. To know the skeleton is not to copy every nook and cranny, but to learn the most significant points (usually at the joints) that impact the figure's movement and shape. Anatomy is a subject that requires continuous study; in fact, I encourage you to label and learn the skeletal features shown here. This knowledge will increase your ability to identify these features when constructing your figure.

CAPTURING THE EXTERIOR FORM

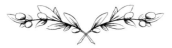

So far we've been looking at the interior framework of the human figure. Now let's study how these features affect the exterior (the outline). Your first priority in drawing an outline is to use the fewest number of lines that will effectively characterize the outside shape. Your lines should have minimal detail. It's easier to adjust a simple line than one with many curves.

Another advantage of a simple outline drawing is that it provides a good opportunity to appraise the figure's big linear relationships and interrelationships. Interrelationships occur when you mentally or physically project a line beyond its end point and find that it relates to another key point or line on the figure. In my constellation drawing, for example, the lines documenting the sides of the neck continue down and relate to the outside of the hip. Notice how the sides of the upper torso converge at the pubis. These interrelationships give figure drawings great rhythmic unity and flow. You'll be amazed at how often they occur once you start looking for them.

1. *Active side*
2. *Skeletal/boney landmarks*
3. *Line of contrast*
4. *Surface center*
5. *Passive side*
6. *Interrelationship of lines*

CONSTELLATION: MICHELE
Jon deMartin, 2008
White chalk on blue paper
25" × 19" (64cm × 48cm)

Most poses we draw are not static, especially those that have a decisive action. The poses that have the most action and movement are the short poses. To bring the energy of a short pose to a long pose, a shorthand way of efficiently and economically seizing the figure's action is needed.

One key way of identifying the figure's action is to look for the lines of contrast—the alignment of the shoulder in relation to the orientation of the pelvis. As a result of this contrast, the figure has an active (or tense) side and a passive (or relaxed) side. The active side is where the rib cage is compressed against the pelvis, which bears the weight of the standing leg. Here, the lines tend to be straighter and have shorter bursts, or segments. On the passive side, the leg is relaxed, so the lines can be longer sweeping curves that give flow to the drawing. Remember that straight and curved lines have graphic power.

Let your eyes be pulled to the bigger points that reveal the most characteristic shapes. Regardless of the perspective from which you are viewing the model, surface centers must be correct or the exterior outlines will be off.

GILDA
Jon deMartin, 1993
Black chalk on newsprint
24" × 18"(61cm × 46cm)

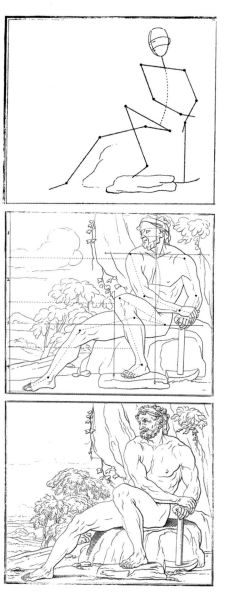

In my drawing of Gilda, I found it very helpful to find the opposite pelvic point behind the model's right leg, so that I could understand and appreciate the dynamic contrast of the pelvis' relationship to the rib cage, which shows a dynamic contrapposto pose. The artist Gustav Rehberger once noted, "The artist begins where the model ends." You're more likely to copy when you only observe the figure's outside shape because you're at the mercy of the model staying absolutely still. This is the difference between drawing what the model *is* and drawing what the model is *doing*. Bringing knowledge to your drawing enables you to penetrate beyond the appearance of the outside shape; it empowers you to draw an action pose, or any pose, for that matter, with confidence and accuracy.

1. Pelvic points

THE FIGURE IN STEPS

This eighteenth-century engraving by an unknown artist demonstrates a figure drawing broken down into steps. In the first step, the artist used the concept of the "stick figure" for the figure's action and proportional relationships. In the second step he drew the figure's basic outline in order to gain a simple appraisal of the figure's shapes, both outside and inside. In the third step, he created a more developed contour, indicating the figure's spatial qualities as shown by overlapping lines with various line densities. In this step you can see more developed indications of the interior forms. These forms established a road map for the eventual modeling of form.

This piece provides an interesting view into the mind of its artist and reveals how important structural knowledge was in the artist's thinking process. In the middle frame, you can see how he visualizes the model's far-right hipbone despite it being obstructed by the left leg. Without this reference, he would have had to copy where the leg first appeared rather than know where it originated anatomically.

The illusion of a solid entity moving through space can make a drawing powerful and beautiful. Understanding how lines twist and undulate through space in three dimensions makes them alive and organic. Studying lines may seem boring, elementary or unnecessary, but it is no different than a ballet dancer practicing at the barre, learning all the elementary steps that precede the more complex choreography performed on stage. The practice of sketching from sculpture in a museum can be a great resource and training ground for your studio or classroom work. It's not only instructive but also fun to discover exciting action poses that in real life models cannot hold for an extended period of time. Your appreciation of great masterworks will deepen when you try to understand what makes them so exceptional. As your knowledge of the dynamics and construction of the figure increases, so will your skill when drawing God's most beautiful creation—the human figure.

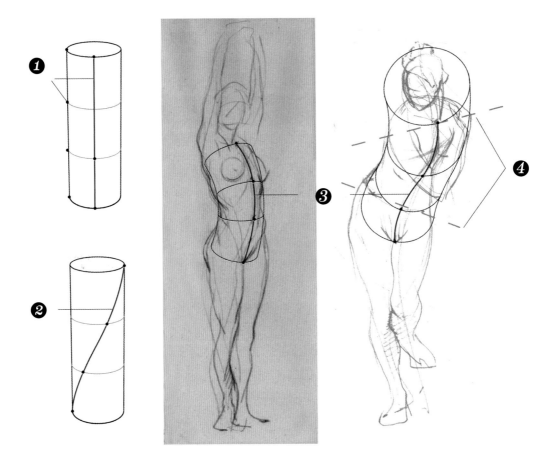

CROSS SECTIONS CONVEY THE ILLUSION OF VOLUME

Here is a straight vertical cylinder with a line inscribed on its surface that also runs straight and vertical (a plane curve). The four points along the cross-sections rest on the same plane because the line is unchanging. If you were to bend or twist the cylinder, the line would change and appear three-dimensional. All four points would then rest on a curved plane rather than on a flat plane. This line is called a *space curve* because it moves three-dimensionally. No two consecutive points are on the same plane. This phenomenon happens all the time when you look for the structural points that appear on the surface center of the figure. Some poses are more dramatic and reveal this more than others. But lines on the figure are always moving in space—they're never flat.

1. *Plane curve on surface center*
2. *Space curve on surface center*
3. *Space curve*
4. *Lines of contrast*

The Figure in Action: One-Minute Pose

MATERIALS

- crayon or chalk holder (porte-crayon)
- Cretacolor black charcoal lead (medium)
- kneaded eraser
- rough newsprint pad
- single-edge razor blades

There are no set rules about how to draw the figure, but this demonstration will break down the main objectives to look for when drawing from life. Whether it's a long pose or short pose, I believe the most important objective of the first lines drawn is to find the action of the pose. Follow the steps to draw the figure in a one-minute pose.

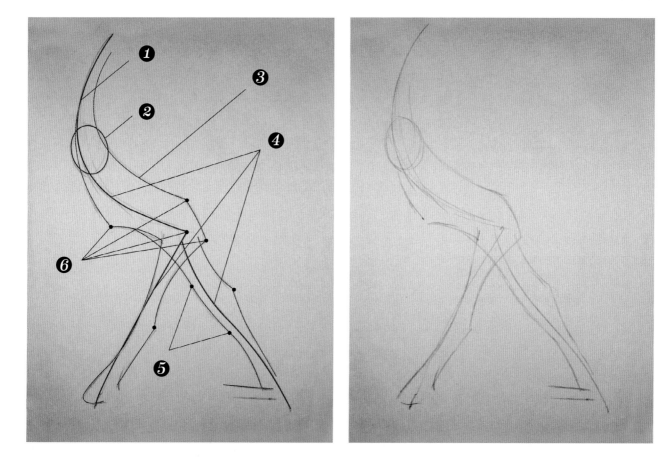

1 Place the Significant Action Lines

Let your eye sweep over what the model is doing and then consider the most significant lines that can capture the eye's movement. The sweep arcs are lines that feel and look natural when drawing from life. They can be both convex and concave, and they can inevitably make the difference between the figure looking dynamic or static. Straight lines can create an abrupt and fragmented drawing, whereas sweeping lines move and suggest the continuum of life.

No matter what the pose, if visible, the head will immediately give scale to your drawing and help dictate the placement of your lines, both on the inside and on the outside.

1. *First lines (axis)*
2. *Basic head shape*
3. *Sweep arcs*
4. *Main axes (action)*
5. *S-curve*
6. *Points of inflection*

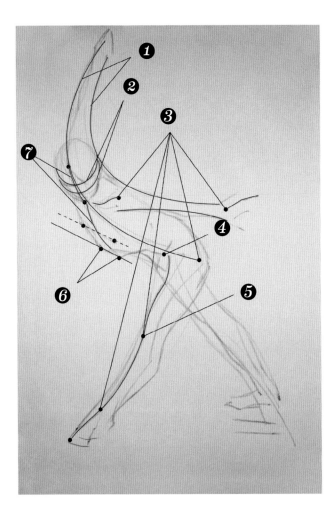
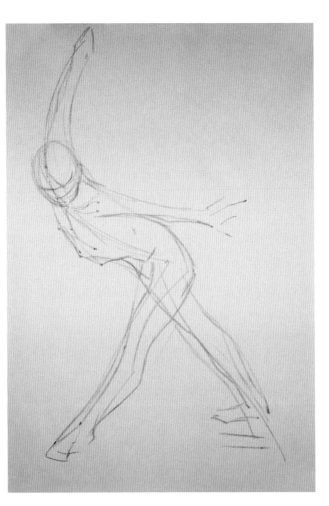

2 Establish Construction Points to Anchor the Figure

After the action is established, look for construction points that will anchor the figure in three-dimensional space. The points are at the joints, which are the boney landmarks; they're responsible for both the figure's proportion and action. The sweeping arcs not only give life to your lines but they abbreviate detail, which increases the grandeur of your design. Paying attention to the points of inflection enables you to appreciate both the C-curves and the S-curves, which add variety, elegance and grace to the drawing. The orientation of the head and rib cage are explained with its surface centers.

1. *Sweep arcs*
2. *Feature guidelines*
3. *Points at the joints*
4. *Skeletal/boney landmarks*
5. *S-curve (point of inflection)*
6. *7th ribs (lines must converge)*
7. *Surface centers*

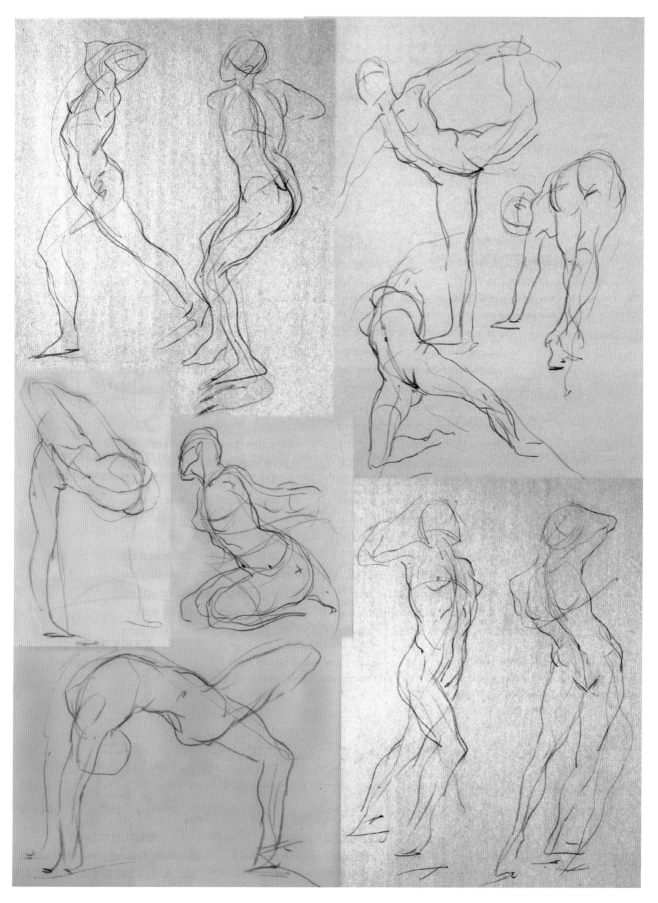

COMPILATION OF ONE-MINUTE GESTURE DRAWINGS
Jon deMartin, 1989–1990
Pastel on newsprint
24" × 18" (61cm × 46cm)

The Figure in Action: Five-Minute Pose

MATERIALS

- crayon or chalk holder (porte-crayon)
- Cretacolor black charcoal lead (medium)
- kneaded eraser
- rough newsprint pad
- single-edge razor blades

Now follow the steps to sketch the figure in a five-minute pose.

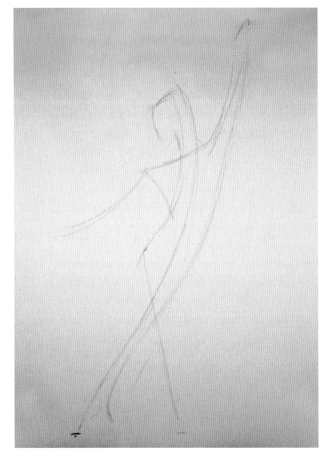

1 Draw the Action Lines

The first line I saw or felt in this case was the large sweeping axis (the line of action) that ran down the middle of the model from the top of her head to the bottom of her right heel. If the inner axis is not apparent, then try to choose the most telling line or lines that can capture the model's outside action. Frank Reilly once said, "A line should come from somewhere and go somewhere," and in most cases a line changes its direction at the joints. These points can connect the sweeping arcs of the figure. Notice the beautiful contrast of the compression (left) and the stretching (right) of the model's pose.

1. *Main axis*
2. *Line of action (axis)*
3. *Sweep arcs*
4. *Points of inflection*

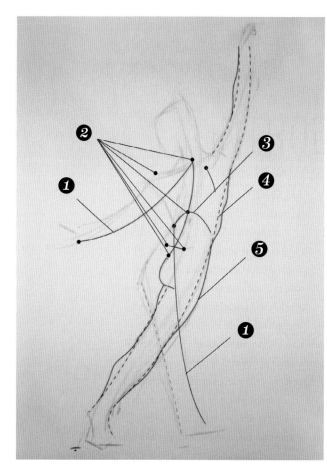

2 Identify the Base Boundaries and Boney Landmarks

If time allows, identify the model's base boundaries, which inform the size, position and shape of the forms found inside the figure's outside shape. The base boundaries also give the relationships of the parts that will further confirm your construction. Remember that they should come after identifying the skeletal boney landmarks, which set the framework of the figure. The sweeping arcs can be thought of as imaginary lines underneath the form's contour. Remember while drawing these beautiful undulating contours to preserve the initial action underneath, and the addition of these forms will begin to make the figure look more human.

1. *Sweep arc*
2. *Skeletal/boney landmarks*
3. *Base boundary of the rib cage*
4. *Action of the contour*
5. *Addition of forms*

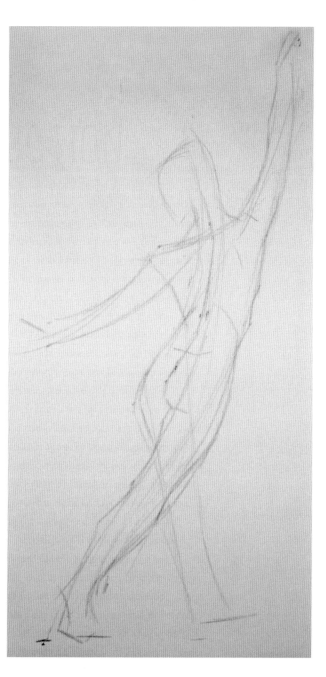

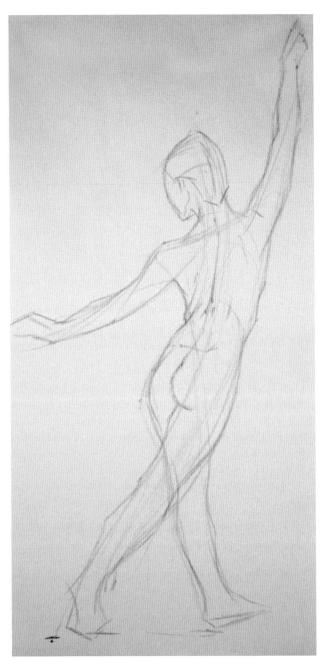

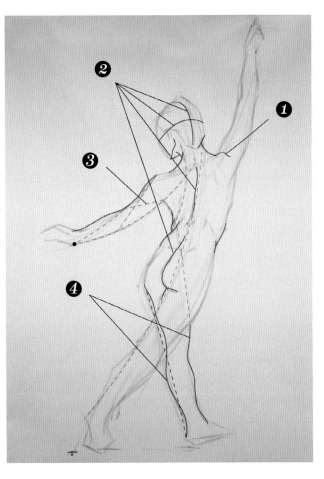

1. *Overlapping forms*
2. *Surface centers*
3. *Interrelationship of lines*
4. *Addition of forms*

3 Sculpt With Line

If the initial lines are kept simple, it will make it easier to both see and appreciate their interrelationships. Even though a line may optically stop, try to mentally and physically, but very lightly, continue the line. In many cases you'll be surprised by how many interrelationships you'll discover. These connections further enhance the rhythmic qualities of the drawing. The viewer may not be consciously aware of these interrelationships, but they will sense a pleasing unity in the drawing.

The base boundaries "telegraph" where the overlaps occur and will further solidify the figure in space. Remember, the surface centers orient the figure's three main masses aided by the axis of each mass.

The Figure in Action: Twenty-Minute Pose

Short poses typically present the most dynamic movements of the figure. Twenty minutes is the usual time frame a model can hold a pose before taking a rest. It's also a time frame that tests your ability to construct a believable three-dimensional figure in line. Follow the steps to draw a figure in a twenty-minute pose.

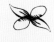

MATERIALS

- Conté à Paris crayon pencil
- crayon or chalk holder (porte-crayon)
- Cretacolor white chalk lead
- kneaded eraser
- single-edge razor blades
- Twinrocker handmade toned paper (light blue)

1. *Sweeping S-curve*
2. *Stretching side*
3. *Lines of contrast (acromion processes)*
4. *Surface centers*
5. *Ovoid*
6. *Main axis (action)*
7. *Concave arc*
8. *Compression side*
9. *Point of inflection (greater trochanter)*
10. *Main direction of the leg*

1 Capture the Action Lines and Sketch the Basic Shapes

Try to find the most continuous and concise line possible that will capture the model's movement. In this case it is the beautiful flowing axis that appears as a flowing S-curve that runs from the model's head to the far rear right leg.

Draw the head as a simple ovoid because it's main function is to give a general idea of its proportion relative to the length of the figure. Once you feel comfortable with the head's scale, look for the line of contrast, beginning with the alignment of the shoulders. After estimating the shoulders' width, "hang" your lines on their corners

(the acromion processes) like pants hanging from a closet hanger. But these lines are obviously not straight, they're undulating three-dimensionally through space, like ribbons twisting and blowing in the wind.

I generally look to the figure's compression side first, and then to the stretching side, which is longer and more flowing. These two lines, which define the outside shape, give an opportunity to see the figure's approximate width. In the early stages it doesn't matter if you use convex or concave lines as long as you can capture the figure's action in the simplest and most direct terms.

 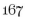

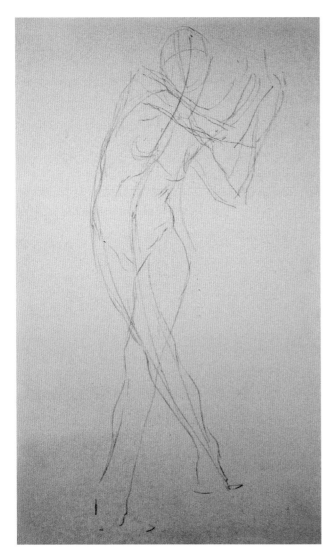

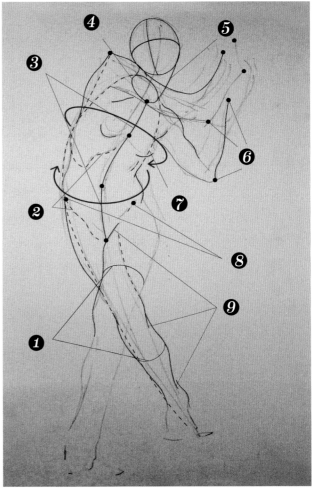

1. *Direction and thrust*
2. *Main base boundaries*
3. *Surface centers*
4. *Opening of the rib cage*
5. *Cylinder of the neck*
6. *Skeletal/boney landmarks*
7. *Simplified outline of the rib cage*
8. *Pelvis (axis)*
9. *Overlapping forms*

2 Sketch the Main Forms and Orient the Surface Centers

Lightly draw the main forms that undulate over the original sweeping abstractions underneath. Turn your attention to the surface centers to orient the positions of the head, rib cage and pelvis in space. Slight indications of the rib cage's and pelvis's base boundaries help to identify the main parts of the torso. Try visualizing the entire mass of the rib cage because it's important to understand how the neck flows out of the rib cage. The pelvis's anterior superior iliac spine establishes its direction, which is in opposition to the rib cage, creating a dynamic contrapposto. The torso is also twisting, or spiraling in two opposite directions—the front of the chest faces one direction and the front of the pelvis faces a different direction, making the pose even more dramatic. Remember that in posing, contrast creates variety and beauty. Keep in mind that the model's left leg passes in front of the right leg.

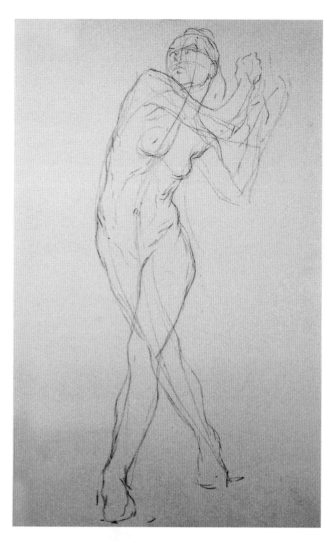

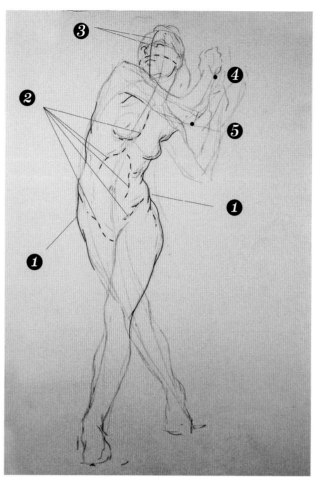

3 Build Features and Draw the Base Boundaries

Change the head's surface centers and begin to build the features on their guidelines underneath. As each stage of the drawing is resolved, the lines become more varied, taking on the character of form and light while never betraying the larger sweeping abstractions underneath. This gives the work its cohesion. In essence, the contours are space curves that gracefully undulate three-dimensionally. As you become more familiar with the model's anatomy, you can better perceive where the overlapping forms occur.

Lightly draw the base boundaries that will guide your placement of the dark lights, which end at the point they intersect a new form. To imagine the form's varied recessions or relief, think of how the form would appear if you were looking at it from the profile. (See *relief form* in the Terminology section at the front of the book.)

1. *Overlapping form*
2. *Base boundaries*
3. *Revised surface centers*
4. *Ulna*
5. *Olecranon*

Understanding Linear Construction

You must continually build your skills in linear construction independent of a light source. If a figure looks three-dimensional in line and without tone, then the construction has been thoroughly understood. This aspect of the drawing personally excites me. William Hogarth writes in The Analysis of Beauty, *"The eye is peculiarly entertained and relieved in the pursuit of these serpentine lines...they not only give play to the imagination but delight the eye as well." It also has the functional benefit of constructing a solid three-dimensional figure in a comparatively short amount of time, opening up many creative windows of opportunity, which inevitably point towards picture making.*

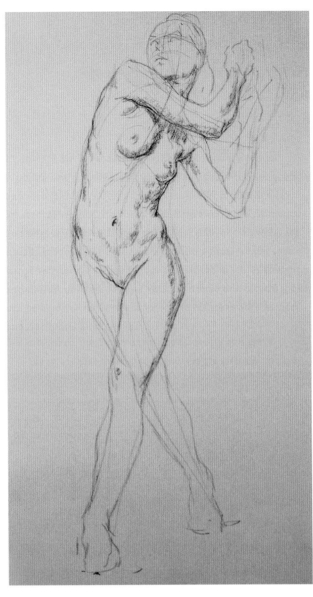
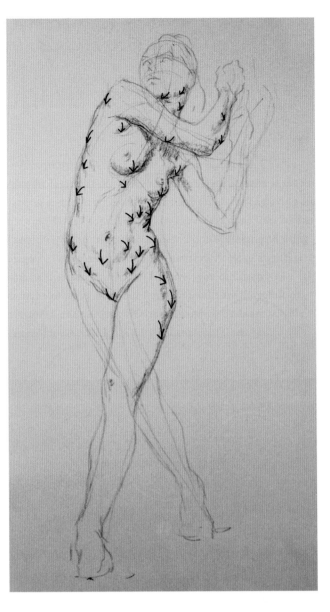

4 Add Values

Begin with your darkest darks, always starting with the shadows, which represent the exact point on a form where the light can no longer reach. However, since the light source is frontal and the shadows are minimal in this case, concentrate on the darkest lights, which are the halftones. The halftones convey the planes of the form that are turning away from the light source. These express the roundness of form. Using the base boundaries as your guide, gently shade the darker lights according to their relief, as can be seen in the torso's abdomen and oblique muscles. The curved arrows represent the forms that turn away from the light source as they become gradually darker and darker.

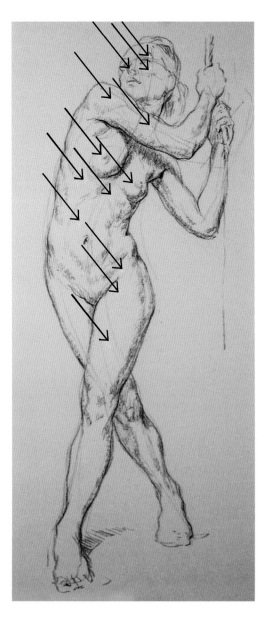

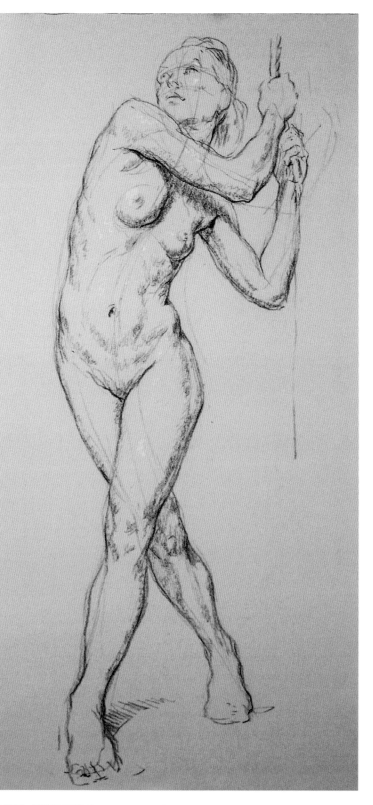

5 Strengthen the Shadows and Add Highlights to Finish

The shadows and halftones are further strengthened over the entire figure. Since you're working on a light toned paper, you can bring out the light lights and highlights with white chalk. The straight arrows represent the peaks of the forms that are facing most directly towards the light source.

MAYA, TWENTY-MINUTE POSE
Jon deMartin, 2015
Red and white chalk on toned paper
22" × 15" (56cm × 38cm)

INDEX

a content + ecommerce company

Other fine North Light Books are available from your favorite bookstore, art supply store or online supplier. Visit our website at fwmedia.com.

21 20 19 18 17 7 6 5 4 3

DISTRIBUTED IN CANADA BY FRASER DIRECT
100 Armstrong Avenue
Georgetown, ON, Canada L7G 5S4
Tel: (905) 877-4411

DISTRIBUTED IN THE U.K. AND EUROPE
BY F&W MEDIA INTERNATIONAL LTD
Brunel House, Forde Close, Newton Abbot, TQ12 4PU, UK
Tel: (+44) 1626 323200, Fax: (+44) 1626 323319
Email: enquiries@fwmedia.com

ISBN 13: 978-1-4403-4285-1

Edited by Christina Richards
Designed by Jamie DeAnne
Production coordinated by Jenn Bass

ABOUT THE AUTHOR

Jon deMartin is among the leading figurative artists working today and has taught life drawing and painting for more than twenty years at the most prestigious academies and ateliers in the country. Among them are the Art Students League of New York, New York Academy of Art, the Grand Central Academy of Art (Grand Central Atelier), the Janus Collaborative School of Art, Studio Incamminati and Parsons School of Design (The New School). He has exhibited at Hirschl & Adler Galleries, John Pence Gallery, the Arnot Art Museum, the Butler Institute of American Art, the Florence Griswold Museum and the Beijing World Art Museum, and has also featured in the exhibit "Contemporary American Realism."

Jon grew up in Wilmington, Delaware and later moved to New York where he graduated from Pratt Institute with a Bachelor of Fine Arts in Filmmaking. He subsequently enrolled at the Art Students League, and also studied privately with reknowned artist Michael Aviano. He currently lives in White Plains and teaches in his studio in Port Chester, New York.

Jon's work has been reproduced in various publications including, *The Classicist, Classical Drawing Atelier, Lessons in Classical Drawing* (Watson-Guptil), *Star Wars Art: Visions,* (Abrams), and *Classical Life Studio: Lessons & Teachings in the Art of Figure Drawing* (Sterling). He has written and illustrated more than twenty-five articles on classical figure-drawing techniques for *Drawing* magazine.

In his paintings, Jon concentrates on the figure placed in outdoor and interior situations, as well as portraits and industrial landscapes. To see more of his work, visit his website: jondemartin.com.

Metric Conversion Chart		
To convert	to	multiply by
Inches	Centimeters	2.54
Centimeters	Inches	0.4
Feet	Centimeters	30.5
Centimeters	Feet	0.03
Yards	Meters	0.9
Meters	Yards	1.1

I would like to express my deepest gratitude to my friend and teacher, Michael Aviano. I am forever grateful for his incredible gift of deconstructing the art of classical drawing and making it simple and understandable. With his generous guidance, I have been able to articulate the principles found in this book.

To my friend, sculptor and author Eliot Goldfinger, my thanks for his generosity, encouragement, wisdom and steady guidance throughout the entire process of writing this book.

Heartfelt thanks go to my student and friend, Nancy Dyer, for her thorough reading of the manuscript and for her useful comments about language and style.

I am indebted to all my students for their loyalty and encouragement; they have made writing this book worthwhile.

I'd like to thank my friends and colleagues for their support and inspiration, particularly Dan Thompson, Gary Hoff, Paul Toner and Deane Keller.

I am indebted to the teachers who have influenced my education as an artist: Gustav Rehberger, Romolo Costa, Ted Schmidt and Millet Andreevich.

After my friend, Bob Martin, read my first article in *Drawing*, he said, "You really should write a book!" Thank you, Bob.

I am indebted to my inspirational models and friends who have posed for my drawings: Gilda Cao, Wendy Chu, Maya Rojkova, Pedro Jimenez, Marilyn Lee, Shasta Wonder, Antonio Santiago, Michael-Thorton Smith, Helen Dupre and Julie Wyble.

I am grateful to my student, William Rorick, who organized all of my past *Drawing* articles—a librarian's gift that has made writing this book so much easier.

To Ed Hoehn ("Aquaman"), for his timely technical support, I am most grateful.

Special thanks to Federico Moretto at PDK Labs for his keen digital eye.

To Alan Metz, thank you for sharing those wonderful and hard-to-find books on classical drawing.

To my editor Christina Richards for her patience and guiding hand throughout the book's production, a special thank you. Thank you as well to Jamie DeAnne for the beautiful and complex book design.

My gratitude to all the people and schools I've been privileged to be associated with: A special thanks to Nelson and Leona Shanks at Studio Incamminati in Philadelphia; Linda Dulaney, founder of the Bay Area Classical Artist Atelier in the San Francisco area; Pam and Gary Faigin at Gage Academy of Art in Seattle; Parsons School of Design; New York Academy of Art; the Lyme Academy College of Fine Arts, University of New Haven, Connecticut; Brandon Soloff at Chelsea Classical Studio School of Fine Art; Eric Angeloch at the Woodstock School of Art; Jacob Collins at the Grand Central Atelier and Ira Goldberg at the Art Students League of New York.

I acknowledge Austin Williams for his support and comments regarding my articles written for *Drawing* magazine, and for helping to make this book a reality. A special thanks also to Steven Doherty and Bob Bahr.

My deepest and heartfelt gratitude to the late Dave Wanner for his friendship, support, wisdom and guidance.

A very special thank you to my father for all his love and support. He has helped proofread my magazine articles and has always kept me up to date on the New York Yankees.

To my daughter Victoria, thank you for bringing so much joy and inspiration to our lives.

And finally to my wife, Ann, my partner in life as well as a fellow artist, my love and heartfelt gratitude for her support and encouragement. Thirty years ago she gave me her translation from the old French of Jombert's, *Méthode Pour Apprendre le Dessein.* That was one of the seeds from which this book eventually grew.

DEDICATION

To my father and to the memory of my mother.

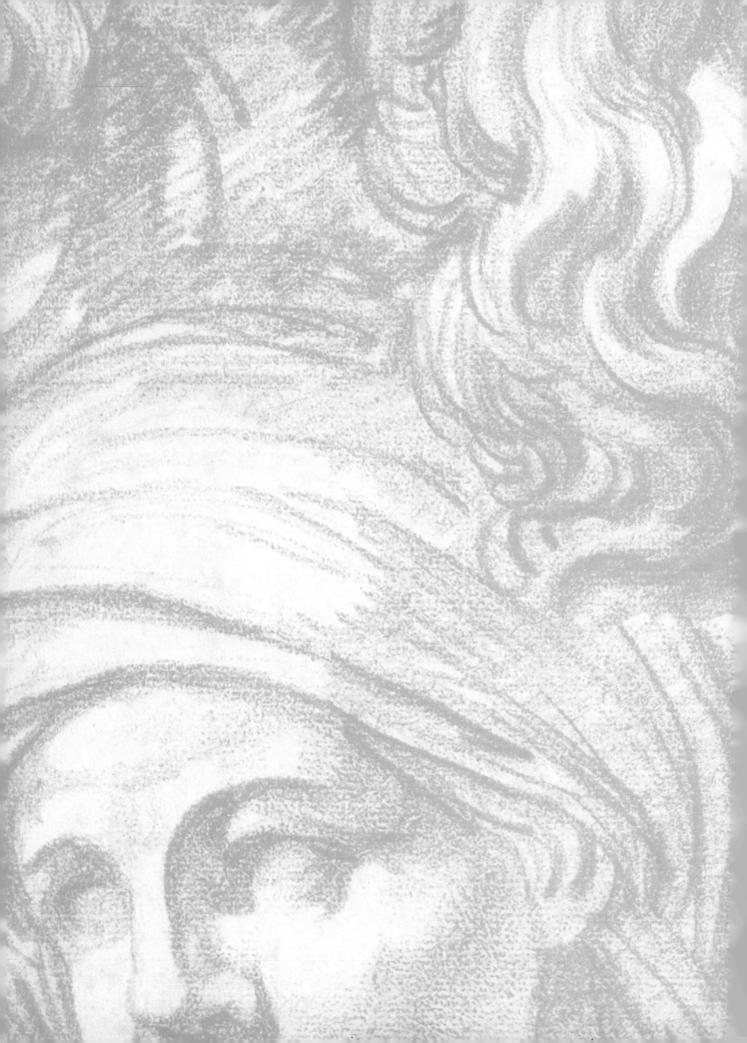